DO OR DIE

AUF LEBEN UND TOD

DO OR DIE

The Human Condition in Painting and Photography
Teutloff meets Wallraf

AUF LEBEN UND TOD

Der Mensch in Malerei und Fotografie
Die Sammlung Teutloff zu Gast im Wallraf

Wallraf-Richartz-Museum & Fondation Corboud, Köln

Hirmer Verlag München

Dieses Buch erscheint anlässlich der Ausstellung
Auf Leben und Tod
Der Mensch in Malerei und Fotografie
Die Sammlung Teutloff zu Gast im Wallraf
17. September 2010 – 9. Januar 2011
im Wallraf-Richartz-Museum & Fondation Corboud, Köln
www.wallraf.museum

This book appears in conjunction with the exhibition
Do or Die
The Human Condition in Painting and Photography
Teutloff meets Wallraf
September 17, 2010 – January 9, 2011
at the Wallraf-Richartz-Museum & Fondation Corboud, Cologne
www.wallraf.museum

Herausgeber / Editors Andreas Blühm und Roland Krischel
Idee / Idea Andreas Blühm, Roland Krischel, Lutz Teutloff
Konzeption / Concept Roland Krischel
Katalogredaktion / Catalogue editor Roland Krischel
Verwaltung / Administration Karin Heidemann
Öffentlichkeitsarbeit / Public relations Stefan Swertz, Berni Cimera
Konservatorische Betreuung / Conservation Isabella Ionescu,
Tomoyoshi Iwamatsu, Thomas Klinke, Ester Mönnink, Caroline von
Saint-George, Iris Schaefer
Ausstellungsgestaltung / Exhibition design Daniel Schäfers,
TRANSPORTdesign (Idee: Roland Krischel)
Ausstellungsaufbau / Setup Bruno Breuer, David Owsianik,
Grzegorz Polecki
Haustechnik / Building utilities management Michael Franke,
Kurt Rossetton, Michael Schirpke
Fotos der Gemälde / Photographs of the paintings Rheinisches
Bildarchiv
Fotos der Fotografien / Photographs of the photographs
Kurt Steinhausen

© 2010 Wallraf-Richartz-Museum & Fondation Corboud, Köln;
die Autoren / authors; Hirmer Verlag GmbH, München
© 2010 Bazon Brock, Cronenberg

Bibliografische Information der Deutschen Nationalbibliothek:
Die Deutsche Nationalbibliothek verzeichnet diese Publikation
in der Deutschen Nationalbibliografie; detaillierte bibliografische
Daten sind im Internet über http://dnb.d-nb.de abrufbar.

Bibliographic information published by the Deutsche Nationalbibliothek:
The Deutsche Nationalbibliothek lists this publication in the Deutsche
Nationalbibliografie; detailed bibliographic data are available on the internet
at http://dnb.d-nb.de.

Katalog / Catalogue Hirmer Verlag München
Projektmanagement / Project management Karen Angne,
Katja Durchholz
Gestaltung, Satz und Produktion / Graphic design, typesetting,
production Katja Durchholz
Umschlaggestaltung / Cover design Bärbel Maxisch, BÜRO211,
Düsseldorf
Umschlagmotiv / Cover image Hendrik Kerstens, Bag, S./pp. 73, 132
Übersetzung deutsch–englisch / Translation German–English
Michael Scuffil, Köln
Lektorat deutsch / Copy-editing German Susanne Ibisch, Leipzig
Lektorat englisch / Copy-editing English Michele Tilgner, München
Lithografie / Lithography Reproline Genceller, München
Druck und Bindung / Printed and bound by Printer Trento S.r.l., Trento
Papier / Paper GardaArt matt, 150 g

ISBN: 978-3-7774-2971-7 (deutsch)
ISBN: 978-3-7774-3261-8 (englisch)

Printed in Italy
Alle Rechte vorbehalten / All rights reserved

www.hirmerverlag.de

Inhalt / Contents

6 Auf Leben und Tod – Degrees of Separation
Do or Die – Degrees of Separation
Andreas Blühm

10 Über die Dramaturgie der Verknüpfung
von Anfang und Ende
The Dramaturgy of the Link between Beginning and End
Bazon Brock

18 Leben im Tod. Das Porträt in Malerei und Fotografie
Life in Death: The Portrait in Painting and Photography
Roland Krischel

44 Fotografie sammeln
Ein Interview mit Lutz Teutloff
Collecting Photography
An Interview with Lutz Teutloff

51 Bildteil / Catalogue

122 Kommentiertes Verzeichnis der Werke / List of Works
Roland Krischel

157 Literatur / Literature
160 Bildnachweis / Photographic Credits

Auf Leben und Tod – Degrees of Separation

Diese Ausstellung handelt von Trennung und Gemeinschaft, von Beziehungen, Wahlverwandtschaften und zufälligen Begegnungen.

Zunächst soll von einem Ablöseprozess die Rede sein, dessen Trennungsschmerz anhält: 2001 wurde mit der Eröffnung des neuen Wallraf-Richartz-Museums im Bau von Oswald Mathias Ungers die endgültige räumliche Separierung vom Museum Ludwig vollzogen. Das Wallraf hatte immer auch Kunst der jeweils gültigen Gegenwart gezeigt, und mit den Sammlungen von Josef Haubrich 1946 sowie Peter und Irene Ludwig 1976 fanden große und bedeutende Konvolute der Moderne die Nähe zu Lochner, Dürer, Rembrandt und van Gogh. Die exponentielle Ausdehnung der Gegenwartskunst in Umfang und Zahl und der Zuwachs um Ludwigs Picasso-Konvolut erzwangen schließlich die Scheidung von alten und neuen Meistern. Köln steht damit nicht allein, im Gegenteil. In vielen Städten haben die modernen Abteilungen ihre kunsthistorische Basis verloren bzw. die alten Abteilungen den Anschluss an die Gegenwart. Selten sind die Häuser geworden, in denen der Parcours vom Mittelalter bis heute noch im Trockenen abgelaufen werden kann.

Das ist bedauerlich und daher ist es für uns im Wallraf-Richartz-Museum nicht nur eine Spielerei, wenn wir immer mal wieder das vertraute Feld der Tafelmalerei und der Kupferstiche verlassen und den Brückenschlag in Moderne und Gegenwart wagen. Immerhin verursacht die Trennung, dass Begegnungen von Alt und Neu bewusster wahrgenommen werden können. In den letzten Jahren gab es schon mehrere dieser Begegnungen: 2006 zeigten wir mit der Kunsthochschule für Medien Werke der Träger des Spiridon-Neven-DuMont-Preises (»Echo«). 2007 präsentierten wir unter dem Titel *Hotel California* Arbeiten der Fotokünstler Desiree Dolron und Thomas Wrede im Dialog mit mittelalterlichen Martyrienszenen und barocken Paradiesdarstellungen. 2008 war das Wallraf Veranstaltungsort für die Ausstellung der Künstler des Nam June Paik Awards der Kunststiftung Nordrhein-Westfalen. Jetzt haben wir die Sammlung Teutloff zu Gast – für uns ein temporäres Geschenk, das uns nicht nur willkommen ist, sondern die Gelegenheit bietet, wieder einen neuen Schritt auf weniger vertrautes Terrain zu wagen.

Lutz Teutloff sammelt mit Leidenschaft, aber nicht wahllos. Seine Fotos und Videos haben den Menschen und seine körperliche Befindlichkeit zum Thema. Die vertretenen Positionen sind nicht selten extrem und verstörend. In der Konfrontation mit Gemälden aus unserer reichen Sammlung stellen wir Thesen auf, von denen manche auf den ersten Blick vielleicht banal erscheinen: 1. Kunst kennt keine zeitliche Grenze, 2. die Künstler sind ihren Themen treu und 3. der Mensch bleibt das wichtigste Motiv. Ausgehend von diesen Statements mögen Leser und Betrachter also in alle Richtungen ausschwärmen.

Do or Die – Degrees of Separation

This exhibition deals with separation and society, with relationships, elective affinities and chance encounters.

First of all, I would like to mention a process of separation, the pain of which is still felt. In 2001, with the opening of the new Wallraf-Richartz-Museum in the building designed by Oswald Mathias Ungers, the geographical separation from the Museum Ludwig was finally consummated. The Wallraf had always exhibited art of what was at the time the present day, and with the collection of Josef Haubrich in 1946 and that of Peter and Irene Ludwig in 1976 large and important accumulations of modern art found a place in the immediate vicinity of Lochner, Dürer, Rembrandt and van Gogh. The exponential expansion of contemporary art, along with the addition of Ludwig's Picasso collection, however, finally forced the divorce of the old masters from the new. Cologne was not alone in this development, on the contrary. In many cities, the modern departments have lost their art-historical foundation, or, to put it another way, the continuity linking the old works with the new has been broken. Museums where visitors can still proceed from the Middle Ages to modernity under one roof have become the exception.

This is regrettable, and hence, for us at the Wallraf-Richartz-Museum, it is not just a self-indulgent game when, time and again, we leave the familiar field of easel painting and engraving to take a bold leap into the modern age. For after all, separation means that when old and new do meet, the encounter can be experienced with greater awareness. In recent years there have been several such encounters. In 2006 we collaborated with the Academy of Media Arts Cologne to exhibit works by the holders of the Spiridon-Neven-DuMont Prize ("Echo"). In 2007, under the title "Hotel California," we presented works by the art photographers Desiree Dolron and Thomas Wrede in dialogue with medieval martyrdom scenes and Baroque depictions of Paradise. In 2008 the Wallraf was the venue for an exhibition by the artists who had received the Nam June Paik Award from the Kunststiftung Nordrhein-Westfalen. And now we are playing host to the Teutloff Collection. For us this temporary gift is not only welcome, but also provides us with an opportunity once more to take a new leap into less familiar territory.

Lutz Teutloff collects with passion, but not at random. His photographs and videos have as their theme human beings and their bodily experiences. The works in the collection are, sometimes, extreme and disturbing. By confronting them with paintings from our own rich collection, we postulate theses that at first sight may strike many as banal: 1. art knows no temporal boundaries; 2. artists are true to their subject matter; and 3. the *condition humaine* remains the most important theme. From the starting point of these theses, we hope that readers and visitors will fan out in all directions.

What the works, which span the period between the 15th and 21st centuries, evince in the way of formal similarities and differences is revealed by attentive and patient observation. You may find the comparisons obvious, you may find them stimulat-

Was die Arbeiten, die vom 15. bis ins 21. Jahrhundert reichen, in formaler Hinsicht an Gemeinsamem und Unterschiedlichem aufweisen, erschließt sich bei aufmerksamer und geduldiger Betrachtung. Sie mögen die Vergleiche mal vordergründig, mal »an den Haaren herbeigezogen« oder mal sehr reizvoll und originell finden. Alle Beteiligten an diesem Projekt sind sich sicher, dass die Gesamtschau eine große Fülle an hochinteressantem Bildmaterial bietet, das ganz neue Blicke auf die Bilder vom Menschen auslöst. Dazu wünschen wir viel Sehvergnügen.

Der Katalog bietet einige Hilfestellungen: Kurator Roland Krischel formuliert eine kritische Auseinandersetzung mit der Fototheorie und geht dabei konkret auf die Bildvergleiche ein; Bazon Brock befasst sich mit der zyklischen Entwicklung der Thematik vom Leben zum Tod und wieder zurück. Eine entscheidende Inspirationsquelle für die innere Struktur der Ausstellung und ihr Erscheinungsbild war Mark Z. Danielewskis *House of Leaves*. Wir vereinen also nicht nur Bilder, sondern auch Autoren, die uns viel zu sagen haben. Nicht nur ihnen gilt unser Dank, sondern natürlich auch den Künstlern. Hervorheben möchte ich stellvertretend Hendrik Kerstens, der uns das Foto seiner Tochter als Leitbild zur Verfügung stellte.

Daniel Schäfers und sein Team setzten die Idee einer Illusionsarchitektur meisterhaft um. Perspektivische Linien trennen die Bilder und vereinen sie in einer räumlichen Augentäuschung, die unterschiedliche Formate ausgleicht. Die Gestalterin Bärbel Maxisch fand überzeugende Lösungen für ein komplexes Thema. Beim Hirmer Verlag kümmerten sich Kerstin Ludolph und Katja Durchholz um die vorbildliche Produktion.

Wir danken im Haus selbst für Rat und Tat Bruno Breuer, Berni Cimera, Götz Czymmek, Karin Heidemann, Isabella Ionescu, Tomoyoshi Iwamatsu, Thomas Ketelsen, Thomas Klinke, Ester Mönnink, Tobias Nagel, David Owsianik, Grzegorz Polecki, Caroline von Saint-George, Iris Schaefer, Elisabeth Schmidt-Altmann, Stephanie Sonntag, Stefan Swertz, Barbara Trier sowie Jörg Streichert vom Verein der Freunde und den Mitarbeitern des Rheinischen Bildarchivs.

Für vielfältige Unterstützung danken wir auch Christian Alexander Bauer, Thomas Böhm, Warren Frazier, Regina Hundeck, Elizabeth Kerr, Kurt Steinhausen und Sabine Weichel.

Last but not least danken wir Lutz Teutloff. Er hatte die Idee und er hat die Fotos, die uns so viel über die alte Kunst und über uns selbst gelehrt haben.

Andreas Blühm
Köln, Juni 2010

ing and original, or you may find them merely far-fetched. All those involved in this project are, however, certain that the exhibition in its totality offers an abundance of highly interesting pictorial material that stimulates entirely new ways of seeing pictures of the human being and the human body. We wish you an enjoyable visual experience.

The catalogue provides a number of aids to this experience. The curator Roland Krischel presents a critical examination of photographic theory, addressing the pictorial comparisons directly. Bazon Brock looks at the cyclical development of the theme from life to death and back. A crucial source of inspiration for the internal structure of the exhibition and its appearance was Mark Z. Danielewski's novel *House of Leaves*. We therefore bring together not only pictures, but also authors who have a great deal to say to us. We are grateful not just to them, but also of course to the artists. I should like to single out in this connection, as representative of all of them, Hendrik Kerstens, who allowed us to use the photograph of his daughter as our theme picture.

Daniel Schäfers and his team were masterly in their implementation of the idea of illusionist architecture. Perspective lines separate the pictures and at the same time unite them in a spatial optical illusion that compensates for the differences in size. The designer Bärbel Maxisch has found convincing solutions for a complex subject. Kerstin Ludolph and Katja Durchholz of Hirmer Verlag have produced an exemplary catalogue.

Among our own staff, we should like to thank Bruno Breuer, Berni Cimera, Götz Czymmek, Karin Heidemann, Isabella Ionescu, Tomoyoshi Iwamatsu, Thomas Ketelsen, Thomas Klinke, Ester Mönnink, Tobias Nagel, David Owsianik, Grzegorz Polecki, Caroline von Saint-George, Iris Schaefer, Elisabeth Schmidt-Altmann, Stephanie Sonntag, Stefan Swertz and Barbara Trier, along with Jörg Streichert from the Verein der Freunde, as well as the staff of the Rheinisches Bildarchiv.

Thanks are also due to Christian Alexander Bauer, Thomas Böhm, Warren Frazier, Regina Hundeck, Elizabeth Kerr, Kurt Steinhausen and Sabine Weichel for their assistance in a variety of fields.

And not least we must say thank you to Lutz Teutloff. It was his idea, and it is his photographs that have taught us so much about the art of the Old Masters and about ourselves.

Andreas Blühm
Cologne, June 2010

Über die Dramaturgie der Verknüpfung von Anfang und Ende

Bazon Brock

Sicherheit der Prophetie:
Altern ist die Zukunft der Jugend

Warum dürfen wir darauf vertrauen, dass unsere Biografieentwürfe sinnvoll sein können? Sinnvoll heißt, unsere Herkunft mit unserer Zukunft verbunden zu haben und dabei nicht bloß eine beliebige Zukunft zu imaginieren, sondern eine, die sich aus der Entwicklungslogik unseres bisherigen Lebens erschließt.

Das für jedermann entscheidende Beispiel für die Sinnhaftigkeit einer solchen Prophetie bietet die Aussage, Alter sei die Zukunft der Jungen. Das ist in jeder Hinsicht stimmig, obwohl ja, wie wir gern behaupten, die Zukunft ganz unbestimmt sei. Am Beispiel dieser hundertprozentig zutreffenden Prophetie gewinnen wir das Vertrauen in die Leistungsfähigkeit derartiger Orientierung auf die Zukunft. Das widerspricht nicht der natürlichen Auffassung, Leben sei ein Prozess der Entwicklung – aber eben nicht ein Prozess beliebiger Veränderungen oder Abweichungen. Mit Entwicklung (Evolution) wird ja die Entfaltung dessen angesprochen, was in uns, bei einer bestimmten Lebenswelt und in bestimmten zeitgeschichtlichen Kontexten, angelegt ist.

Entwicklung meint also die Entfaltung unseres Potenzials. Deshalb hören wir mit besonderem Interesse auf Äußerungen von Eltern, Verwandten oder Lehrern, dass in jemandem offensichtlich ein ganzer Kerl stecke oder umgekehrt, dass an jemandem ein großartiger Arzt oder Kaufmann verloren gegangen sei.

Die biblische Weisheit ermahnt uns, mit unseren Pfunden zu wuchern, also unser Potenzial weitestgehend zu entfalten. Der Alltagsrealismus folgt dem immerhin noch mit der Empfehlung, das Beste aus uns zu machen, wobei das Beste die erheblichen Unterschiede zwischen den Entwicklungspotenzialen von Individuen bezeichnet. Mögen auch die Menschen sehr unterschiedlich ausgestattet sein – wenn sich jeder mit Blick auf sein Potenzial die größte Entwicklungsanstrengung abverlangt, ist der Handwerker auf die gleiche Weise zu würdigen wie der Hochleistungsingenieur. Diese gleich Wertvollen und Anerkennungswürdigen können dann völlig unabhängig von dem, was sie im Lauf ihres Lebens aus der Potenzialität in die Realität brachten, am Ende feststellen, dass »es gut war« oder dass ihnen ihr Leben gelungen ist.

Transzendierung des Endes durch Auferstehung

Bei aller Anerkennung, dass ein gelebtes Leben gelungen sei, wird von so gut wie jedermann mit Blick auf das eigene Lebensende gefragt, ob es nicht mit der Feststellung des Endes auch ein Jenseits des Endes geben müsse und natürlich auch ein Jenseits des Anfangs. Letztere Frage ist schnell beantwortet: Bevor wir ins Leben treten, sind wir Bestandteil des Zeugungspotenzials unserer Eltern und von deren Eltern, weshalb wir uns selbst in der Vergangenheit auffindbar werden lassen, wenn wir mit geschichtlichem Bewusstsein dem Gewesenen huldigen wie der Adel seinem Stammbaum.

The Dramaturgy of the Link between Beginning and End

Bazon Brock

Certainty of the Prophecy: Aging is the Future of Youth

Why can we all trust that our life designs can be meaningful? Meaningful means linking our provenance with our future, and in the process, not just imagining any old future, but one that becomes apparent from the developmental logic of our lives hitherto.

An example, decisive for everyone, of the sense of such a prophecy is provided by the statement that old age is the future of the young. This is in every respect coherent, even though, as we are always asserting, the future is totally undetermined.

Using the example of this invariably correct prophecy, we gain confidence in the benefit potential of such an orientation to the future. This does not contradict the natural view that life is a process of development, but precisely that it is not a process of arbitrary changes or deviations. By development (evolution) we mean the unfolding of what is invested within us, given a particular life-world and in certain historical contexts.

So development means the unfolding of our potential. This is why we listen with particular interest to our parents, relations or teachers when they say that someone has the potential to do great things, or, conversely, that someone else might have been a splendid businessman or doctor.

Biblical wisdom urges us to lend out our talents at interest, in other words, to develop our potential to the fullest extent possible. Everyday realism follows with the recommendation to make the best of ourselves, although the best must be seen in relation to the considerable differences in the development potential of individuals. While people may be equipped very differently, if each demands of himself the greatest developmental effort given his potential, the ordinary workman should be honored in the same way as the highly qualified engineer. These equally valuable and equally estimable people can then, regardless of how much of their potential they actually realized in the course of their lives, say at the end that "it was good," or that their lives were a success.

Transcending the End through Resurrection

For all the recognition that a life as lived has been successful, almost everyone, at least with the end of his or her own life in mind, will ask whether the ascertainment of the end does not entail a beyond-the-end, and of course also a beyond-the-beginning. The latter question is quickly answered. Before we enter life, we are a component of the creation-potential of our parents and their parents, which is why we create the possibility of finding ourselves in the past when, with historical awareness, we pay homage to what has been, just as the nobility worships its pedigree.

The answer to the question of the beyond-the-end has been, since Gutenberg: Who writes, survives. That is, whoever writes himself into the memory of others can postpone the end of his life to the furthest future by transforming his real physical presence into a virtual presence.

Die Antwort auf die Frage nach dem Jenseits des Endes lautet seit Gutenberg: Wer schreibt, der bleibt. Das heißt, wer sich ins Gedächtnis der Mitlebenden einschreibt, kann das Ende seines Lebens in die weiteste Zukunft hinausschieben, indem er real-physische Präsenz in eine virtuelle verwandelt.

In vielen zurückliegenden Zeiten war das relativ einfach zu bewerkstelligen, weil es nur wenige »unsterbliche Autoren« oder Staatengründer, Künstler oder Stifter von Weltanschauungen, Lebensretter oder Notwandler gab, denn alle derartigen Kulturheroen wirkten in relativ kleinen voneinander abgegrenzten Gemeinschaften. Im Zeitalter der Globalisierung ist die Zahl der ins Gedächtnis der Kollektive Eingeschriebenen viel zu groß, als dass auch nur noch die Bildungsbeflissensten in der Lage wären, die Namen der Unsterblichen zu memorieren. Eine gewisse Erleichterung bieten immerhin Institutionen wie Museen, Universitäten und Archive, zu deren Leistungen eben die ständige Wiederholung eines Namens- und Titelkanons gehört (*relegere*, also »immer wieder lesen«, ist eine der Begründungen von Religion). Die Institutionen garantieren in gewissen Maßen die ewige Wiederkehr durch ewige Wiederholung mit der Tendenz der Aufbewahrung des Kanons für alle Zeit.

Bei weltweit Millionen von Namen Erinnerungswürdiger kann es niemandem mehr gelingen, den Kulturheroen Unsterblichkeit dadurch zu garantieren, dass man deren Namen wenigstens einmal pro Jahr im Munde führt. Wer heute angesichts des Namensfriedhofs Internet wie einstmals General Stumm von Bordwehr im Katalograum der Wiener Staatsbibliothek mit Entsetzen auf die Zumutung reagiert, Autorennamen zu würdigen hieße notwendig, ihre Bücher nicht zu lesen, muss sich fragen, was dann noch Dienst am ewigen Gedächtnis der Menschheit bedeuten könne. Soweit selbst Wissenschaftler mit jeder angeführten Fußnote zu erkennen geben, dass sie Angeber und nicht mehr Kenner der angeblich zitierten Werke seien und sich bei Vorhaltungen mit der Gegenfrage entlasten, wie sie denn schreiben könnten, wenn sie andauernd lesen müssten, scheint der Zusammenbruch des kollektiven Gedächtnisses bereits vollzogen.

Die Erklärung, selbst Künste und Wissenschaften seien inzwischen von den kapitalistischen Verwertungszusammenhängen geprägt, hilft nicht weiter. Wir haben uns vielmehr an die Grundeinsicht der Wissenschaften zu erinnern, dass Schreiben und Komponieren und Malen und industrielles Produzieren nur durch ihre Komplemente Lesen und Zuhören und Betrachten und Konsumieren sinnvoll bestimmt werden können: Was nicht gelernt wurde, wurde auch nicht gelehrt. Was nicht gelesen wird, ist nicht geschrieben worden usw. Wir können uns also nur als Schreiber oder Zeichner behaupten, wenn wir selbst lesen und uns auf Betrachtung verpflichten. In dieser Orientierung auf Komplementarität haben Bibliotheken oder Museen eben nicht nur ehemals geschaffene Artefakte zu sammeln und zu konservieren, sondern für deren Wahrnehmung zu sorgen.

Die Bedingung der Möglichkeit des Schreibens ist das Lesen. Die Bedingung der Möglichkeit etwas hervorzubringen, ist die Bereitschaft, das bereits Geschaffene durch Aneignung zu würdigen. Das hieß einst *l'art pour l'art* und wurde völlig missverstanden als zirkulärer Selbstlauf. Wer malen will, muss sich zum Betrachter der Gemälde anderer heranbilden. Zu schreiben ist nur sinnvoll, wenn man selbst liest. Darin liegt noch der tiefste, heute leider völlig vergessene Sinn der Gründung von Akademien der Wissenschaften und der

In many past ages this was relatively easy to bring about, because there were few "immortal authors," founders of states, artists or originators of worldviews, savers of life or saviors of nations, for all such cultural heroes were active in relatively small, clearly defined communities. In the age of globalization the number of immortals written into the collective memory is far too big for even the most educated to memorize their names. A certain facilitation is offered by institutions such as museums, universities and archives, which provide, among other services, the constant repetition of a canon of names and titles (*relegere*, in other words "to read over and over again," is at the origin of religion). The institutions guarantee, in certain measure, eternal return through eternal repetition, with the tendency to preserve a canon for all time.

Given that worldwide there are millions of names of people worth remembering, no one can manage any longer to guarantee immortality to cultural heroes by reciting their names at least once a year. In view of the Internet, that graveyard of names, all those nowadays who, like General Stumm von Bordwehr in the catalogue room of the Vienna State Library, react with horror to the idea that honoring the names of authors necessarily implies not reading their books, must ask themselves what serving the eternal memory of mankind could still mean. To the extent that even scholars give their readers to understand, with every footnote, that they are show offs and no longer connoisseurs of the (allegedly) quoted works, and brush off criticism by asking how they could be expected to write if they spent all their time reading, the collapse of the collective memory seems already to have taken place.

Nor do we derive any assistance from the explanation that even arts and sciences are now characterized by capitalist ideas of profitable exploitation. We must, rather, remember the basic insight provided by science that writing and composing and painting and industrial production can be usefully defined only through their complements, namely, reading and listening and beholding and consuming. What has not been learned was never taught. What is not read has not been written, and so on. We can only assert ourselves as writers and visual artists if we ourselves read and oblige ourselves to look at pictures. Gearing themselves to this aspect of complementarity, libraries and museums have not only to collect and conserve artifacts made in the past, but to ensure that they are also perceived.

The precondition of the possibility of writing is reading. The precondition of the possibility of creating something is the readiness to appreciate, through appropriation, what has already been created. That used to be called "art for art's sake" and was totally misunderstood as a circular process. Those who wish to paint must first educate themselves to behold the pictures painted by others. Writing has a purpose only if one reads oneself. Therein still lies the profoundest, today unfortunately totally forgotten, purpose behind the foundation of academies of sciences and arts, namely that their members can provide each other with a reciprocal guarantee that what has been written is also read, and that what has been painted will also be beheld. For communication can succeed only where there is community.

To this extent the favorite maxim of the sociologists, namely that the development of modern society is always characterized by the continuing further differentiation of functional typologies, is refuted. Reading is not a further differentiation vis-à-vis writing, beholding pictures not a further differentiation vis-à-vis creating pictures, but rather in each case complementary. The thesis of constant further differentiation at the same time explains

Künste, dass deren Mitglieder sich wechselseitig garantieren, dass das Geschriebene auch gelesen und das Gemalte auch betrachtet wird. Denn Mitteilungen gelingen nur, wo man miteinander teilt.

Insofern ist die Lieblingsmaxime von Soziologen, die Entwicklung der Moderne sei durch immer weiter gehende Ausdifferenzierung von Funktionstypiken gekennzeichnet, widerlegt: Lesen ist nicht eine Ausdifferenzierung gegenüber dem Schreiben, Bildbetrachtung nicht eine Ausdifferenzierung gegenüber dem Bildermachen, sondern deren Komplement. In der These von der immer weiter gehenden Ausdifferenzierung steckt zugleich die Erklärung, warum ein derartiges Verständnis von Wissenschaft zu ihrer Marginalisierung geführt hat.

Den allgewaltigen Verwertungszusammenhang parodierte der unsterbliche Loriot mit seiner Huldigung an den »Advent«, an dem eine Förstersfrau die zerstückelten, das heißt »ausdifferenzierten« Glieder ihres verewigten Gatten dem Nikolaus als hübsch verpackte Gaben anvertraut. Einstmals war die Liebe darauf verpflichtet, die *disiectae membrae*, die aus dem Zusammenhang des Lebens gerissenen Körperteile von Osiris, Dionysos oder Christus, wieder zusammenzufügen im Begriff der Auferstehung. Die Loriotsche Kritik setzt dieser Glorie den zeitgemäßen Prozess der konsumeristischen Resteverwertung entgegen.

Immerhin gelingen auch heute noch kleine Auferstehungen, soweit wir an unseren Videogeräten und DVD-Playern durch das immer wiederkehrende Abspielen von Dokumentationen historischer Ereignisse die längst verstorbenen Personen wieder und wieder verlebendigen. Generell gilt, dass die technologischen Innovationen zu einem guten Teil in dem Bestreben erreicht wurden, theologische Zentralbegriffe wie »Auferstehung« und »Ewigkeit« faktisch werden zu lassen. Aber so sehr wir auch auf die Theotechnologie vertrauen, das technisch eingelöste theologische Versprechen bleibt von unserer Bereitschaft abhängig, die alltäglichen Wunder der Transzendierung aller Grenzen als bloße logische Konsequenz von Grenzziehung anzuerkennen. Man muss eben Grenzen ziehen, um Grenzen überschreiten zu können.

Optionalismus: Leben aus der Antizipation von Möglichkeiten

Unter denjenigen, die bei Arbeitsplatzwechsel einen Ausblick auf ihr zukünftiges Verhalten durch eigenhändige Darstellung ihres bisherigen Lebenslaufs eröffnen müssen, versuchen viele den Schwierigkeiten der Lebenssinnstiftung in der Verknüpfung von Beginnen und Beenden dadurch zu entgehen, dass sie sich nicht auf *ein* Ende ihrer Biografie orientieren, sondern auf viele mögliche Abschlüsse. So mancher meint, dass er dem Entscheidungsdruck durch Verweis auf jeweils andere Möglichkeiten der Fortsetzung des Lebenslaufs entgehen könnte. Er will nach dem Muster der Börsenspekulation, also des Handelns mit diversen Optionen, sich alle Möglichkeiten offenhalten. Groß ist aber die Enttäuschung, wenn er feststellen muss, dass Optionen nicht nur eröffnet, sondern auch gelöscht werden durch den Fortgang des Lebens. Ein gutes Beispiel bieten jene Singles oder Paare, die der Entscheidung zum Kind mit dem Hinweis zu entkommen glauben, dass ihnen die Optionen fürs Kinderkriegen ja immer noch erhalten blieben, wenn erst Berufseinstiege geschafft, soziale Netzwerke geknüpft und ein hinlängliches Einkommen auch zukünftig erreichbar sei. Wer es mit einer Frau nicht aushält, glaubt es mit diversen anderen doch erreichen zu können.

why such an understanding of science has led to its marginalization.

The omnipotent doctrine of profitable exploitation has been parodied by the immortal Loriot with his homage to "Advent," in which a forester's wife entrusts the dismembered (that is to say "differentiated") limbs of her immortalized husband as prettily wrapped gifts to Santa Claus. Love was at one time obliged to reassemble, in the sense of resurrection, the *disiectae membrae*, the body parts of Osiris, Dionysus or Christ, which had been snatched out of the context of life. Loriot's critique confronts this glorious act with the modern process of consumerist exploitation of residual value.

Still, even today there are successful mini-resurrections, insofar as we can use our DVD players to play and replay the documentary films of historic events, and thus bring long-deceased personages back to life again and again. It is generally the case that these technological innovations have been achieved in large measure through the endeavor to make central theological concepts such as "resurrection" and "eternity" come true. But no matter how much trust we place in theotechnology, the theological promise, now redeemed by technology, remains dependent on our readiness to recognize the daily miracles of transcending all boundaries as the mere logical consequence of drawing boundaries in the first place. Boundaries have to be drawn before they can be crossed.

Optionalism: Living by Anticipating Possibilities

Many of those who, when they change jobs, are required to give an insight into their future behavior by providing a résumé in their own hand of their lives hitherto, attempt to escape the difficulty of linking beginnings and ends to find a purpose to life by orienting themselves not to *one* end of their life story, but to many possible endings. Some think that they can avoid the pressure to arrive at a decision by pointing to other possible ways in which their lives may continue. On the model of stock-exchange speculation, in other words trading in a range of options, they want to keep all possibilities open. Deep, then, is the disillusion when they are forced to recognize that the progress of their lives not only opens up options, but also extinguishes them.

A good example is provided by those singles or couples who think they can avoid a decision on whether to have a baby by saying that they will still have the option when they are established in their careers, have formed social networks, and ensured an adequate income for the future.

A man who cannot tolerate life with one woman believes he will succeed with various others. All too often, following the example of Hollywood's social elite, such persons fall into a cycle of divorce and remarriage. What results, however, is not an experience of something better. For the alternatives to suboptimal circumstances of a life together do not consist in constant changes of partner in which the same wretched experiences of unacceptability and incompatibility are repeated. Optionalism, therefore, does not mean simply hopping around from one possibility to the next after each experience of failure. But what?

A young man aged between twenty and twenty-five, sorting out the possibilities facing him of having to choose one of his dozen marriageable girlfriends, because he can marry only one of them and not all (desirable though that may be), does not escape the choice by realizing, consecutively, as many as possible of the twelve options.

He will get nearer to his profound need for fulfillment only if he succeeds, in his life together with the eventually chosen part-

Allzu häufig wird, nach dem Beispiel hollywoodesker Gesellschaftseliten, dann der Reigen der Scheidungen und Wiederverehelichungen eröffnet. Was herauskommt, ist aber nicht eine Erfahrung des Besseren. Denn die Alternativen zu nicht optimalen Gegebenheiten des Zusammenlebens bestehen nicht im dauernden Wechsel der Verhältnisse, in denen aber jeweils die gleichen leidvollen Erfahrungen der Unzumutbarkeit und Nichtertragbarkeit gemacht werden. Optionalismus meint also nicht das beliebige Herumspringen von einer Möglichkeit zur anderen nach der jeweiligen Erfahrung des Misslingens. Sondern?

Wer mit 20 bis 25 Jahren die sich ihm eröffnenden Möglichkeiten sortiert, eine unter den Dutzend heiratbaren Freundinnen wählen zu müssen, weil man sich nur mit einer und nicht mit allen verbinden kann, so wünschenswert das auch wäre, entgeht der Qual der Wahl auch dann nicht, wenn er nacheinander möglichst viele der zwölf Optionen realisiert.

Er wird seinem tiefsten Bedürfnis nach Erfüllung nur dann näherkommen, wenn es ihm gelingt, im Zusammenleben mit der nun einmal gewählten Partnerin den Bezug auf die Nichtgewählten produktiv werden zu lassen. Das Wünschen hilft ja nur solange, wie die Wünsche stark bleiben, und das heißt, solange die Wünsche nicht erfüllt werden. Glücklich kann sich schätzen, wer eine Partnerin oder Partner hat, die es ihm erlauben, seine Wünsche gerade deshalb ausleben zu dürfen, weil sie ja prinzipiell nicht in Erfüllung gehen dürfen und also auch nicht das bestehende Verhältnis gefährden. Man lebt schließlich nicht aus der Fülle je gelungener Wunscherfüllungen, sondern aus der Kraft des Wünschens. Man lebt nicht von der Verwirklichung der eröffneten Möglichkeiten, sondern von der immer weiter gehenden Komplementierung der je gegebenen Realitäten durch das Unerreichte, ja prinzipiell Unerreichbare. Deshalb kann man auch nicht das Urteil des kleinbürgerlichen Triumphalismus über ältere Menschen akzeptieren, demzufolge die Betreffenden alle großen Möglichkeiten schon hinter sich hätten. Deren Lebenskraft und Perspektive wird sich vielmehr durch ihren zur Geltung gebrachten Möglichkeitssinn erweisen.

Solchen Möglichkeitssinn beschrieb Robert Musil im schon angesprochenen Roman *Der Mann ohne Eigenschaften* als Komplement zu dem unabdingbaren Wirklichkeitssinn, mit dem wir uns den Anforderungen der alltäglichen Lebensanstrengung gewachsen zeigen. Unseren Möglichkeitssinn durch Verweis auf die Realitäten zu schulen, ist die vornehmste Aufgabe der Künste in all ihren Ausprägungen – gerade wenn jedermann klar ist, dass es sich bei Romanen, Gemälden, Kompositionen um Eröffnungen von Lebensaspekten handelt, die wirksam werden, ohne dass wir eine Romanhandlung in unserem eigenen Leben realisieren oder eine Bildwahrnehmung in Umgestaltung unserer Wohnung überführen.

Die Ausstellung *Auf Leben und Tod* bietet uns statt der dualistischen Entgegensetzung der Sphären eine Fülle von Beispielen für die Einheit der Komplementaritäten von Gegenwart und Vergangenheit, von Heil und Zerstörung, von Gut und Böse, von Wirklichkeit und Möglichkeit, von Realität und Potenzialität, von sterblich und unsterblich und dergleichen. Wer die Beispiele für sich akzeptiert, macht die Erfahrung größter Steigerung seiner Lebenskraft, ohne realitätsflüchtig zu werden, ohne also die alltägliche Erfahrung ihm gesetzter Grenzen zu leugnen. Er wird diese Grenzen in höchstem Maße zu schätzen lernen, weil er sie mit einem delikaten Möglichkeitssinn zu überschreiten vermag.

ner, in making sure his relationships with the ones who were not chosen are productive. The wishing helps only as long as the wishes remain strong, and that means, as long as they are not fulfilled. People can count themselves lucky if they have a partner who allows them to live out their wishes precisely because they may not in principle be fulfilled and hence do not endanger the existing relationship. After all, one does not live from an abundance of successfully fulfilled wishes, but from the strength of wishing. One does not live from the realization of possibilities that have been opened up, but from the continuing complementation, by the unachieved, indeed the unachievable, of the realities at any given time. For this reason, one cannot accept the judgment of petty-bourgeois triumphalism on older people, according to which those concerned have already left all the larger possibilities behind them. Their vital strength and perspective will, rather, be demonstrated by the sense of possibility that they have brought to bear.

Robert Musil described such a sense of possibility in the novel, already alluded to, *The Man without Qualities*, as the complement to the indispensable sense of reality with which we demonstrate that we are up to the demands of life's daily challenges. To train our sense of possibility by reference to realities is the loftiest task of the arts in all their manifestations, particularly when it is clear to everyone that novels, paintings, compositions deal with the opening up of aspects of life which become effective even without our acting out the plot of a novel in our own lives or transferring our perception of a picture to the decoration of our own houses.

The exhibition "Do or Die" offers us, in place of dualistic confrontation, an abundance of examples of the unity of the complementarities of present and past, of salvation and destruction, of good and evil, of realities and possibilities, of the real and the potential, of mortal and immortal, and the like. Those who accept the examples for themselves will experience a great enhancement of their vitality without fleeing from reality, without in other words denying the everyday experience of the limits that have been set for them. They will learn to appreciate these limits to the highest degree, because they can overstep them with a fine sense of possibility.

Leben im Tod. Das Porträt in Malerei und Fotografie

Roland Krischel

Im April 1842 veröffentlichte Edgar Allan Poe eine Erzählung, die später unter dem Titel *The Oval Portrait* bekannt werden sollte. In der Zeitschrift *Graham's Magazine* erstreckte sich diese Kurzgeschichte über nur zwei Seiten – eine »Gothic Novel« *en miniature*: Der von Banditen verletzte Ich-Erzähler rettet sich in ein unbewohntes Apenninenschloss, um dort die Nacht zu verbringen. In seinem entlegenen Turmzimmer entdeckt er unter zahlreichen anderen »modernen« Gemälden das außerordentlich lebensechte Porträt einer sehr jungen Frau. Einem auf dem Kopfkissen vorgefundenen Führer zu den Gemälden entnimmt er die Geschichte dieses Leinwandbildes. Es handelt sich um ein Konterfei, das ein berühmter Maler von seiner ebenso schönen wie lebensfrohen jungen Ehefrau anfertigte, und zwar, so wird suggeriert, in eben diesem Turm. Wochenlang saß sie ihm geduldig Modell und während das Bildnis immer mehr an Lebendigkeit gewann, wich das Leben allmählich aus der Dargestellten. Als nach den letzten Pinselstrichen der Maler selbst zutiefst vor der unheimlichen Präsenz des Porträts erschrak und sich seiner Angetrauten mit einem Ausruf zuwandte, fand er sie – tot.

Durch den expliziten Vergleich des ovalen Damenporträts mit Werken des amerikanischen Bildnismalers Thomas Sully verankert Poe seine Erzählung klar im aktuellen kunstkritischen Kontext der Zeit um 1840. Ganz im Gegensatz zu dem von ihm beschriebenen Bildnis erkannte man Porträts in mittelalterlichen Bildern wie etwa Stifter in Altargemälden (S. 71) weniger oder gar nicht dank physiognomischer Ähnlichkeit, sondern vielmehr durch ihre Stellung innerhalb der Gesamtkomposition, durch die Proportion zwischen den (kleineren) porträtierten und den (größeren) heiligen Personen, durch Kleidung, Haltung und Gestik der – oft betend dargestellten – Porträtierten, nicht zuletzt auch durch beigefügte Wappen. In der Renaissance erlangte das Porträt als Bildgattung eine neue, eigenständige Bedeutung, unter anderem dank der Sammeltätigkeit humanistischer Gelehrter wie Paolo Giovio, der in seiner Villa am Comer See ein »Musäum« mit Bildnissen berühmter Männer anlegte.

Der venezianische Renaissancemaler Tizian schuf Formate und Formeln für das Porträt, die bis in das 19. Jahrhundert (S. 112) fortwirkten. Die Folgen seines berühmten Selbstporträts (Berlin) reichen über Ingres' *Bildnis des Monsieur Bertin* bis zu Picassos *Bildnis der Gertrude Stein*. Aufklärung, Französische Revolution und Romantik führten allerdings zu neuen Porträtauffassungen. So geht es bei Poe nicht mehr um ein Stifter-, Staats- oder Amtsporträt, auch von einem Ehebildnis (S. 82) oder einem Totenporträt (S. 118) kann keine Rede sein. Allenfalls die im Italien der Renaissance so wichtige Bildgattung des weiblichen Idealporträts (S. 92) findet hier – auch landschaftlich – ein Echo. Im Gegensatz zum klassischen Bildnis verfügt Poes ovales Porträt über keinen eigentlichen Anlass, keine ereignismäßige Verankerung im Lebenslauf des Modells. Es dient nicht der Porträtierten, sondern

18

Life in Death: The Portrait in Painting and Photography

Roland Krischel

In April 1842 Edgar Allan Poe published a short story that was later to become famous as "The Oval Portrait." This Gothic novel in miniature took up just two pages in *Graham's Magazine*. The first-person narrator, having been wounded by bandits, takes refuge for the night in an abandoned chateau in the Apennines. In a remote turret room he discovers, among numerous other "modern" paintings, the extraordinarily lifelike portrait of a young woman. A small volume in which the paintings are described has been left lying on the pillow and tells the story of this picture on canvas. It is a portrait painted by a famous artist of his young wife, who was as cheerful as she was beautiful. The suggestion is that it was painted in this very turret. For weeks she sat patiently to him, and as the portrait took on more and more life, this same life gradually left the sitter. After the final brushstrokes were applied, the painter himself stood "aghast" before the uncanny presence in the portrait, and turned to regard his beloved – *"who was dead"*.

By explicitly comparing the oval portrait to works by the American portraitist Thomas Sully, Poe clearly anchors his short story in the art-critical context of the time, around 1840. In stark contrast to the portrait he describes, portraits in medieval pictures, such as of donors in altarpieces (p. 71), were identified less, if at all, by physiognomic likeness, but rather by their position within the total composition, by the relative sizes of the (smaller) sitters and the (larger) saints, by the clothing, attitudes and gestures of the sitters, who were often portrayed praying,

and not least by the addition of coats of arms. In the Renaissance the portrait as genre took on a new, autonomous significance, thanks partly to the collecting activities of humanist scholars.

The Venetian Renaissance painter Titian devised portrait formats and formulae whose influence could be felt into the 19th century (p. 112). Reactions to his famous self-portrait (in Berlin) can be found in works ranging from Ingres's *Portrait of Monsieur Bertin* to Picasso's *Portrait of Gertrude Stein*. The Enlightenment, the French Revolution and the Romantic Movement, however, led to new notions of what a portrait should be. Thus in Poe's story what we have is not a donor portrait, a state portrait or an official portrait, nor can we call it a wedding portrait (p. 82) or a postmortem portrait (p. 118). At most we can discern echoes here (not least in the landscape) of the genre of the idealized female portrait (p. 92), so important in Renaissance Italy. In contrast to the classic portrait, Poe's oval portrait was not created in response to a specific occasion. There is no corresponding event that would have firmly rooted the portrait in the life of the sitter. It serves not the sitter, in other words, but the portraitist and his art: *l'art pour l'artiste*. In a sense a path is being paved here for the self-sufficiency of the (often anonymous) photographic portrait (pp. 73, 80, 94/95, 96/97).

A Little POEtology of the Photographic Portrait

The Promethean aspiration of the painter, the lengthy process of creating the lady's portrait and the tragic outcome of Poe's story

dem Porträtisten und seiner Kunst: *l'art pour l'artiste*. Dem Eigenwert des (oft anonymen) fotografischen Bildnisses (S. 73, 80, 94/95, 96/97) wird also in gewisser Hinsicht schon der Weg bereitet.

Kleine POEtologie des fotografischen Porträts

Der prometheische Anspruch des Malers, die langwierige Entstehung des weiblichen Bildnisses und der tragische Ausgang von Poes Geschichte erinnern an die gut zehn Jahre ältere Erzählung Balzacs *Le chef-d'œuvre inconnu*, die mit der Vernichtung der Bilder und ihres Malers endet. Die Bedrohung, ja Auslöschung des Modells durch den Akt des Porträtierens wiederum gemahnt an Champfleurys literarische Karikatur des Sammlers und Mäzens Alfred Bruyas, der durch die zahllosen von ihm beauftragten Bildnisse seiner selbst angeblich einen zunehmenden Identitätsverlust erlitt. Champfleurys *Sensations de Josquin* erschienen allerdings erst ab 1856, also erheblich später als Poes Erzählung.

Ihre zeitliche Nähe zur spektakulären Veröffentlichung der Daguerreotypie am 19. August 1839 lässt aufmerken. Schon wenige Monate später, im Januar 1840, stellte ausgerechnet der spätere Autor des *Oval Portrait* mit dem sehr kurzen, aber ausgesprochen weitsichtigen Artikel »The Daguerreotype« in *Alexander's Weekly Messenger* die neue Technik einer amerikanischen Leserschaft als »the most important, and perhaps the most extraordinary triumph of modern science« vor. Bestimmte Passagen lassen erkennen, dass Poe keineswegs Wissen aus zweiter Hand mitteilte, sondern sich persönlich über die praktische Handhabung, wenn nicht gar die Geschichte der Daguerreotypie informiert hatte. Im Kernsatz seiner Nachricht konstatierte er, sie sei »*infinitely* more accurate

in its representation than any painting by human hands«. Dreierlei fällt an dieser fein ziselierten Formulierung auf: erstens die bewusste und ausdrücklich betonte Verwendung des Begriffes »unendlich« mit all seinen, hier gar nicht zu erörternden philosophischen Weiterungen, zweitens die indirekte Bezeichnung der Fotografie als »acheiropoieton« (ein nicht von Menschenhand geschaffenes Bild wie das Grabtuch von Turin oder das Schweißtuch der heiligen Veronika) und drittens der in Form des Paragone, des klassischen Wettstreits der Künste, vorgetragene Vergleich mit der Malerei.

Auf letztgenannten Aspekt, erklärten Gegenstand unserer Ausstellung, werden wir zurückkommen. An dieser Stelle sei zunächst daran erinnert, dass der Auffassung von Fotografien als »acheiropoietoi« im 20. Jahrhundert noch eine beachtliche Karriere bevorstand. Nicht nur an Susan Sontags oft zitiertes Gedankenexperiment zum mutmaßlichen Reliquiencharakter einer (fiktiven) Porträtfotografie Shakespeares ist zu denken, sondern auch an ältere Überlegungen von André Bazin zur »Synthese von Reliquie und Fotografie im Turiner Grabtuch«. Ihre literarische Ausgestaltung erfuhr diese Idee durch Michel Tournier in der Erzählung *Les suaires de Véronique* von 1978, ihre wissenschaftliche durch Nicholas Allen, der während der 1990er Jahre in mehreren Studien zu zeigen versuchte, dass es sich bei dem Turiner Grabtuch in der Tat um eine hochmittelalterliche, zwischen 1260 und 1320 entstandene Fotografie handelt.

Auch wenn es in *The Oval Portrait* auf den ersten Blick um Macht und Hybris der Malkunst geht, deuten bei genauerem Hinsehen diverse Details auf einen versteckten Diskurs hin, der sich um das neue Medium der Fotografie rankt: etwa die dunkle, durch ein explizites Schließen der Fensterläden abge-

are reminiscent of Honoré de Balzac's short story, written a good ten years earlier, entitled "Le Chef-d'œuvre inconnu," which ends with the destruction of the pictures and their painter. The threat to, indeed the elimination of, the sitter by the act of portraiture in its turn recalls Champfleury's literary caricature of the collector and patron Alfred Bruyas, who, through the countless portraits of himself that he had commissioned, allegedly suffered a creeping loss of identity. Champfleury's "Sensations de Josquin," however, did not begin to appear until 1856, in other words, considerably later than Poe's story.

The latter's temporal propinquity to the spectacular public announcement of the daguerreotype on August 19, 1839, is worth noting. Just a few months later, in January 1840, no less a person than the future author of "The Oval Portrait," in a very short but extremely far-sighted article in *Alexander's Weekly Messenger* entitled "The Daguerreotype," introduced the new process to an American readership as "the most important, and perhaps the most extraordinary triumph of modern science." Certain passages reveal that Poe was not merely passing on second-hand knowledge, but had personally informed himself about the practical technique, if not also the history, of the daguerreotype. At the heart of his article is the statement that the process was "*infinitely* more accurate in its representation than any painting by human hands." Three things are worth noting about this crisp formulation: firstly, the deliberate and expressly emphatic use of the term "infinitely," with all its philosophical repercussions, which we cannot discuss here; secondly, the indirect characterization of photography as *acheiropoieton* (a picture that has not been created by human hands, such as the Turin Shroud or the Sudarium of Veronica); and, thirdly, the comparison with painting, stated in the form of the *paragone*, the classical rivalry of the arts.

I shall return to the last point, the declared object of our exhibition, later. First, though, I should like to issue a reminder that in the 20th century the concept of photographs as *acheiropoietoi* gained considerable weight. We might think not only of Susan Sontag's oft-quoted thought experiment on the alleged relic status of a (fictitious) photographic portrait of Shakespeare, but also of the earlier thoughts of André Bazin on the "synthesis of relic and photograph in the Turin Shroud." This idea took on a literary form in Michel Tournier's 1978 short story "Les suaires de Véronique," and its scientific form thanks to Nicholas Allen, who in the 1990s attempted in a number of studies to show that the Turin Shroud was indeed a photograph produced in the high Middle Ages, some time between 1260 and 1320.

Even though "The Oval Portrait" deals at first sight with the power and hubris of the painter, closer inspection reveals various details pointing to a hidden discourse that relates to the new medium of photography: for example the dark room (the narrator is cut off from the world by closing the window shutters) as the scene of the action, or the significance of the (artificial) light (he moves the candelabrum, which brings the picture into, and then out of, view). Particularly revealing is the metaphor used in the first version of the story, dating from April 1842, to describe the psychological state of the narrator, namely "galvanic battery," a device that (as Poe certainly knew) was used in the daguerreotype process to prepare the copper plate or, to be more precise, to apply the silver layer by means of electrolysis.

It would not be an isolated case for a 19th-century man of letters to criticize one medium in the guise of another. The theoretical vacuum that existed following the photographic "big bang" might have been reason enough for a corresponding displacement in Poe's story. In his article of January 1840 he had himself

schlossene Kammer als Ort der Handlung oder die Bedeutung des (künstlichen) Lichts, mit dessen Lenkung das ovale Porträt erst zum Erscheinen und dann wieder zum Verschwinden gebracht wird. Besonders verräterisch ist die in der Erstfassung vom April 1842 für den psychischen Zustand des Ich-Erzählers verwendete Metapher der »galvanic battery« – eines Gerätes, das (wie Poe zweifellos wusste) in der Daguerreotypie zur Bereitung des Bildträgers, genauer: zur silbernen Beschichtung der Kupferplatten mittels Elektrolyse, verwendet wurde.

Es wäre kein Einzelfall, wenn ein Literat des 19. Jahrhunderts *ein* Medium im Gewand des *anderen* kritisierte. Das nach dem fotografischen »Urknall« zunächst existierende theoretische Vakuum könnte Grund genug für eine entsprechende Verschiebung in Poes Text gewesen sein. In seinem Artikel vom Januar 1840 hatte er selbst darauf hingewiesen, dass »[t]he results of the invention cannot, even remotely, be seen«. Es mag Poe daher sinnvoll erschienen sein, die Implikationen der neuen Technik, die er sogleich und wie selbstverständlich auch als Kunst begreift, gewissermaßen indirekt zu betrachten, indem er sich vor dem Anblick ihres schrecklich schönen Medusenhaupts durch den spiegelnden Schild der altvertrauten Malerei schützte. (Bezeichnenderweise schließt sein Ich-Erzähler nach dem ersten flüchtigen Erblicken des schockierend lebendigen Porträts sogleich reflexartig die Augen.)

Deutet man *The Oval Portrait* als frühe Auseinandersetzung mit der Daguerreotypie, und zwar speziell der Porträtaufnahme, so werden gleich mehrere Ideen erkennbar, die in der späteren kunstkritischen beziehungsweise -theoretischen Diskussion um die Fotografie und ihr Verhältnis zu anderen Bildkünsten eine fundamentale Rolle spielen.

An erster Stelle ist hier die spezifische Verwendung des romantischen Doppelgängermotivs zu nennen. Die Porträtaufnahme ist so echt, dass sie nicht bloß wie ein besonders gelungenes Abbild des leibhaftigen Originals wirkt, sondern dessen Stelle im Leben usurpiert. Ermöglicht wird dies durch einen vampirischen Prozess, bei dem die Lebensgeister der Porträtierten auf ihr Bild übergehen. Diese Vorstellung korrespondiert einerseits mit zahlreichen ethnologischen Berichten vor allem des späten 19. und frühen 20. Jahrhunderts über die Furcht außereuropäischer Völker vor der Fotografie: Dem »Raub des Schattens« oder der Seele, mithin auch dem Eindringen des Mediums in den Körper des Fotografierten, stehen dort sogar bestimmte Abwehrgesten (wie etwa das Verhüllen des Mundes) entgegen. Andererseits wird in Poes besonderer Variation des Doppelgängermotivs sehr frühzeitig die Idee der abdruckhaften Verbindung von Wirklichkeit und Fotografie, der »Nabelschnur« zwischen Abgebildetem und Bild erkennbar, also die Idee der *Indexikalität*. Was Henry Fox Talbot als »magisch« beschrieb, kennzeichnete Poe in seiner Meldung vom Januar 1840 bereits als »most miraculous beauty«. Der mehrfach wiederholte Schlüsselbegriff dieses Artikels lautet »truth«. Im Vergleich zu einem gewöhnlichen Kunstwerk weise die *photogenische Zeichnung*, so Poe, »a more absolute truth, a more perfect identity of aspect with the thing represented« auf.

Gerade mit diesem besonders bewunderten, aber auch als unheimlich wahrgenommenen Aspekt der Fotografie verbindet sich die Assoziation des Todes. Wenn Moritz Thausing der Fotografie 1866 »etwas Leichenhaftes« bescheinigte, so meinte er damit noch einen Mangel an Seele (im Vergleich etwa zum handgemachten Kupferstich). In seinem Roman

pointed out that: "The results of the invention cannot, even remotely, be seen [...]." Poe may, therefore, have seen a certain logic in regarding the implications of the new technique (which he immediately understood to be self-evidently art) indirectly, by choosing to protect himself from the gaze of the dreadfully beautiful Medusa's head through the reflecting shield of the familiar art of painting. (Tellingly his first-person narrator immediately closes his eyes, as if by reflex, on his first fleeting sight of the shockingly lifelike portrait.)

If we interpret "The Oval Portrait" as an early confrontation with the repercussions of the daguerreotype process, and in particular of its implications for portraiture, we immediately recognize a number of ideas that played a fundamental role in the later art-critical or art-theoretical discussion of photography and its relationship to other visual arts.

The first thing to mention in this connection is the specific use of the Romantic doppelganger motif. The portrait is so lifelike that it comes across not so much as a particularly successful likeness of the sitter, but rather usurps the latter's place in life. This is made possible by a vampiric process, in which the life spirits of the sitter pass into her portrait. This idea corresponds on the one hand to numerous ethnological reports, above all from the late 19th and early 20th centuries, concerning non-European peoples' fear of photography. The "theft of the shadow" or of the soul, and consequently the penetration of the medium into the body of the person photographed, are even countered by specific defensive gestures, such as covering the mouth. On the other hand Poe's particular variation on the doppelganger theme brings out at a very early stage the idea of the replica-like link between photograph and reality, the "umbilical cord" between the picture and the depicted subject, in other words the idea of *indexicality*. What Henry Fox Talbot described as "magic," Poe in his article of January 1840 already calls "most miraculous beauty." The key term in this article, repeated several times, is "truth." Compared with an ordinary work of art, the "photogenic drawing," according to Poe, "discloses [...] a more absolute truth, a more perfect identity of aspect with the thing represented."

It is precisely this aspect of photography, which was both particularly admired but also felt to be eerie, that prompts an association with death. When Moritz Thausing said in 1866 that photography had "something cadaverous" about it, what he meant was still the absence of a soul (compared, for example, with the handmade copperplate engraving). In his novel *The Picture of Dorian Gray*, written in 1890, Oscar Wilde turned the tables, for here the picture has more soul than its sitter. It is worth noting that Wilde repeated Poe's displacement gesture. The demonic portrait of Dorian may be painted (a brilliant version of this was created in 1943–44 by the American painter Ivan Le Lorraine Albright as a prop for Albert Lewin's film adaptation), but the supernatural link between picture and person depicted points clearly, here too, to the indexicality of photography. The outcome of this novel resembles that of Poe's short story: Painter and sitter are dead; only the portrait continues its radiant life. In the 20th century André Bazin and Roland Barthes would talk of an "embalming" (for example, of time) by photography or the photographer, as the case may be. "Life in Death" was the first title of Poe's short story. This corresponds to the idea developed by Barthes of human photography as the living image, unnaturally present, of a dead person. Siegfried Kracauer even regarded the photograph as a ghost that destroyed rather than preserved. A further, philologically well-founded conceit relating to the con-

The Picture of Dorian Gray von 1890 drehte Oscar Wilde den Spieß herum, denn hier ist das Bild beseelter als sein Modell. Bemerkenswerterweise wiederholte Wilde den verschiebenden Gestus Poes. Das dämonische Porträt Dorians ist zwar gemalt – eine kongeniale Umsetzung schuf (als Requisite für die Verfilmung von Albert Lewin) 1943/44 der amerikanische Maler Ivan Le Lorraine Albright –, doch verweist die übernatürliche Verbindung zwischen Bild und Abgebildetem hier ebenfalls klar auf die Indexikalität der Fotografie. Auch im Resultat ähnelt dieser Roman der Poeschen Erzählung: Maler und Modell sind tot, nur das Porträt lebt strahlend fort. Im 20. Jahrhundert werden André Bazin und Roland Barthes von einer »Einbalsamierung« (etwa der Zeit) durch die Fotografie beziehungsweise den Fotografen sprechen. »Life in Death«, so lautete der erste Titel von Poes Erzählung: Dem entspricht die bei Barthes entwickelte Idee von der Menschenfotografie als dem lebenden, auf unnatürliche Weise präsenten Bild einer toten Person. Siegfried Kracauer begriff die Fotografie gar als Gespenst, das vernichtet statt zu erhalten. Eine weitere, auch philologisch gut begründete Zuspitzung erfuhr die Konzeption von der tödlichen Fotografie schließlich bei Daniel Arasse in der Analogie zwischen Guillotine und Fotoapparat.

Die Malerei und ihr Double

Besondere Betonung legt Poe in seiner Kurzgeschichte auf die Rivalität zwischen den beiden Bräuten des Künstlers, seiner ihm eben erst angetrauten jungen Ehefrau und der Malerei mit ihren älteren Rechten. Seltsam unpassend zur Fügsamkeit der Künstlergattin erscheint ihr »wild eye«, von dem in der Erstfassung der Geschichte die Rede ist. Deuten wir diese

Motive richtig, so entpuppt sich Poes Erzählung nicht bloß als vage Reflexion über ein neues Medium, sondern als präzise Allegorie auf den gerade ausbrechenden Konkurrenzkampf zwischen der Malerei und ihrer jungen Nebenbuhlerin mit dem wilden (um nicht zu sagen: bösen) Blick, der Fotografie. Wenn die Jüngere in diesem Duell unterliegt, so ist das nicht zuletzt eine Folge der Verschiebung der Poeschen Medienkritik von der Fotografie auf die Malerei, wobei Letztere hier weniger ihre eigene, sattsam bekannte theoretische Bürde trägt, sondern vielmehr die (seinerzeit noch weitaus leichtere) ihrer jüngeren Konkurrentin.

Durch eine eigenartige Ellipse, das Verschweigen des eigentlichen Themas, lässt Poe die Figuren von Täterin und Opfer, Siegerin und Besiegter changieren – man fühlt sich erinnert an das Schwanken einer Daguerreotypie zwischen Negativ und Positiv, je nach Lichteinfall.

Befürchtete Poe nun das Ende der Malerei oder wünschte er sich bereits den Tod der Fotografie? Es scheint nicht leicht, diese Frage zu entscheiden. Tatsächlich ist sie falsch gestellt. In seinem Artikel über die Daguerreotypie deutete Poe an, über deren Geschichte im Bilde zu sein und nannte dabei als Stichwort die Camera obscura. Spätestens seit dem frühen 17. Jahrhundert dienten mobile Camerae obscurae der Fixierung des Projektionsbildes auf diaphanem Zeichenpapier. David Hockney und in seiner Nachfolge diverse andere Autoren haben uns unlängst mit Nachdruck in Erinnerung gerufen, welche Bedeutung derlei optische Hilfsmittel für die Alten Meister hatten. Angesichts der engen medienhistorischen Verflechtung von Malerei und Fotografie mag Poe durchaus zu der Auffassung gelangt sein, dass der Tod der einen zugleich auch das Ende der anderen bedeuten könnte.

cept of the "lethal photograph" is due to Daniel Arasse, who made an analogy between the camera and the guillotine.

Painting and Its Double

In his story Poe places special emphasis on the rivalry between the two brides of the artist: his newly wedded young wife on the one hand and painting with all its existing rights on the other. Strangely out of tune with the compliance of the artist's wife is her "wild eye," an expression Poe uses in the first version of the story. If we interpret this motif correctly Poe's story turns out to be not just a vague reflection on a new medium, but a precise allegory of the competition between painting and its young rival with the wild (not to say evil) eye, namely photography. If the younger rival is the loser in this duel, this is not least a result of Poe's displacement of his media critique from photography to painting, the latter bearing less its own, perfectly familiar theoretical burden than that (at the time far lighter) of her younger rival.

By a strange ellipsis, namely the concealment of the actual theme, Poe has the figures oscillate between perpetrator and victim, victor and vanquished. One is reminded of the way a daguerreotype oscillates between negative and positive, depending on the angle of the incident light.

So did Poe fear the end of painting, or even wish for the death of photography? It is not easy to answer this question. In fact, it is wrongly formulated. In his article on the daguerreotype process, he hinted that he knew about its history, and mentioned the key concept, namely the camera obscura. At the latest since the early 17th century, mobile camera obscuras were used to fix a projected image on translucent drawing paper. David Hockney, and following him, various other authors have recently emphat-ically reminded us of the importance of such optical aids for the Old Masters. In view of the close media-historical entanglement of painting and photography, Poe may well have been of the opinion that the death of one could also mean the end of the other. After all, his first-person narrator is in an abandoned chateau where he meets not only no young artist's wife, but no artist either.

The fact that the electrified lyrical narrator thinks of the "galvanic battery" (see above), the fact that the story is particularly short (corresponding to the exposure time of a daguerreotype), along with Poe's enthusiastic article in *Alexander's Weekly Messenger*, suggest a spontaneous identification on the part of the author with the new medium. This increases the significance of a further detail: The narrator is very precise in his description of the soft focus of the feminine contours, which, in the oval portrait, imperceptibly merge with the deep shade of the background. This passage has a metapoetic quality insofar as it reflects the deliberately "soft" literary focus on the actual theme. Over and beyond the implicit comparison between soft focus in literature and the visual arts, there is another element here, an interesting one in our context. For alongside the link between femininity and *sfumato*, which has continued into the world of today's advertising, we already have a hint of the role of soft focus in the early discussions concerning the status of photography. At the latest during the photographic movement known as "pictorialism" it was to become an important argument for the status of photography as art, and in more recent photography it also plays a major role (pp. 99, 100). In Poe's short story it is not only *indexicality* that is already (indirectly) examined, but in parallel we see the incipient demand for an aesthetic view (and aesthetic composition!) of photography, and going

Immerhin trifft sein Ich-Erzähler im menschenleeren Schloss nicht nur keine blutjunge Künstlergattin mehr an, sondern auch keinen Maler.

Der Gedanke des förmlich elektrisierten lyrischen Ich an die »galvanic battery« (siehe oben), die besondere, einer daguerreotypischen Belichtungszeit entsprechende Kürze der Erzählung sowie auch Poes enthusiastischer Artikel in *Alexander's Weekly Messenger* lassen seitens des Autors eine spontane Identifikation mit dem neuen Medium vermuten. Damit gewinnt ein weiteres Detail an Bedeutung: Sehr genau beschreibt der Erzähler die Weichzeichnung der weiblichen Konturen, die im ovalen Porträt unmerklich mit dem tief verschatteten Fond verschmelzen. Diese Passage hat insofern metapoetische Qualität als sie die bewusst unscharfe literarische Fokussierung des eigentlichen Themas reflektiert. Über den impliziten Vergleich zwischen literarischer und bildkünstlerischer Unschärfe hinaus kommt hier aber noch ein weiteres, für unseren Zusammenhang interessantes Element ins Spiel, denn neben der bis in die heutige Werbung hinein topischen Verbindung zwischen Weiblichkeit und *sfumato* deutet sich bereits die Rolle der Unschärfe in der frühen Diskussion um den Status der Fotografie an. Spätestens in der fotografischen Bewegung des »pictorialism« sollte sie zu einem wichtigen Argument für den Rang der Fotografie als Kunst werden, und auch in der jüngeren Fotografie spielt sie eine wichtige Rolle (S. 99, 100). In Poes Erzählung wird demnach nicht allein die *Indexikalität* bereits – indirekt – in den Blick genommen, sondern es zeichnet sich parallel dazu schon die Forderung nach einer ästhetischen Betrachtungsweise (wie auch Gestaltung!) der Fotografie ab und damit einhergehend eine Bewusstwerdung ihrer kulturellen, sozialen und ökonomischen *Codierung*.

Porträtzeiten

Die Kürze von Poes Erzählung steht in einem äußerst reizvollen Kontrast zur darin verhandelten Thematik der Dauer. Die zeitliche Länge der Porträtaufnahme war schon lange vor Erfindung der Fotografie ein Thema. Als 1548 in Anbahnung der Hochzeit mit Herzog Francesco Gonzaga ein Porträt der 15-jährigen Erzherzogin Katharina, einer Nichte Karls V., nach Mantua geschickt wurde, beeilte sich ein Höfling aus Innsbruck, ein Entschuldigungsschreiben hinzuzufügen: Die junge Dame zeige in Tizians Porträt ernstere Gesichtszüge als in Wirklichkeit, wohl da sie beim langen Posieren ins Sinnieren verfallen sei. Ob die Porträtierte selbst diese Erklärung hätte bestätigen können, erscheint zumindest fraglich. Gerade bei hochgestellten und/oder vielbeschäftigten Persönlichkeiten pflegten die großen Bildnismaler des 16. Jahrhunderts nämlich meist lediglich Zeichnungen oder farbige Skizzen, allenfalls rasch in Öl gemalte Studien des Kopfes anzufertigen, die dann erst in Abwesenheit des Kunden auf den eigentlichen Bildträger kopiert und nach allen Regeln der Kunst ausgeführt wurden. Die als Rang- und Standesbezeugung so wichtige Kleidung ließ sich separat, etwa auf einen stummen Diener drapiert, studieren. Dass im Akt des Porträtierens ein Fluidum des Modells unmittelbar ins Konterfei zu übertragen und Letzterem damit eine besondere Authentizität zu geben wäre, ist zu Poes Zeit noch ein relativ junger Gedanke.

Als Paul Cézanne im Herbst 1899 ein protokubistisches Porträt des Kunsthändlers Ambroise Vollard schuf, der ihm täglich vormittags dreieinhalb Stunden lang Modell sitzen musste, soll er ihn aufgefordert haben, stillzuhalten »wie ein Apfel«. Angeblich baute Cézanne für seine Porträtmodelle extrem wacklige Podeste, die bei der kleinsten Bewegung

hand in hand with this, an awareness of its cultural, social and economic *coding*.

Times of Exposure

The shortness of Poe's story forms a nice contrast with its theme of duration. The length of time needed to create a portrait was a talking point long before the invention of photography. When in 1548, during the negotiations for a marriage with Francesco Gonzaga, a portrait of the fifteen-year-old Archduchess Katharina, a niece of Emperor Charles V, was sent to Mantua, a courtier hurriedly added a note of apology from Innsbruck: The young lady, it said, looked more serious in Titian's portrait than she did in real life, doubtless because the long sessions of sitting to the artist had cast her into a meditative mood. Whether the sitter herself could have confirmed this explanation seems questionable at the very least. Particularly in the case of high-ranking or important personalities, the great portrait painters of the 16th century used mostly only to make drawings or colored sketches, at most cursory studies in oils, of the sitter's head, which were then, in the absence of the client, transferred to the actual panel or canvas and completed according to the prevailing conventions of art. The clothing, so important as an indication of rank and status, could be studied separately, for example draped over a dummy. It was a relatively new idea in Poe's time that particular authenticity could be bestowed on the image of a sitter by a direct transfer on to canvas during the act of portraiture.

When Paul Cézanne, in the autumn of 1899, painted a proto-Cubist portrait of the art dealer Ambroise Vollard, who had to sit to him for three and a half hours every morning for this purpose, the artist is said to have urged him to sit as still "as an apple." Cézanne is purported to have set up extremely shaky supports for his models, which threatened to topple over at the slightest movement. An endeavor to immobilize life is evident here. If one thinks of the French term for the genre that we call "still life" (obviously hinted at by Cézanne's reference to the apple), namely "nature *morte*," the relevance is clear. One is reminded of the idea of "lethal photography" (see above). And indeed, Cézanne's preparations are reminiscent of procedures to which the portrait-victims of the early daguerreotype process were required to submit, such as having their head screwed into a frame.

It is only against this historical background that certain portrait strategies employed by Andy Warhol become recognizable as such. With his "screen tests," which lasted between three and five minutes, and which he originally called "film portraits" or "stillies" (in contrast to "movies"), Warhol not only created, so to speak, "living pictures." He also used filmic means to artificially extend, to the length required by a daguerreotype, what by then had long since become much shorter exposure times in photography. Evidently Warhol was trying, as he later did by using a Polaroid camera, to drag out for as long as possible the impersonal, automatic and thus uncoded moment of portrait production. Ideally, the "reproduction" character of the portrait would be increased as a result. This procedure became a genuine test of endurance for his friend and patron Henry Geldzahler, to whom he devoted a ninety-nine-minute silent-film portrait in 1964. Only after filming was finished did Geldzahler realize the degree to which he had embarrassingly revealed himself under the steady gaze of the stationary 16mm camera with which Warhol had left him alone: "I went through my entire history of gestures. Viewing the film later on, they gave me away completely [...]." In a certain sense the result can be seen as the "sudarium" of Henry Geldzahler. A photographic portrait of Andy

umzustürzen drohten. Ein Bestreben, das Leben stillzulegen, wird hier erkennbar. Bedenkt man die französische Bezeichnung für die (mit dem Verweis auf den Apfel deutlich genug aufgerufene) Gattung des Stilllebens, »nature *morte*«, so wird die ganze Tragweite deutlich. Man fühlt sich an die Vorstellung von der »tödlichen Fotografie« (siehe oben) erinnert. Und tatsächlich gemahnen die Vorkehrungen Cézannes an Prozeduren, denen sich die Porträtopfer der frühen Daguerreotypie zu unterziehen hatten, wie etwa das Einspannen des Kopfes in ein Schraubgestell.

Erst vor diesem historischen Hintergrund werden bestimmte Porträtstrategien Andy Warhols als solche erkennbar. Mit seinen etwa drei- bis fünfminütigen »screen tests«, die ursprünglich »film portraits« oder »stillies« (im Gegensatz zu »movies«) hießen, schuf er nicht nur gleichsam »lebende Bilder«. Er verlängerte auch die mittlerweile längst deutlich kürzere Belichtungszeit der Fotografie künstlich durch den Einsatz filmischer Mittel wieder auf die Dauer einer Daguerreotypie. Offensichtlich versuchte Warhol, wie später auch durch seine Verwendung der Polaroidkamera, den unpersönlichen, automatischen und damit uncodierten Moment der Porträtherstellung möglichst auszudehnen. Im Idealfall würde dadurch der Abdruckcharakter des Porträts erhöht. Zu einem echten (Belastungs-)Test geriet diese Vorgehensweise für seinen Freund und Förderer Henry Geldzahler, dem er 1964 ein 99-minütiges Stummfilmporträt widmete. Erst nach dem Dreh realisierte Geldzahler, wie er sich unter dem Dauerblick der stillstehenden 16-mm-Kamera, mit der Warhol ihn allein ließ, bloßgestellt hatte: »I went through my entire history of gestures. Viewing the film later on, they gave me away completely …« In gewisser Hinsicht lässt sich das filmische Resultat als

»Schweißtuch« des Henry Geldzahler betrachten. Ein von Christopher Makos stammendes Porträtfoto Andy Warhols (S. 85) beantwortet diese sadistische, von Warhol über Cézanne bis zu Poe zurückreichende Porträttechnik mit einer »Dornenkrönung« des Künstlers, der darin vom Täter zum Opfer mutiert.

Hatte Poe 1840 in seinem Artikel »The Daguerreotype« noch von einer Belichtungszeit zwischen zehn und dreißig Minuten – je nach Tageszeit und Wetter – gesprochen, so gelang bereits 1841 eine Verkürzung der Porträtsitzung von fünfzehn auf fünf Minuten. Aus dieser Kürze der Belichtungszeit bezieht die nun langsam, mit einer gewissen Verzögerung (wie das daguerreotypische Bild auf der belichteten, silberbeschichteten Kupferplatte) erkennbar werdende Pointe von Poes Kurzgeschichte ihren grimmigen Humor: Hätte die junge Braut in eine französische oder amerikanische Großstadt geheiratet statt in ein Apenninenschloss und wäre der von seiner Kunst besessene Ehemann Fotograf statt Maler gewesen, so »wäre das alles nicht passiert«, denn mit einer Aufnahmezeit von fünf Minuten kann man niemanden zu Tode porträtieren. Italien mag zwar die Wiege der Kunst sein – aus der Sicht des soeben angebrochenen fotografischen Zeitalters und aus der Distanz eines Ozeans betrachtet verkörpert es »*Old* Europe«.

Die Fotografie und ihr Double

Welche Bedeutung Landschaft und Stadtlandschaft Italiens für die Vor- und Frühgeschichte der Fotografie – gerade auch hinsichtlich ihres Austauschs mit der Malerei – hatten oder haben sollten, konnte Edgar Poe natürlich nicht ahnen. Mit seiner wichtigen (wenn auch nicht unumstrittenen) Aus-

Warhol (p. 85) by Christopher Makos responds to this sadistic portrait technique, which reaches from Warhol via Cézanne right back to Poe, by giving the artist a "crown of thorns," thus turning the perpetrator into the victim.

While in his 1840 article "The Daguerreotype" Poe had still talked of an exposure time of between ten and thirty minutes, depending on the weather and time of day, the very next year sitting times could be reduced from fifteen to five minutes. This shortness of the exposure time lends the punchline of Poe's story, slowly emerging as it does (like the image on the silver-coated copper plate used in the daguerreotype process), its grim humor: If the young bride had married into a French or an American city instead of a chateau in the Apennines, and if the art-obsessed husband had been a photographer rather than a painter, "none of this would have happened," because with an exposure time of five minutes, it is impossible to portray anyone to death. Italy may be the cradle of art, but from the point of view of the new age of photography, and from the distance of the New World, it very much embodied "*Old* Europe."

Photography and Its Double

Edgar Allan Poe could of course have had no inkling of the importance the landscapes and townscapes of Italy had or were to have for the pre- and early history of photography, particularly with respect to its interaction with painting. With his important (albeit not uncontroversial) 1981 exhibition "Before Photography: Painting and the Invention of Photography," Peter Galassi delved into the question of why photography was not invented earlier, for after all the camera obscura had long been in use, and the chemical prerequisites for the new process had been known since 1727 at the latest. He sought the answer not in the history of science, but in the history of seeing, by attempting to show that certain seemingly constituent features of photography (such as its "cropped" character and its directness, but also the fundamental endeavor to create a two-dimensional image of the three-dimensional world) were already emerging in the landscape oil sketch at the start of the 19th century. His catalogue illustrations open with views by a number of French and English painters of Rome, the Roman Campagna and Naples.

The fact that landscape (traditionally, and especially vis-à-vis history painting, a genre of lowly status) was able to serve as a field of experimentation in early photography was demonstrated by Wolfgang Ullrich's concentrating on soft focus, which as a stylistic element was transferred from landscape to portrait photography (and to other subjects as well). The forms of reciprocal influence between the media of painting and photography that were possible at a very early stage can be seen in the work of Camille Corot, whose early Roman landscape studies dating from the late 1820s were claimed by Galassi to be photographs *avant la lettre*, and who, thirty years later (again in Rome in some cases) experimented more intensively than anyone else with *cliché-verre*, a hybrid of etching and photography. At the same time famous French artists working in every conceivable style, for example Eugène Delacroix and Gustave Courbet, were now using photography as a motif reservoir and compositional aid. The much adduced example of the photograph taken by the photographer (and trained painter!) Julien Vallou de Villeneuve, which Courbet used as the model for his female nude in his famous *Atelier* (Musée d'Orsay, Paris), was, incidentally, discovered by the artist in the home of Alfred Bruyas.

The interaction between painting and photography, which subsequently developed in an ever more complex web, cannot

stellung *Before Photography – Painting and the Invention of Photography* ging Peter Galassi 1981 der Frage nach, warum die Fotografie nicht früher erfunden wurde, wenn doch die Camera obscura längst Verwendung fand und auch die chemischen Voraussetzungen für das neue Verfahren seit spätestens 1727 bekannt waren. Die Antwort suchte er nicht in der Wissenschaftsgeschichte, sondern in der Geschichte des Sehens, indem er versuchte aufzuzeigen, dass bestimmte, scheinbar konstitutive Merkmale der Fotografie (etwa Ausschnitthaftigkeit und Unmittelbarkeit, aber auch das grundsätzliche Bestreben, von der gegebenen dreidimensionalen Welt ein zweidimensionales Bild zu ziehen) sich um 1800 in der Gattung der mit Ölfarben ausgeführten Landschaftsskizze herausbildeten. Den Reigen seiner Katalogabbildungen eröffnen Ansichten aus Rom, aus der römischen Campagna und Neapel von diversen französischen und englischen Malern.

Dass die Landschaft, eine traditionell und namentlich im Vergleich zum Historienbild eher niedrig rangierende Gattung, auch in der frühen Fotografie als Experimentierfeld dienen konnte, belegte Wolfgang Ullrich am Beispiel der Unschärfe, die als Stilmittel aus der Landschafts- in die Porträtfotografie (und auf andere Sujets) übertragen wurde. Welche Rückkopplungen schon früh zwischen den Medien Malerei und Fotografie möglich waren, zeigt sich im Werk Camille Corots, dessen frühe römische Landschaftsstudien aus der zweiten Hälfte der 1820er Jahre Galassi als Fotografien vor der Fotografie in Anspruch nimmt und der dreißig Jahre später (teils wiederum in Rom) so intensiv wie kein anderer mit dem *cliché-verre*, einem Hybrid aus Radierung und Fotografie, experimentierte. Gleichzeitig bedienten sich nun

namhafte französische Maler denkbar unterschiedlichster Couleur, etwa Delacroix und Courbet, der Fotografie als Motivreservoire und Kompositionshilfe. Das gern als Beispiel angeführte, von dem Fotografen (und ausgebildeten Maler!) Julien Vallou de Villeneuve stammende Foto, das Gustave Courbet als Vorlage für den weiblichen Akt in seinem berühmten *Atelier* (Musée d'Orsay, Paris) verwendete, hatte der Maler übrigens bei Alfred Bruyas entdeckt.

Die sich in der Folge entspinnenden, immer komplexer werdenden Wechselbeziehungen zwischen Malerei und Fotografie können und sollen hier nicht ausführlich dargestellt werden. Maler wie Edgar Degas, Franz von Stuck, Edvard Munch, Ernst Ludwig Kirchner, Marcel Duchamp, Pablo Picasso, René Magritte, Francis Bacon, Arshile Gorky und Larry Rivers verwendeten vorgefundene, bestellte oder auch selbst angefertigte Fotografien als Vorlagen für Porträts und andere Menschendarstellungen. Im Gegenzug hatte beispielsweise der amerikanische Maler Edward Hopper so nachhaltigen Einfluss auf die Fotografie (und den Film!), dass diesem Phänomen bereits mehrere Ausstellungen gewidmet waren. Man Ray (als *one-man-movement*), Décollagisten, Fotorealisten und Pop-Artisten loteten die theoretischen wie praktischen Grenz- oder Überschneidungsbereiche zwischen Fotografie und Malerei aus, und auch im späten 20. und frühen 21. Jahrhundert setzt sich der Paragone zwischen Malerei und Fotografie fort. Dabei behandelt zum Beispiel der Fotograf Thomas Struth die Malerei nicht mehr als Subjekt, sondern als – historisches – Objekt, während gleichzeitig ein Gerhard Richter die Fotografie einmal mehr zum Malgrund im doppelten Sinne erklärt. Von Künstlerhand überarbeitete Fotografien finden sich beispielsweise auch bei Buetti (S. 65) und

be gone into in any detail here. Painters such as Edgar Degas, Franz von Stuck, Edvard Munch, Ernst Ludwig Kirchner, Marcel Duchamp, Pablo Picasso, René Magritte, Francis Bacon, Arshile Gorky and Larry Rivers used, as their models for portraits and other depictions of human beings, photographs that they had found, commissioned or taken themselves. Conversely, the American painter Edward Hopper, for example, had such a lasting influence on photography (and film) that a number of exhibitions have been devoted to this very subject. Man Ray (as a "one-man movement"), décollagistes, Photorealists and Pop artists plumbed the theoretical and practical limits or overlaps between photography and painting, while in the late 20th and early 21st centuries too, the paragone between painting and photography has continued. The photographer Thomas Struth, for example, no longer treats painting as subject, but as (historical) object, whereas Gerhard Richter declares photography once more to be the ground of painting, in both senses. Photographs processed by artists can also be found, for example, among the works of Daniele Buetti (p. 65) and Micha Brendel (p. 87). A new, hitherto almost undreamed-of convergence with painting has emerged since the late 1980s with the development of digital photography (p. 83). Pixels are movable in a way comparable to oil paints; it is striking that the relevant icons in graphics-editing programs are still based on the old, analogue instrumentarium of painters and craftsmen.

In parallel with these developments, a considerable body of theory has arisen since the late 1960s, which has even been viewed by authors such as Douglas Crimp as the *discovery* of photography as opposed to its mere *invention* in the 19th century. The feedback between theory and practice is appearing at ever shorter intervals, and in an ever more direct fashion; artists such as Victor Burgin, Jeff Wall and Wiebke Leister embody in personal union the linkage between photographic practice and the history and/or theory of art. The battle zone is now extending to architecture and sculpture: Not only digital coding, which embraces everything, including the human genome (pp. 80, 101, 102/103), but also the rapid culmination of attempts to perfect 3D technologies, are opening up new, still barely visible horizons to a multilateral paragone.

Comparability of the Non-contemporaneous?

Like its predecessor "Hotel California" and unlike, for example, the show "Painting on Photography: Photography on Painting" (Museum of Contemporary Photography, Columbia College Chicago, 2005), the exhibition "Do or Die" operates with a temporal distance between the media, in that it builds on an encounter between two collections. At the heart of the collection of paintings built up by Ferdinand Franz Wallraf are works from the late Middle Ages (pp. 53, 71) and the Early Modern period (pp. 57, 69, 88, 118). Later acquisitions have extended the present-day collection of the museum into the early 20th century; among the newest paintings in the exhibition is Wilhelm Leibl's *Girl at the Window*, which dates from 1899 (p. 98). The photographs in the Lutz Teutloff Collection date from the 1960s to the present. When the collector himself cites 1968 as a symbolic date, the connotations are explicitly political (see Interview pp. 45–49). While this was a period that witnessed heavy theorizing and the appearance of Photography with a capital "P," these developments played no significant role as a collecting criterion, at least not consciously. What we should note at this juncture is the humanist, Enlightened impetus as the most important common feature shared by the collectors Wallraf and Teutloff.

31

bei Brendel (S. 87). Eine neue, bis dato kaum geahnte Annäherung an die Malerei ergab sich seit Ende der 1980er Jahre durch die Entwicklung der digitalen Fotografie (S. 83): Pixel sind ähnlich verschiebbar wie ölgebundene Pigmente; es fällt auf, dass betreffende Icons in Bildbearbeitungsprogrammen gern das alte, analoge Instrumentarium der Maler und Handwerker zeigen.

Parallel zu diesen Entwicklungen erfolgte ab Ende der 1960er Jahre eine beachtliche Theoriebildung, die von Autoren wie Douglas Crimp sogar als eigentliche *Entdeckung* der Fotografie ihrer bloßen *Erfindung* im 19. Jahrhundert gegenübergestellt wurde. Zwischen Theorie und Praxis erfolgen die Rückkopplungen in immer kürzeren Abständen und in einer immer unmittelbareren Weise; Künstler wie Victor Burgin, Jeff Wall oder Wiebke Leister verkörpern in Personalunion fotografische Praxis und Kunstgeschichte beziehungsweise -theorie. Inzwischen zeichnet sich die »Ausweitung der Kampfzone« auf Architektur und Skulptur ab: Nicht nur die alles, bis hin zum menschlichen Genom, erfassende digitale Codierung (S. 80, 101, 102/103), sondern auch die sich rasant perfektionierenden 3-D-Techniken eröffnen einem multilateralen Paragone neue, heute noch kaum sichtbare Horizonte.

Vergleichbarkeit des Ungleichzeitigen?

Wie ihre Vorgängerin *Hotel California* und anders als etwa die Schau *Painting on Photography: Photography on Painting* (Museum of Contemporary Photography, Columbia College Chicago, 2005) operiert die Ausstellung *Auf Leben und Tod* mit einer zeitlichen Distanz zwischen den Medien, indem sie auf die Begegnung zweier Sammlungen baut. Schwerpunkte der Gemäldesammlung von Ferdinand Franz Wallraf bilden das Spätmittelalter (S. 53, 71) und die frühe Neuzeit (S. 57, 69, 88, 118). Durch spätere Erwerbungen reicht der heutige Museumsbestand bis ins frühe 20. Jahrhundert; zu den jüngsten Gemälden in der Ausstellung zählt Leibls *Mädchen am Fenster* von 1899 (S. 98). Die Fotos der Sammlung Lutz Teutloff ihrerseits weisen Entstehungsdaten von den 1960er Jahren bis in die aktuelle Gegenwart auf. Wenn der Sammler selbst 1968 als Symboldatum nennt, so verbindet er damit ausdrücklich politische Konnotationen (siehe Interview S. 44–50); die seinerzeit mit Macht einsetzende Theoriebildung und die damit verbundene Entstehung *der* Fotografie im Sinne des Fotografischen spielte für ihn als Sammelkriterium keine herausragende – oder zumindest keine bewusste – Rolle. Festzuhalten ist an dieser Stelle zunächst der humanistische, aufklärerische Impetus als wichtigste Gemeinsamkeit der Sammler Wallraf und Teutloff.

In ihrer jeweiligen Struktur sind beide Kollektionen – wie alle großen Sammlungen – durch diverse Umstände determiniert, von persönlichen Vorlieben des Sammlers über die Geschmacksgeschichte bis hin zum verfügbaren Angebot an Kunstwerken. Offensichtlich ist eine Präferenz Teutloffs für die Fotografie als »legitime Kunst«, für eine inszenierende (und nicht etwa dokumentarische oder gar Amateurfotografie). Selbst die ursprünglich als Reportagefotos entstandenen Werke von Robert Lebeck (S. 70), Adam Nadel (S. 55, 104) oder Stanley Greene (S. 99) weisen ein außerordentlich hohes Maß an Bild- und Kompositionsbewusstsein auf. Es ist, als folge der Sammler dem Diktum Bazon Brocks, demzufolge »alles, was nicht eindeutige und bewusste fotografische Handlungsweise ist«, einer Fälschung oder Verfälschung der Wirklichkeit gleichkommt.

In their respective structures the two collections, like all great collections, have been determined by a variety of circumstances, ranging from the personal predilections of the collector via the history of taste to the particular works of art that are/were available. It is clear that Teutloff prefers photography as "legitimate art," that is, deliberately staged photography as opposed to documentary, let alone amateur, photography. Even the works of Robert Lebeck (p. 70), Adam Nadel (pp. 55, 104) or Stanley Greene (p. 99), which originated as reportage, evince an extraordinarily high degree of pictorial and compositional awareness. It is as though the collector were following the dictum of Bazon Brock, according to which "everything that is not an unambiguously and deliberately photographic form of action" is tantamount to a faking or falsification of reality.

In view of the structure of our exhibition, it is self-evident that attention is not centered on the influences of photography on painting (which would apply only to 19th-century works in the case of the Wallraf-Richartz-Museum), but on the inverse influence: The direct juxtaposition of paintings and photographs will, it is hoped, enable us to test whether, and if so how, old pictorial formulae, picture-rhetorical strategies, and compositional and pathos formulae have been taken up by photographers. Sometimes the reference of photography to painting is evident, even though the Wallraf collection does not always include the precise painting that was known to the photographer or that he or she had in his or her mind's eye (pp. 54/55, 56/57, 72/73, 82/83, 88/89, 92/93, 116/117). In other cases the references suggest themselves strongly (pp. 62/63, 84/85, 90/91, 118/119) or are at least plausible (pp. 74/75, 114/115).

Recourse to religious and secular iconography is roughly equally balanced, although we should note that among the artist

(self-)portraits in photographs there is a predilection for pictures of the suffering Christ as models (pp. 84/85, 88/89, 90/91). Often within the photographic work we see a consciously staged, mostly ironic tension between old form and new content (pp. 59, 62, 73, 83, 93, 116). In certain instances formal or thematic breaks with tradition are striking (pp. 61, 79, 101, 102/103). They lay a trail to themes such as "body awareness" or "sexual identity," to which, with the exception of the political body, the Old Masters would not have been able to devote any attention (in the sense of *aisthesis*, meaning "perception"). In contrast to the present catalogue, which, being a book, favors a dialectical confrontation in the style of a diptych, the exhibition often creates garlands of argumentation among a number of paintings and photographs. Almost casually, or on the side, so to speak, revealing dialogues within the medium of photography also often emerge in the process, some of which this publication has managed to preserve (pp. 78/79, 120/121).

Body and Clothing, Skin and Space

Lutz Teutloff himself gives the "body" as the main thematic criterion for the selection of "his" works (see Interview). In this connection the unspoken question arises of the dignity of the human being and his or her depiction in photographs: Heroicization (pp. 61, 62), genetic manipulation (p. 83), unexpected or unwelcome breaches with the discourses of youth, beauty (p. 68) and old age (pp. 113, 115), exposure (p. 79), breach of taboo (p. 120) and (black) humor (p. 121) constitute the multifaceted answer. In addition, closer inspection of the collection reveals a further, comprehensive theme directly related to the body: that of clothing and fashion, of the "dress*code*" and of "self-fashioning," in the literal sense. One is tempted to link the

Angesichts der Struktur unserer Ausstellung ergibt sich von selbst, dass die Aufmerksamkeit nicht etwaigen, hier ja ohnehin nur für die Werke des 19. Jahrhunderts in Frage kommenden, Einflüssen der Fotografie auf die Malerei gilt, sondern der umgekehrten Bewegungsrichtung: Im direkten Nebeneinander von Gemälde und Fotografie soll überprüfbar werden, ob – und wenn ja: wie – alte Bildformulare, bildrhetorische Strategien, Kompositions- und Pathosformeln von der Fotografie aufgegriffen werden. Bisweilen ist der Rückbezug der Fotografie auf die Malerei evident, auch wenn die Sammlung Wallraf nicht immer just das Gemälde enthält, das dem Fotografen bekannt war oder »vorschwebte« (S. 54/55, 56/57, 72/73, 82/83, 88/89, 92/93, 116/117). In anderen Fällen sind die Bezüge sehr naheliegend (S. 62/63, 84/85, 90/91, 118/119) oder zumindest diskutabel (S. 74/75, 114/115).

Rückgriffe auf religiöse und profane Ikonografie halten sich in etwa die Waage, wobei festzustellen ist, dass für die (Selbst-)Darstellung des Künstlers in der Fotografie mit Vorliebe auf Bilder des leidenden Christus rekurriert wird (S. 84/85, 88/89, 90/91). Oft entsteht innerhalb des fotografischen Werks eine bewusst inszenierte, meist ironische Spannung zwischen alter Form und neuem Inhalt (S. 59, 62, 73, 83, 93, 116). An bestimmten Stellen fallen formale beziehungsweise inhaltliche Traditionsbrüche ins Auge (S. 61, 79, 101, 102/103). Sie legen eine Spur zu Themen wie »Körperbewusstsein« oder »sexuelle Identität«, die – mit Ausnahme des politischen Körpers – von den Alten Meistern keiner Wahrnehmung (im Sinne von *aisthesis*) gewürdigt werden konnten. Anders als im vorliegenden Katalog, der als Buch eine dialogförmige Gegenüberstellung in Diptychonform favorisiert, bilden sich in der Ausstellung oft Argumentationsgirlanden zwischen mehreren

Gemälden und Fotografien. Quasi nebenbei entstehen dadurch auch aufschlussreiche Zwiegespräche innerhalb des Mediums Fotografie, die sich teilweise in die vorliegende Publikation retten ließen (S. 78/79, 120/121).

Körper und Kleid, Haut und Raum

Lutz Teutloff selbst gibt das Thema »Körper« als inhaltliches Hauptkriterium für die Wahl »seiner« Werke an (siehe Interview). Unausgesprochen damit verbunden ist die Frage nach der Würde des Menschen und seiner fotografischen Wiedergabe: Heroisierung (S. 61, 62), genetische Manipulation (S. 83), unerwartetes oder unwillkommenes Ausbrechen aus den Diskursen von Jugend, Schönheit (S. 68) und Alter (S. 113, 115), Exponiertheit (S. 79), Tabubruch (S. 120) und – schwarzer – Humor (S. 121) bilden die facettenreiche Antwort. Darüber hinaus erschließt sich bei eingehender Betrachtung der Kollektion eine weitere, übergreifende und mit der Frage nach dem Körper unmittelbar verbundene Thematik: die des Kleides und der Mode, des »dress*codes*« und des »self-fashioning« im wörtlichen Sinne. Man ist versucht, den auffallend prominenten Platz dieser Thematik innerhalb der Teutloffschen Sammlung mit der Biografie des Sammlers, namentlich seinen Erfahrungen in der Textilindustrie, in Zusammenhang zu bringen. Da sind das erste und das letzte Hemd (S. 59, 119), Hochzeits- und Bestattungsästhetik (S. 77, 93), die Konstruktion von Geschlecht durch Kleidung (S. 59), Mode als Körperpraktik (S. 93) sowie auch die Reflexion alter und neuer Mode samt ihrer Vermarktungsstrategien (S. 65, 73, 89).

Von den zahlreichen Akten in Lutz Teutloffs Sammlung sind die wenigsten unbekleidet. Oft ist es die tätowierte Haut,

conspicuously prominent place of this theme in Teutloff's collection to the life of the collector, in particular to his experiences in the textile industry. We see the first and last shirts (pp. 59, 119), wedding and funeral aesthetics (pp. 77, 93), the construction of sexuality through clothing (p. 59), fashion as body styling (p. 93) and the reflection on fashion old and new along with its marketing strategies (pp. 65, 73, 89).

Of the numerous nudes in Lutz Teutloff's collection, very few are actually naked. Often it is the tattooed skin that, as a non-Euclidean surface for the inscription of social and cultural codes, forms the apparel of the sitter (pp. 66, 79, 113). "Ce qu'il y a de plus profond dans l'homme, c'est la peau" (The most profound thing about people is their skin): This aphorism, which may be due originally to Jean Cocteau, but was used in 1925 by André Gide and in 1932 by Paul Valéry, is back on a roll at the start of the new millennium. Recently (2005–06) it even provided the title for an exhibition and colloquium at the Musée des Beaux-Arts in Valenciennes. In the Teutloff Collection the "skin" phenomenon is positively "conjugated" through all its voices and moods: Sitters apply makeup to their skin (p. 95) or, stretching it to the utmost, pull it out toward the beholder (p. 61). Artists duplicate the skin (p. 59) or subject it to pseudo-dermatological studies (p. 111). As the "battlefield" for passions and addictions, the skin evinces scarifications (p. 89), traces of devastation (p. 68) or of love-play (p. 74).

A key work in many respects is the portrait of the student Andrea Kummer by Herlinde Koelbl (p. 66). The body of the sitter, which bears witness to a variety of artificial changes (from hair-dying via tattooing to piercing) is reflected on the one hand, like Titian's *Venus* (p. 92), in a mirror, and on the other in pictures of the Madonna, Christ and the seemingly crucified Jim Morrison.

As pictures-within-a-picture, these devotionalia surround the "illustrated woman" like a second, somewhat larger skin, or maybe (see the wrinkled black wallpaper) a skin that she has sloughed. The room, of which the mirror gives us an almost all-around view, thus becomes an integral part of the portrait. We cannot avoid a comparison with the similarly eloquent room in which François Boucher portrayed Marie-Louise O'Murphy (p. 75), which, however, does not seek to be interpreted portrait-like as it is, but so to speak in the continuous form, as the matrix of a sexual encounter actual or imaginary.

Alongside the otherwise comparatively neutral backgrounds of the paintings on display, the particular, and particularly varied, significance of the rooms in the Teutloff Collection photographs is striking. Sometimes the decorated body, as with Koelbl, continues in a sense into the room (p. 113), whereas in other instances, by contrast, the room in the background serves as a foil for the forms of the body (p. 52). While St. Patrick's Cathedral in Lebeck's photograph (p. 70) and the tent in Nadel's (p. 55) represent historical spaces, Hans Op de Beeck (p. 77) and Aziz + Cucher (p. 101) create allegorical spaces. Gerd Bonfert (p. 105), in turn, in a picture that contains almost no space, succeeds by dint of the allusion to Ariadne's thread in evoking a complete (metaphysical) labyrinth.

One recurrent motif in the photographs on display is the window. Even for Leon Battista Alberti, this was *the* metaphor of the picture. Whereas in the works of Larry Towell (p. 52), Greene (p. 99) and Bill Jacobson (p. 100) it marks primarily the temporal boundary between the photographed present on the one hand and the future or the past on the other, it refers elsewhere (pp. 55, 68, 111, 115) to the membrane between inside and outside, the individual and society.

die als nicht-euklidische Einschreibefläche für soziale und kulturelle Codes das Kleid der Porträtierten bildet (S. 66, 79, 113). »Ce qu'il y a de plus profond dans l'homme, c'est la peau« (Das Tiefgründigste am Menschen ist die Haut) – dieser ursprünglich vielleicht von Jean Cocteau stammende, 1925 bei André Gide und 1932 bei Paul Valéry auftauchende Aphorismus hat Anfang des neuen Jahrtausends wieder Konjunktur. Unlängst lieferte er sogar den Titel für eine Ausstellung samt Kolloquium im Musée des Beaux-Arts von Valenciennes (2005/06). In der Sammlung Teutloff wird das Phänomen »Haut« geradezu durchdekliniert: Porträtierte schminken ihre Haut (S. 95) oder spannen sie aufs Äußerste und strecken sie dem Betrachter entgegen (S. 61). Künstler verdoppeln die Haut (S. 59) oder unterziehen sie pseudodermatologischen Studien (S. 111). Als »Schlachtfeld« von Passionen und Süchten zeigt die Haut Skarifikationen (S. 89), Spuren der Verwüstung (S. 68) oder des Liebesspiels (S. 74).

Ein Schlüsselwerk in mancherlei Hinsicht ist das Bildnis der Studentin Andrea Kummer von Herlinde Koelbl (S. 66). Der von diversen Körperpraktiken (vom Haarefärben über das Tätowieren bis zum Piercing) zeugende Leib der Porträtierten reflektiert sich einerseits – wie Tizians *Venus* (S. 92) – in einem Spiegel, andererseits in Bildern der Muttergottes, Christi und des wie gekreuzigt erscheinenden Jim Morrison. Als Bilder im Bild umgeben diese Devotionalien die »illustrierte Frau« wie eine zweite, etwas weitere oder vielleicht – siehe die runzlige schwarze Tapete – abgelegte Haut. Der dank des Spiegels fast rundum sichtbare Raum wird somit zum integralen Bestandteil des Porträts. Es drängt sich der Vergleich mit dem ähnlich sprechenden Raum bei Boucher (S. 75) auf, der allerdings nicht zuständlich, porträthaft gelesen werden

will, sondern gleichsam in der Verlaufsform, als Matrize einer stattgefundenen und/oder zu imaginierenden sexuellen Handlung.

Neben den ansonsten vergleichsweise neutralen Fonds der ausgestellten Gemälde fällt die besondere und besonders vielfältige Bedeutung der Räume in den Fotografien aus der Sammlung Teutloff auf. Mal setzt sich der dekorierte Körper – wie bei Koelbl – gewissermaßen im Raum fort (S. 113), mal dient im Gegenteil der räumliche Hintergrund als Kontrastfolie zu den Formen des Körpers (S. 52). Während die St. Patrick's Cathedral bei Lebeck (S. 70) und das Zelt bei Nadel (S. 55) historische Räume darstellen, kreieren Op de Beeck (S. 77) und Aziz + Cucher (S. 101) allegorische Räume. Gerd Bonfert (S. 105) wiederum gelingt es, in einem selbst fast gar nicht raumhaltigen Bild durch die Allusion auf den Ariadnefaden ein ganzes (metaphysisches) Labyrinth zu evozieren.

Ein in den ausgestellten Fotografien immer wiederkehrendes Motiv ist das Fenster – schon bei Alberti Metapher für das Bild schlechthin. Während es in den Werken von Towell (S. 52), Greene (S. 99) und Jacobson (S. 100) vor allem die zeitliche Grenze zwischen der fotografierten Gegenwart einerseits und der Zukunft beziehungsweise Vergangenheit andererseits markiert, verweist es in anderen Fällen (S. 55, 68, 111, 115) auf die Membran zwischen innen und außen, Individuum und Gesellschaft.

Keineswegs will diese kurze *tour d'horizon* als Klassifizierungsversuch missverstanden werden. Jedes einzelne Werk der Sammlung Teutloff ist (wie auch jedes einzelne Werk der Sammlung Wallraf) ein eigener Mikrokosmos und hat zugleich Anteil an einer jeweils individuellen künstlerischen

In no way would I want this brief *tour d'horizon* to be misunderstood as an attempt at classification. Every individual work in the Teutloff Collection is (like every individual work in the Wallraf collection) a microcosm in itself and forms at the same time part of the worldview of an individual artist. Unlike our "Hotel California" exhibition, which was dominated by large complexes of works (Desiree Dolron, Thomas Wrede), it seemed advisable here to provide some space for brief, individual interpretations, in the List of Works (pp. 122–56), of the exhibits selected for the catalogue.

The Exhibition as *House of Leaves*

The temporal distance between the paintings and photographs displayed together ranges from about 80 years (pp. 112 f.) to 560 (pp. 52 f.). In each case it is at least several generations, indeed usually several epochs. Alongside the differences in size between painting and photograph (in one case dramatic: pp. 62 f.), which are not immediately apparent in the present catalogue, account must of course be taken, when viewing and interpreting our compilation of works, of the "distance" between the media. It is well known that painting and photography have not only quite different histories and theories (albeit overlapping or intersecting here and there), but also divergent production and distribution conditions. In order on the one hand to allow a direct comparative view, and on the other to avoid the merest suspicion of a naive, ahistorical one-to-one comparison between painting and photography, it seemed sensible to take certain precautions in the preparations for the exhibition.

As the *condition humaine*, the representation of existentially fundamental situations such as the beginning and end of life, bliss and suffering, confidence and despair, forms the dominant theme of the Teutloff Photo + Video Collection, it seemed natural to lay out the exhibition circuit in approximation to the rhythm of human life as marked by becoming and departing, by growth and decline (see p. 39), whereby when leaving the last of the nine rooms one returns to the first, and thus, so to speak, attains rebirth.

1. Pregnancy – Birth – Childhood (pp. 52–59)
2. Youth (pp. 60–67)
3. Beauty (pp. 68–75)
4. Couples (pp. 76–83)
5. Suffering and Pain (pp. 84–91)
6. Reflection (pp. 92–99)
7. "House of Leaves" (pp. 100–107)
8. Old Age (pp. 108–15)
9. Death (pp. 116–21)

The heart of the exhibition ground plan is the "House of the Red Door" (*ad rufam ianuam*, formerly Obenmarspforten 38), first documented in 1205, excavated from 1990 to 1998 and partly preserved in the exhibition area of the Wallraf-Richartz-Museum. As the plan shows, the structure in which this archeological zone is housed is not parallel but diagonal to the exterior walls of the museum building. Insofar as the exhibition architecture is, for this once, oriented to the House of the Red Door, it gives the impression of being "unhinged" vis-à-vis the permanent museum architecture. As a building within a building, the House of the Red Door forms Hall 7 of the exhibition. Its superscription and theme, "House of Leaves," refers to the eponymous cult book published in 2000 by Mark Z. Danielewski. This horror novel, which uses all manner of unconventional typography, and is open, as it were, to the reader as a "walk-in" volume, is an early example of the "spatial turn." It focuses on a

Weltsicht. Anders als im Fall unserer Ausstellung *Hotel California*, die von größeren Werkkomplexen (Desiree Dolron, Thomas Wrede) dominiert war, erschien es daher angeraten, einer zumindest skizzenhaften Einzeldeutung der für den Katalog ausgewählten Exponate im Werkverzeichnis (S. 122–156) eigenen Raum zu geben.

Die Ausstellung als *House of Leaves*

In zeitlicher Hinsicht liegen zwischen den ausgestellten Gemälden und Fotografien unterschiedliche Distanzen, von etwa 80 (S. 112/113) bis zu 560 Jahren (S. 52/53). Das sind mindestens mehrere Generationen, ja meist sogar mehrere Epochen. Neben den im Einzelfall (S. 62/63) dramatischen Größendifferenzen zwischen Malerei und Fotografie, die im vorliegenden Katalog nicht auf Anhieb sichtbar werden, ist bei Betrachtung und Deutung unserer Werkzusammenstellung selbstverständlich der Abstand der Medien zu berücksichtigen: Bekanntlich haben Malerei und Fotografie nicht nur eine ganz unterschiedliche (wenn auch hier und da sich überschneidende oder kreuzende) Geschichte und Theorie, sondern auch divergierende Produktions- und Verbreitungsbedingungen. Um einerseits das direkt vergleichende Sehen zu ermöglichen, andererseits aber schon dem bloßen Anschein eines naiven, ahistorischen 1:1-Vergleichs zwischen Malerei und Fotografie zu entgehen, erschien es sinnvoll, in der Präsentation der Ausstellung bestimmte Vorkehrungen zu treffen.

Da die »condition humaine«, die Darstellung existenzieller Grundsituationen wie Beginn und Ende des Lebens, Glück und Leid, Zuversicht und Zweifel das beherrschende Thema der Fotosammlung Teutloff bildet, lag es nahe, den Aus-stellungsparcours dem menschlichen Lebensrhythmus von Entstehen und Vergehen anzunähern (s. rechts), wobei man vom letzten der neun Säle zurück zum ersten und damit quasi zur Wiedergeburt gelangt:

1. Schwangerschaft – Geburt – Kindheit (S. 52–59)
2. Jugend (S. 60–67)
3. Schönheit (S. 68–75)
4. Paare (S. 76–83)
5. Leid und Schmerz (S. 84–91)
6. Reflexion (S. 92–99)
7. *House of Leaves* (S. 100–107)
8. Alter (S. 108–115)
9. Tod (S. 116–121)

Kernraum des Ausstellungsgrundrisses – hier: Raum 7 – ist das erstmals im Jahr 1205 urkundlich erwähnte »Haus zur Roten Tür« (*ad rufam ianuam*, ehemals Obenmarspforten 38), das 1990 bis 1998 ergraben und im Ausstellungsbereich des Wallraf-Richartz-Museums fragmentarisch erhalten wurde. Wie der Grundriss zeigt, steht die Einhausung dieses archäologischen Bereichs nicht parallel, sondern schräg zu den Außenwänden des Museumsgebäudes. Indem die Ausstellungsarchitektur sich diesmal ausnahmsweise am Haus zur Roten Tür ausrichtet, erscheint sie, gemessen an der permanenten Museumsarchitektur, »ver-rückt«. Als Haus im Haus bildet das Haus zur Roten Tür den Saal 7 der Ausstellung. Dessen Überschrift und Thema *House of Leaves* bezieht sich auf das gleichnamige, im Jahr 2000 erschienene Kultbuch von Mark Z. Danielewski. Der mit allen typografischen Raffinessen operierende, vom Leser quasi »betretbare« Schauerroman ist ein früher Repräsentant des *spatial turn*. Im Zentrum steht ein Haus, das innen größer ist als außen. Auf verschie-

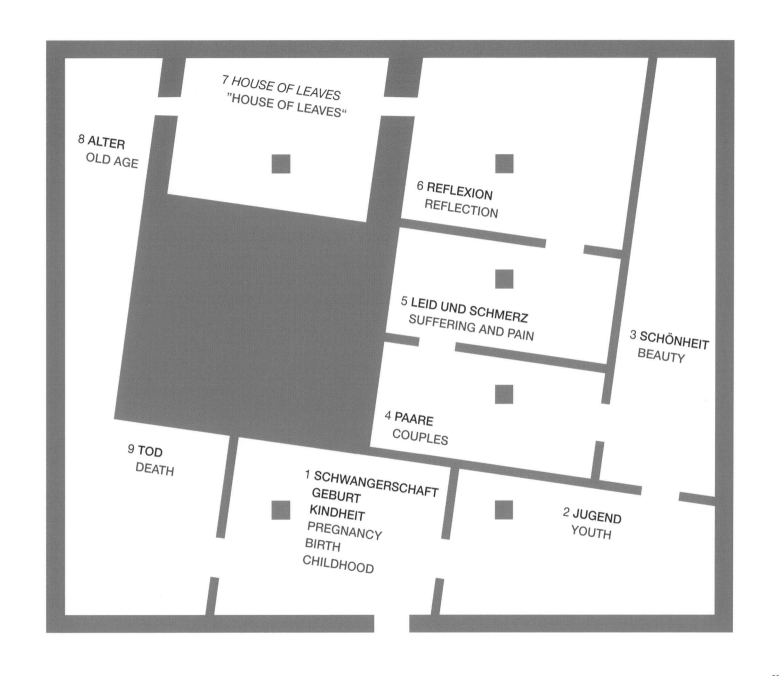

7 HOUSE OF LEAVES
"HOUSE OF LEAVES"

8 ALTER
OLD AGE

6 REFLEXION
REFLECTION

5 LEID UND SCHMERZ
SUFFERING AND PAIN

3 SCHÖNHEIT
BEAUTY

4 PAARE
COUPLES

9 TOD
DEATH

1 SCHWANGERSCHAFT
GEBURT
KINDHEIT
PREGNANCY
BIRTH
CHILDHOOD

2 JUGEND
YOUTH

denen Realitäts- und Diskursebenen entwickelt das vielstimmige Buch ein im wahrsten Wortsinn abgründiges Bild für die menschliche Existenz, nicht ohne die medialen Möglichkeiten ihrer Darstellung – vom geschriebenen Wort über das Foto bis zum Film – auf wahrlich doppelbödige Weise zu reflektieren.

Der kulturhistorische Rezeptions- und Verarbeitungshorizont des Autors ist immens. Die Expeditionen in das unermessliche Labyrinth des Hauses gemahnen an Dantes Höllenreise und nehmen durch ihre typografische Raumentfaltung sogar jüngste Erkenntnisse des Danteforschers Theodore Cachey vorweg, der dem erzählten, trichterförmigen Raum des »Inferno« die nach geometrischen Gesichtspunkten gebaute Versarchitektur des papiernen Erzählraums gegenüberstellen kann. Die mit den Expeditionen in die Eingeweide des *House of Leaves* (S. 101) verbundenen Bemühungen, das Unheimliche filmisch aufzuzeichnen, erinnern unmittelbar an die Geisterfotografie des 19. Jahrhunderts. Schon die spiegelbildlich angeordneten Hauptfiguren des Romans, ein Tätowierer und ein Fotograf, aber auch die allgegenwärtige Thematik des Raumes eröffnen vielfältige Bezüge zu Gegenstand und Exponaten unserer Ausstellung.

Deren Architektur greift den Titel und das zentrale Bild des Romans auf und verlängert ihn damit in einen wirklichen, wenn auch weitgehend ephemeren Ausstellungsraum, der gleichfalls »innen größer als außen« ist: Die tatsächlichen Ausstellungssäle werden durch (rein linear dargestellte) »virtuelle« Räume erweitert, »in« denen sich die eigentlich unmittelbar benachbarten Gemälde und Fotografien dennoch auf verschiedenen Ebenen begegnen (S. 42/43). Auf den solchermaßen perspektivisch zergliederten Ausstellungswänden werden zeitliche Abstände zu scheinbar räumlichen, kleine Bilder zu scheinbar großen und umgekehrt. Diese spielerische Verunsicherung schafft eine Wahrnehmungssituation, welche die medialen Differenzen der gezeigten Bilder permanent im Bewusstsein hält und zugleich den Erlebnischarakter der Ausstellung erhöht. Nicht zuletzt handelt es sich bei dieser räumlichen Konzeption natürlich um eine metainszenatorische *mise-en-abîme*, eine Reflexion der paradigmatischen Rolle des Museums als Wahrnehmungs- und Erinnerungsraum.

Mit unserer Hommage an *House of Leaves* schließt sich der argumentative Kreis, ist doch Mark Z. Danielewski in vielerlei Hinsicht ein legitimer Nachfolger Edgar Allan Poes. Auf den Namen des Dichters wird im Roman ausdrücklich angespielt, wobei mit dieser Allusion auch die Schwester des Autors, Anne Danielewski, gemeint ist, die als musikalisches Parallelwerk zu *House of Leaves* das Album *Haunted* schuf – unter ihrem Künstlernamen *Poe*.

house, which is larger inside than out. On different levels of reality and discourse, the polyphonic book develops a literally abyssal image of human existence, not without reflecting on the media possibilities of its representation, from the written word via photography to film, in a truly ambiguous manner.

The scope of the author's cultural-historical reception and processing of subject matter is extensive. The expeditions into the vast labyrinth of the house are reminiscent of Dante's journey through Hell, and because of their typographical unfolding of space, they even anticipate the latest discoveries of the Dante scholar Theodore Cachey, who compares the funnel-shaped space of the Inferno, as narrated, to the verse architecture of the narrative space on paper, which is constructed on geometric principles. The efforts, connected with the expeditions into the intestines of the *House of Leaves* (p. 101), to make a film record of the uncanny are directly reminiscent of the spirit photography of the 19th century. Not only the mirror-image arrangement of the chief protagonists of the novel (a tattooist and a photographer) but also the omnipresent theme of space, open up multifarious references to the subject of and the exhibits in our exhibition.

Its architecture takes up the title and the central image of the novel, and thus extends it into a real, albeit largely ephemeral exhibition space, which is likewise "bigger inside than out." The actual exhibition rooms are extended by "virtual" rooms (represented purely by lines) "in" which the (actually directly juxtaposed) paintings and photographs nevertheless meet on various planes (see pp. 42/43). On these (thus perspectively anatomized) exhibition walls, temporal intervals come across as spatial, small pictures as large ones, and vice versa. This playful disconcertment creates a perceptual situation that continually underlines the media-determined differences between the pictures on display, and at the same time enhances the "experience" character of the exhibition. Not least, this spatial conception is of course a meta-staged *mise-en-abîme*, a reflection on the paradigmatic role of the museum as a space of perception and memory.

Our homage to *House of Leaves* closes the circle of argument, for after all Mark Z. Danielewski is in many respects a legitimate successor of Edgar Allan Poe. There are explicit allusions to Poe in Danielewski's novel, although it must be noted that this allusion also refers to the author's sister, Anne Danielewski, who created the album *Haunted* as a musical counterpart to *House of Leaves*—under the pseudonym "Poe."

Fotografie sammeln
Ein Interview mit Lutz Teutloff

Andreas Blühm: Herr Teutloff, seit wann sammeln Sie?

Lutz Teutloff: Das kann ich Ihnen ganz genau sagen. 1953 habe ich mein erstes Lehrlingsgehalt auf einer Kunstmesse – das gab es damals schon – in Berlin ausgegeben. Da gab es tatsächlich etwas für 5 und 10 und 20 D-Mark zu kaufen. Ich hab 29 D-Mark verdient im Monat, so dass ich für 20 D-Mark ein Bild kaufen konnte, das noch heute mein Privatbüro schmückt.

A.B.: Dürfen wir erfahren, um was es sich da handelt?

L.T.: Eine Mischung aus Surrealismus und Expressionismus.

A.B.: Es gibt ja verschiedene Arten von Sammlern: passionierte Menschen und reine Investoren, solche, bei denen Beruf und Berufung divergieren, und solche, die sich auch professionell mit Kunst beschäftigen, Teil der Szene sind und sogar mit Kunst handeln – oder gehandelt haben, wie etwa Ernst Beyeler. Welchem Typus von Sammler würden Sie sich zurechnen?

L.T.: Der unlängst leider verstorbene Ernst Beyeler (ich hatte ein, zwei Mal das Vergnügen, mit ihm reden zu dürfen) ist ein absolutes Vorbild. Was er geschafft hat, davon kann ich nur träumen. Weil er sich von Beginn seines Lebens an mit der Kunst beschäftigt hat. Ich bin ja hier in Köln 1989 gestartet als Quereinsteiger. Natürlich hatte ich, als ich meine Firma verkauft habe, dort schon 200 Arbeiten. Aber die habe ich »aus dem hohlen Bauch« gekauft, und es war eine lustige, fröhliche Mischung.

A.B.: Sie waren in der Textilbranche tätig.

L.T.: Ja, in der Bekleidungsindustrie.

Roland Krischel: Und nach der Bekleidungsindustrie kam die Galeristentätigkeit.

L.T.: Ja, das war besagter »Quereinstieg«. Der war am Anfang verdammt schwer; da gab es doch viel Widerstand. Und so gern ich Köln mag (ich bin ja hier zum Hansa-Gymnasium gegangen und liebe die Stadt über alles): Auf einmal war hier jemand, der völlig unbekannt war und eine große Galerie aufmachte in der St. Apernstraße – 350 Quadratmeter, das war auch damals viel. Und wenn man vorher im Leben viel Erfolg hatte, dann hat man gedacht: Das schaffst du in der Kunst auch. Und die Kunst war für mich zu Anfang eine ganz hehre Welt, eine ganz besondere Welt. Ich dachte: Das ist nicht so wie die Bekleidungsbranche. Ich musste aber im Lauf der Zeit merken, dass der Unterschied doch nicht so groß war.

R.K.: Warum sammeln Sie Fotografie – und nicht etwa Malerei oder Druckgrafik?

L.T.: Zu meiner Konfirmation habe ich von meinem Vater eine Leica geschenkt bekommen, aus dem Jahr 1932. Mit dieser Leica habe ich viel Freude gehabt und wunderbare Fotos machen können. Nach meiner Konfirmation bin ich – mit noch nicht einmal 16 Jahren – mit dieser Leica nach Afrika. Bevor ich in die Lehre kam, hat mein Vater gesagt: So, jetzt musst du ins richtige Leben; jetzt kommst du auf ein Frachtschiff nach Nordafrika. Und da habe ich mit dieser Leica fan-

Collecting Photography
An Interview with Lutz Teutloff

Andreas Blühm: Herr Teutloff, how long have you been collecting?

Lutz Teutloff: I can tell you quite precisely. In 1953 I spent my first apprentice wages at an art fair—yes, they existed even then—in Berlin. You could actually buy things for 5, 10, 20 deutschmarks. I earned 29 deutschmarks a month, so I was able to buy a picture for 20 deutschmarks, and it's still in my private office.

A.B.: Might I ask what sort of picture?

L.T.: A mixture of Surrealism and Expressionism.

A.B.: There are various kinds of collector: impassioned individuals and pure investors, those whose career and vocation diverge, and those who are involved professionally with art, who are part of the scene and maybe even deal in art or were once art dealers themselves, such as Ernst Beyeler. Which kind of collector would you classify yourself as?

L.T.: Ernst Beyeler, who unfortunately died recently (I had the pleasure of talking to him once or twice), is my absolute role model. I can only dream of achieving what he achieved. That was because he was involved in art right from the start of his life. I came from outside when I started here in Cologne in 1989. Of course when I sold my firm, I already had 200 works there. But I bought them "with my gut instinct," so to speak. It was a cheerful mixture.

A.B.: You were in the textile sector.

L.T.: Yes, the clothing industry.

Roland Krischel: And after working in the clothing industry you started an art gallery.

L.T.: Yes, that was where I came in from outside. It was very hard at first. There was a lot of resistance. And, as much as I like Cologne (I went to school at the Hansa Gymnasium here and love this city more than anything), suddenly, here was someone totally unknown who was opening a big gallery on St. Apernstrasse—with almost 4,000 square feet. That was a lot even then. And if you'd been successful in life up until then, you thought: "You'll be just as successful with art." And at first art was for me an unspoiled world, a very special world. I thought: "This is not like the garment trade." But as time went by I had to realize that the difference is not that great.

R.K.: Why do you collect photography, rather than paintings or prints?

L.T.: My father gave me a Leica dating from 1932 as a confirmation present. This Leica gave me a lot of pleasure and I took some wonderful photographs. After my confirmation—I wasn't even sixteen—I took this Leica to Africa. Before I took up my apprenticeship, my father said: "Well, now you have to see a bit of real life, you're going on a cargo ship to North Africa." And while I was there I took some fantastic pictures with this Leica. That was how I came to photography, and so of course I've always taken a special interest in this medium. And the Leica has a place of honor…. Recently I turned up an old film with photos of Africa. It was an old Perutz film; the firm no longer

tastische Bilder gemacht. So bin ich zum Fotografieren gekommen und habe dann für dieses Medium natürlich auch ein besonderes Interesse gehabt. Und die Leica halte ich in Ehren … Kürzlich habe ich einen Film mit Afrikafotos wiederentdeckt. Das ist ein alter Perutz-Film; die Firma existiert heute gar nicht mehr. Aber es gibt in den Rocky Mountains eine Firma, die diese alten Filme noch entwickeln kann. Dieser Film ist also vor circa einem Vierteljahr in die Rockys gegangen, zu besagtem Entwickler. Der hat mir gesagt: »We will see. Within the next two, three months you'll have the result.« Nun bin ich natürlich gespannt, was da nach 55 oder mehr Jahren für Bilder kommen.

R.K.: Nach eigenem Bekunden sammeln Sie Werke mit Entstehungsdatum ab 1968 – warum dieses Stichdatum?

L.T.: Man muss das irgendwo begrenzen, und der Anfang der Photo + Video Sammlung war 1968. 68 hat natürlich auch eine besondere Bedeutung. Da war ich in Berlin selbständig und habe meine Bekleidungsfirma geführt …

A.B.: Das spricht nicht dafür, dass Sie sich mit Rudi Dutschke auf der Barrikade befunden haben.

L.T.: … die haben sich am Bahnhof Halensee gesammelt und sind über den Kurfürstendamm an meiner Firma vorbei zum Springer-Haus gegangen – das war bestimmt einmal im Monat. Das hat uns damals richtig behindert in unserem Geschäftsverkehr. Ich war am Anfang nicht so unbedingt begeistert von den 68ern. Heute kann ich sagen: Ich verstehe die Bewegung absolut.

A.B.: Was gibt es für den Fotosammler Teutloff noch für Auswahlkriterien?

L.T.: Die Sammlung ist ja fokussiert auf den Körper. Der ursprüngliche Titel der Kollektion *Vom Sperma bis zum Tod –*

A *Very Private View* heißt ja, dass ich mich nur um den Körper kümmere. Wobei »a very private view« auch heißt: Ich kann gar nicht alles haben; das ist unmöglich bei den Millionen Künstlern weltweit. Es geht eben um den speziellen, individuellen Blick des Sammlers Teutloff auf den Körper. Je spezieller und je globaler er ist, umso besser ist er.

A.B.: Im Grunde haben Sie Ihr Leben lang mit dem Körper zu tun: Mal ziehen Sie ihn an, mal ziehen Sie ihn aus, mal kaufen Sie Fotos.

L.T. (lacht): Richtig – diese Formel gefällt mir!

R.K.: Wie kam es zu der Konzentration auf den Menschen, seinen Körper, die »condition humaine«?

L.T.: Das Leben! Das Leben ist was Wunderbares. Und das Leben einfangen zu dürfen mit guten Fotos und guten Künstlern ist ja auch eine besondere Freude, ist aber nicht, wie man in Köln so schön sagt, »ömmesons«, sondern dafür muss man auch arbeiten. Der Beruf des Sammlers – ich nenne das sogar Beruf – ist nicht mal so nebenbei …

A.B.: Es fällt auf, dass die Fotos Ihrer Sammlung von vornherein als Kunstwerke gemeint sind und nicht etwa im Nachhinein zu solchen erklärt wurden. Es gibt da keine Amateurfotografie und selbst die dokumentarischen Aufnahmen haben künstlerischen Anspruch. Das ist ja auch eigentlich eine Auswahl.

L.T.: Wenn Sie die *New York Times* oder die *Washington Post* oder den *Miami Herald* oder wo auch immer in dieser weiten Welt gute Tageszeitungen lesen, finden Sie hervorragenden Fotojournalismus. Ich nenne mal einfach nur James Nachtwey oder Adam Nadel, die mittlerweile zu echten Künstlern geworden sind.

exists. But in the Rocky Mountains there's a firm that can still develop this film. About three months ago I sent this film to the Rockies, to the said developer. He just said: "We will see. Within the next two, three months you'll have the result." I am of course on tenterhooks to see what sort of pictures I'll get after 55 or more years.

R.K.: You say that you collect works dating from 1968 or later. Why this cut-off point?

L.T.: You have to set a limit somewhere, and the start of the Photo + Video Collection was 1968. That year of course has a particular significance. Back then I was self-employed in Berlin and headed my own clothing firm…

A.B.: It doesn't sound as if you were on the barricades with Rudi Dutschke.

L.T.: …they used to assemble at Halensee Station and march along the Kurfürstendamm past my firm to the Springer head-quarters. They did this once a month. We found it a real nuisance for our business. To start with I was none too enthusiastic about those people. Today I can say: I understand them completely.

A.B.: What other selection criteria do you have as a photo collector?

L.T.: The collection is focused on the body. The original title of the collection was "Vom Sperma bis zum Tod: A Very Private View" (From the Sperm to Death: A Very Private View). In other words I concern myself only with the body. However "a very private view" also expresses the fact that I can't have everything. That's impossible with the millions of artists worldwide. It is Teutloff the collector's special, individual take on the body. The more special and more global, the better.

A.B.: Basically you've been concerned with the body all your life: Sometimes you dress it, sometimes you undress it, sometimes you buy photographs.

L.T.: (laughs): Quite right, I like that!

R.K.: How did you come to concentrate on the human being, the human body, the *condition humaine*?

L.T.: Life! Life is something wonderful. And to be able to capture life in good photographs by good artists is also a special pleasure, but it isn't, as they say in Cologne, "ömmesons" [in standard German *umsonst*, i.e. a free lunch]. You have to work for it. The career of collector—and I use the word "career" quite deliberately—can't just be pursued on the side.

A.B.: It is conspicuous that the photographs in your collection were intended as works of art from the outset, and weren't subsequently declared as such. There's no amateur work here, and even the documentary pictures have pretensions to artistic status. That is also a selection criterion, actually.

L.T.: If you read *The New York Times* or *The Washington Post* or *The Miami Herald* or any good daily newspaper from around the world, you'll find outstanding photojournalism. I need only mention James Nachtwey or Adam Nadel, who have since become real artists.

R.K.: You discovered Adam Nadel when he was still purely a photojournalist.

L.T.: Yes.

A.B.: Are there things that you acquired about which you now say: "How could I have? I'd never do that now."

L.T.: Yes, of course. No question. And I sell the stuff again, even if I only get half of what I paid for it. The first loss is always the best.

R.K.: Adam Nadel haben Sie entdeckt, als er noch reiner Fotojournalist war.

L.T.: Ja.

A.B.: Gibt es Dinge, die Sie erworben haben, wo Sie sagen: Wie konnte ich damals nur? Das würde ich heute nie wieder machen.

L.T.: Ja, natürlich gibt es das, gar keine Frage. Und davon trenn ich mich auch wieder, selbst wenn es dann nur zum halben Preis ist. Der erste Verlust ist immer der beste.

R.K.: Welche Bedeutung hat für Sie die Theorie der Fotografie? Spielt die für Sie eine Rolle oder sammeln Sie eher instinktiv und überlassen sozusagen die Theoriebildung lieber den …

L.T.: … Kuratoren? Ja, absolut, weil sie das wesentlich besser können als ich. Die Zeit des Aus-dem-Bauch-Kaufens ist vorbei, weil eben doch wunderbare Gruppen in der Sammlung entstanden sind, ob es nun eine Tattoo-Gruppe ist oder ob es Kinder sind oder ob es um den Tod geht. Und diese Gruppen gilt es eben zu ergänzen. Ich habe meine Sammlung im Kopf und ich sehe die Lücken.

R.K.: Sie beziehen wie selbstverständlich Werke nach der »digitalen Wende«, nach dem Ende der 1980er Jahre, mit ein. Man sieht in der Sammlung auf Anhieb keine Bruchstelle. Nehmen Sie selber da einen Bruch wahr? Es wird ja sehr heftig diskutiert: Gibt es jetzt eine »Fotografie nach der Fotografie« oder gibt es eine ganz klare Kontinuität …

L.T.: Kurz nach der »Wende«, nach unserer politischen Wende, musste ich in Leipzig einen Vortrag halten in Sachen »digitale Fotografie contra Malerei«. Zum Schluss habe ich den Studenten gesagt: »Sie werden in Zukunft ganz wenig mit Staffelei und Pinsel arbeiten. Der Computer wird Ihr Werkzeug.« Da bin ich heftig ausgepfiffen worden. Mittlerweile ist es so, dass wir in der Welt so digital sind, dass wir gar nicht mehr unterscheiden, was ist analog – was ist digital.

R.K.: Pixel statt Pinsel …

L.T. (lacht): Ja, aber mir gefällt das. Ich find das wunderbar. Nehmen Sie nur Polaroid. Polaroid wird jetzt sicherlich im Wert steigen. Das gibt's nicht mehr, das ist schon Geschichte. Das ist richtig schön. Ich freue mich über jedes Polaroidfoto, das sich in meiner Sammlung findet.

R.K.: Wie sehen Sie als Unternehmer das Verhältnis Ökonomie und Fotografie – gerade auch in Hinsicht auf den technischen Fortschritt?

L.T.: Mein iPhone hat Millionen Pixel, da ist zusätzlich eine Kamera drin, mit der Sie sogar Makrofotos machen können…

A.B.: … und Sie können direkt versenden.

L.T.: Es hat Fortschritte gegeben, die waren noch vor fünf Jahren undenkbar.

A.B.: Ich sprach mal mit den Leuten, die das *World Press Photo* organisieren. Jedes Jahr kriegen die inflationär mehr Fotos eingeliefert: 40 000 Fotos – die müssen alle juriert werden. Man wird ja heute aufgerufen, von den Sendern, von den Zeitungen: Handy bereithalten, Fotos machen – werde unser Reporter!

L.T.: Als »nine/eleven« war, war ich zufällig Zuhause und schaltete CNN an und sah, was da passierte – das war ja live, das war ja unvorstellbar. Ich hab einen Fotografen namens Andrew Moore angerufen. Er ist in meiner Sammlung vertreten und wohnte nur zwei Blocks vom World Trade Center entfernt. Ich hab den Zuhause aus dem Bett geholt und gesagt: »Andy, you must go. You can't believe what's going on!« Mit anderen Worten: Wir sind derartig global geworden – man

R.K.: What importance do you attach to the theory of photography? Does it play a role for you, or do you collect by instinct, and leave the theory so to speak to the…

L.T.: …curators? Yes, the latter, because they are much better at it than I am. The time of gut-feeling purchases is past, because wonderful groups have emerged in the collection, whether it's a tattoo group or children or death. And these groups need to be augmented. I have my collection in my head, and I know where the gaps are.

R.K.: You include, as a matter of course, works dating from after the "digital divide" in the late 1980s. One's initial impression is that there is no caesura in the collection. Do you yourself see one? There is after all a vehement debate about whether there's a "photography after photography" or rather a very clear continuity…

L.T.: Shortly after our political caesura [German unification] I was asked to give a talk in Leipzig on "digital photography versus painting." At the end I said to the students: "You won't be working much with easel and paintbrush in future. The computer will be your tool." They booed and whistled. Meanwhile the world has become so digital that we no longer distinguish between the analogue and the digital.

R.K.: Pigments to pixels…

L.T. (laughs): Yes, but I like it. I think it's wonderful. Just take Polaroid. Polaroid is bound to increase in value. It no longer exists, it's history. But it's really beautiful. I take pleasure in every Polaroid photo in my collection.

R.K.: As an entrepreneur, how do you see the relationship between business and photography, particularly in view of technical advances?

L.T.: My iPhone has millions of pixels. It even has a camera that can take macrophotos.

A.B.: …and you can transmit them right away.

L.T.: We've seen advances that would have been unimaginable just five years ago.

A.B.: I was talking to the people who organize World Press Photo. Every year they get sent more and more photographs: 40,000 photos, and they all have to be judged. People these days are encouraged by broadcasters and newspapers to become reporters by sending in pictures from their mobile phones.

L.T.: On 9/11 I happened to be at home and I switched on CNN and saw what was going on—it was *live*; it was unimaginable. I phoned a photographer called Andrew Moore. He's represented in my collection and lived just two blocks away from the World Trade Center. I got him out of bed and said: "Andy, you must go. You can't believe what's going on!" In other words: we've become so globalized that you can be sitting in front of a TV in provincial Germany and tell a New York artist to go and take pictures!

R.K.: In the entrance zone of your Bielefeld collection you've put up a big sign with a quote from Nam June Paik: "There is no rewind button on the Betamax of life."

L.T.: That has an almost religious character for me. It reminds me every day to thank our creator for the gift of life.

R.K.: Can we see your photo collection as a *memento mori*, maybe even as part of an *ars moriendi*, an art that prepares oneself for death?

L.T.: That is in any case the most important question that we all have to ask ourselves: How do we want to close our lives? And that's why I have a particular affinity with death, that is to say, with eternity.

sitzt im Teutoburger Wald vorm Fernseher und ruft den New Yorker Künstler an und sagt: Geh hin! Mach die Aufnahmen!

R.K.: Im Eingangsbereich Ihrer Bielefelder Sammlung haben Sie auf einem großen Schild ein Zitat von Nam June Paik anbringen lassen: »There is no rewind button on the Betamax of life.«

L.T.: Das hat für mich fast einen religiösen Charakter. Es erinnert mich täglich daran, unserem Schöpfer zu danken, dass wir leben dürfen.

R.K.: Kann man Ihre Fotosammlung ein Stück weit als *memento mori* auffassen, vielleicht gar als Teil einer *ars moriendi*, einer Kunst des Sich-Vorbereitens auf den Tod?

L.T.: Das ist überhaupt die wichtigste Frage, die wir uns alle zu stellen haben: wie wir unser Leben abschließen wollen. Und deswegen habe ich eine besondere Affinität zum Tod, sprich: zur Ewigkeit.

This is for you.

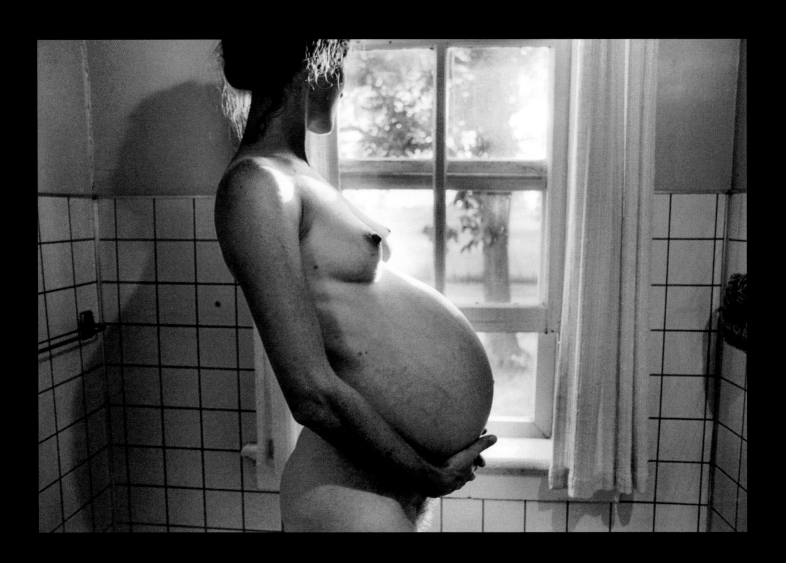

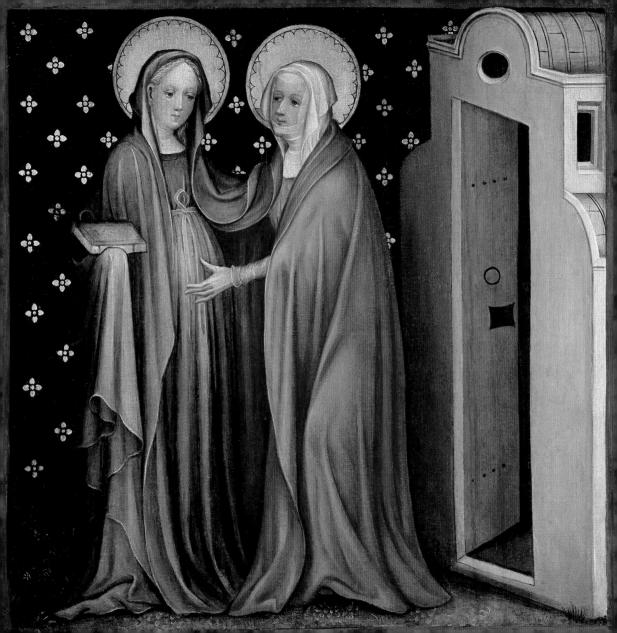

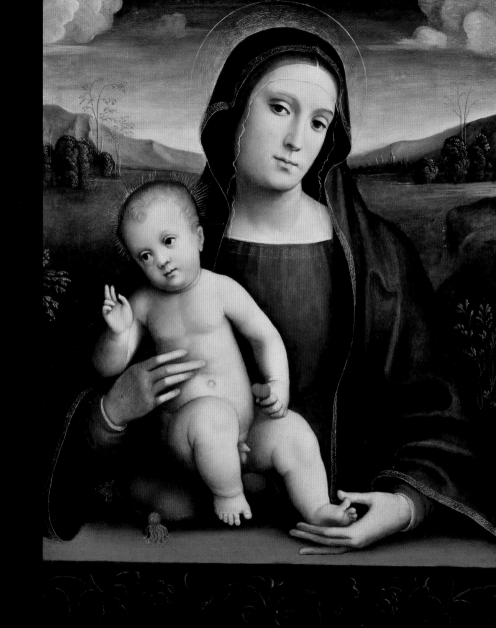

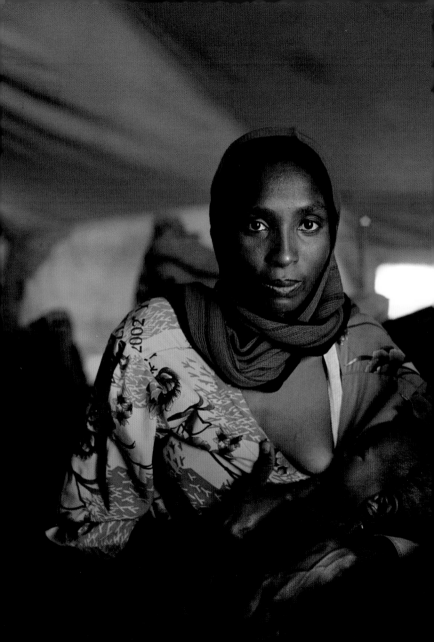

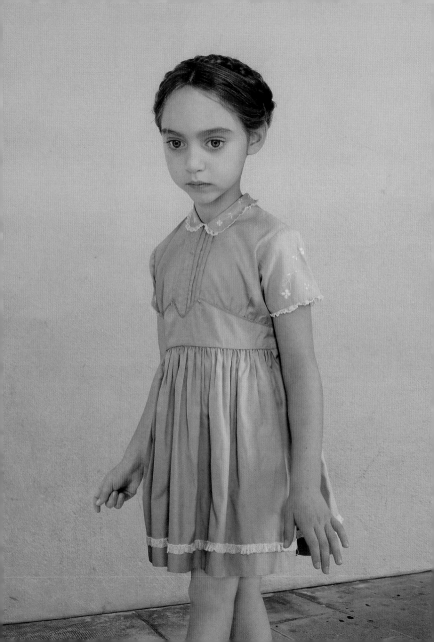

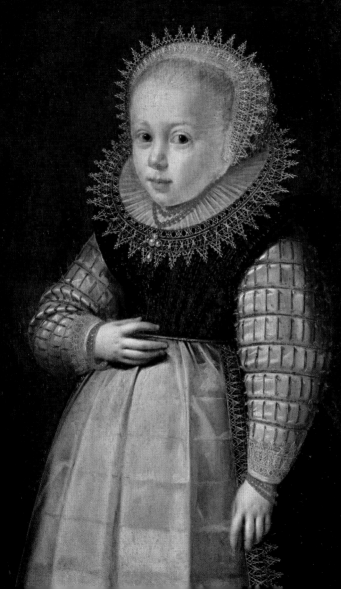

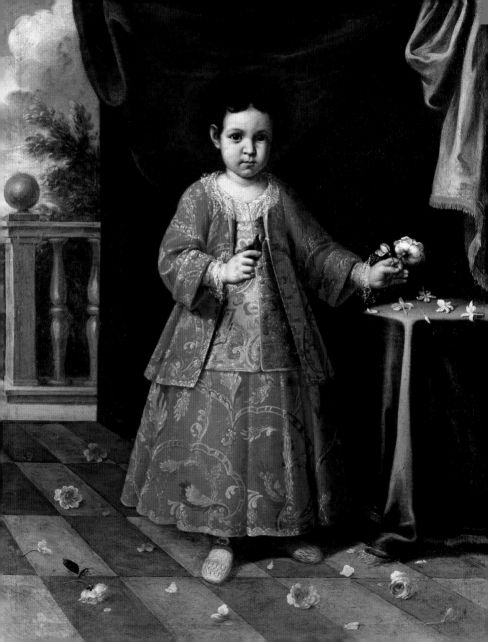

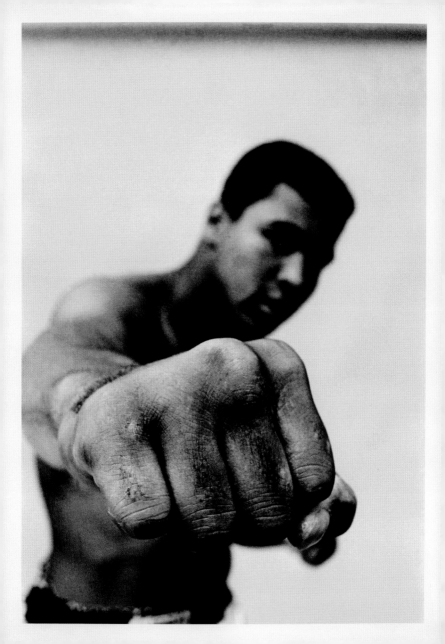

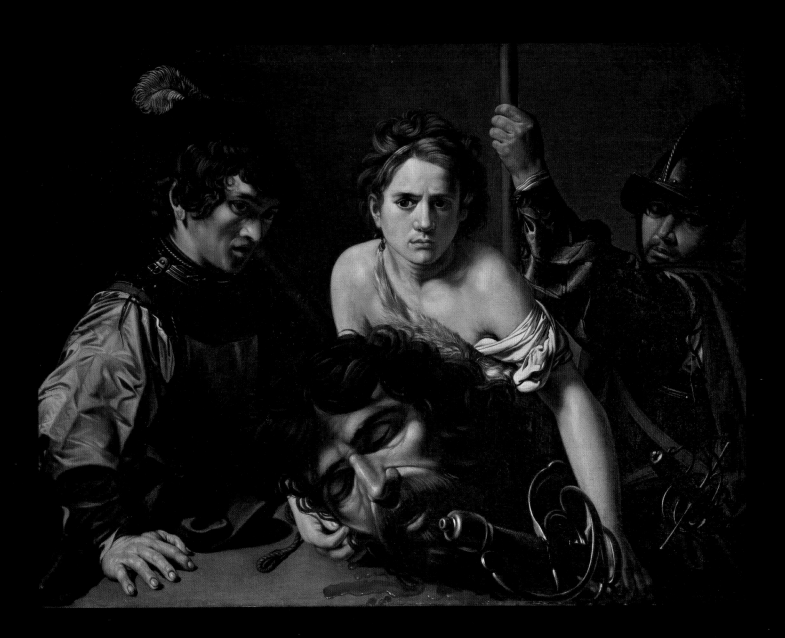

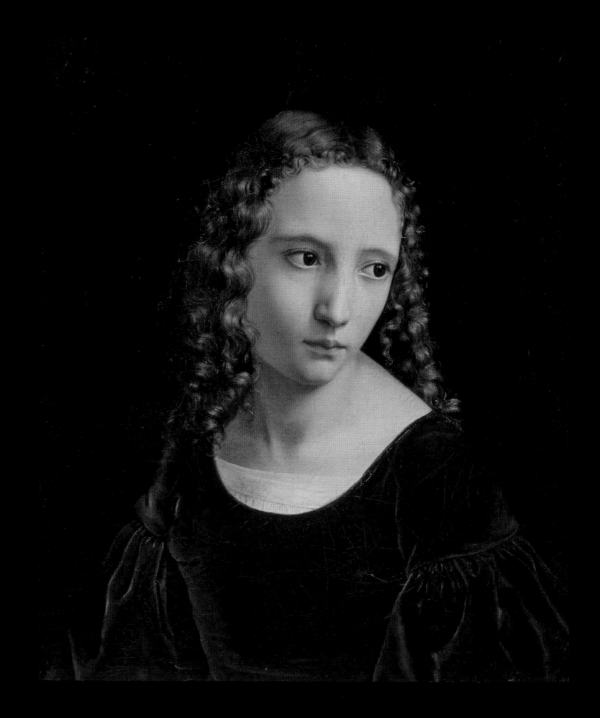

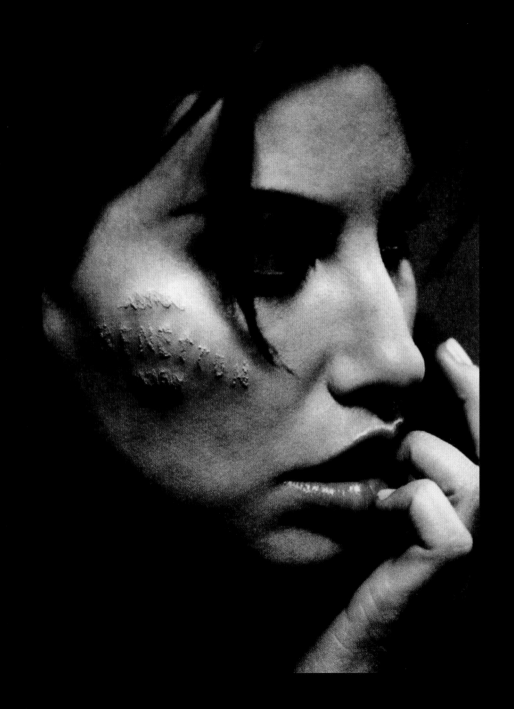

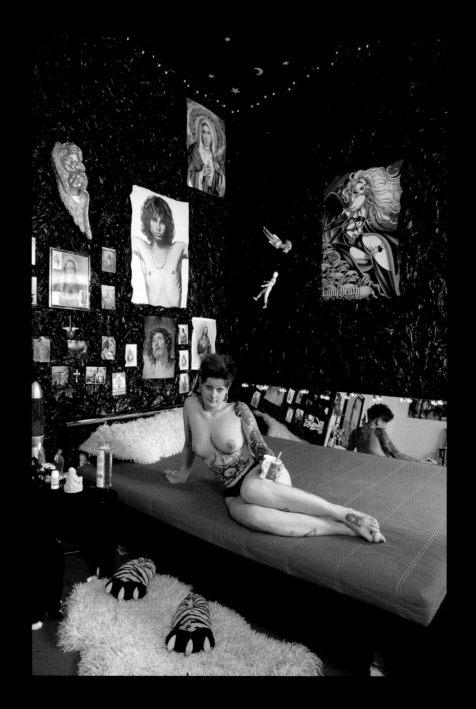

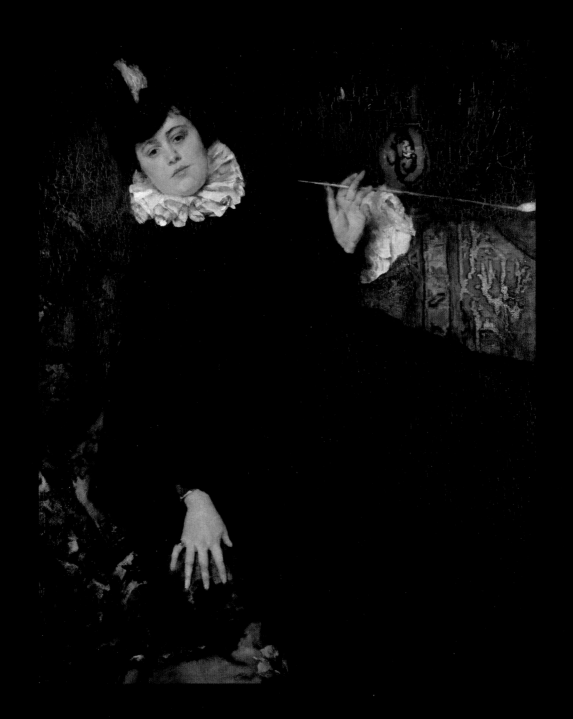

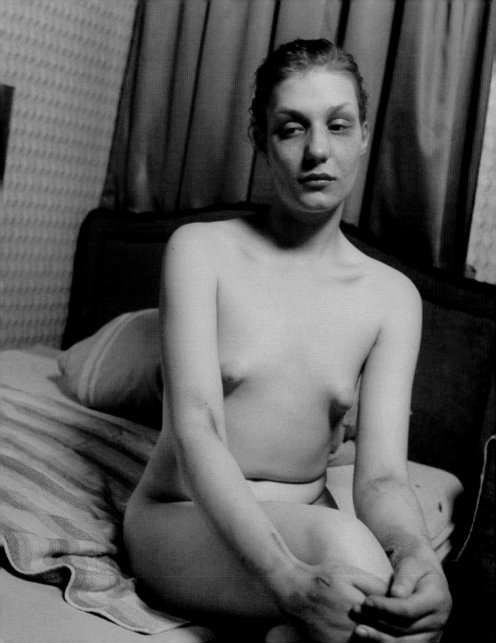

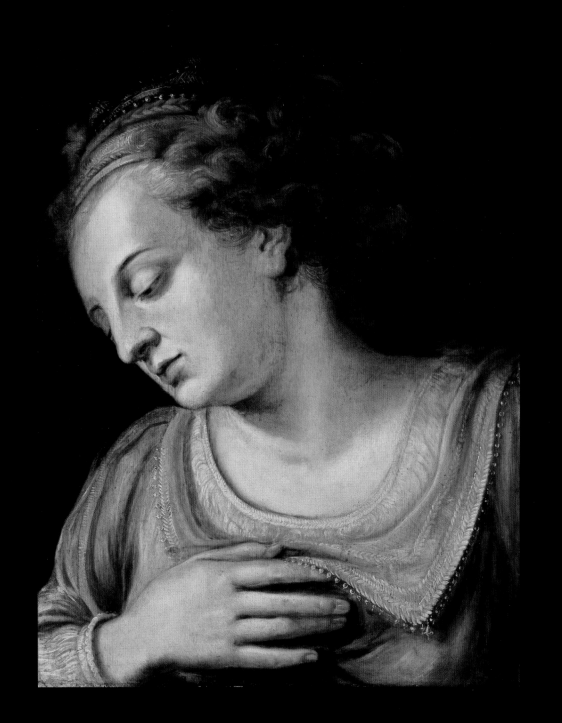

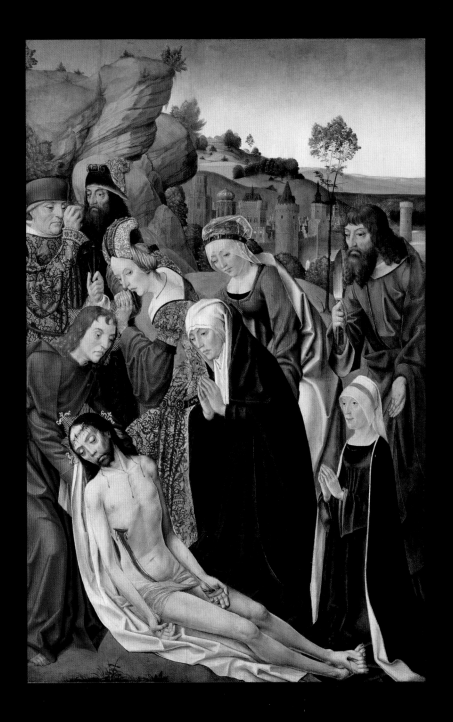

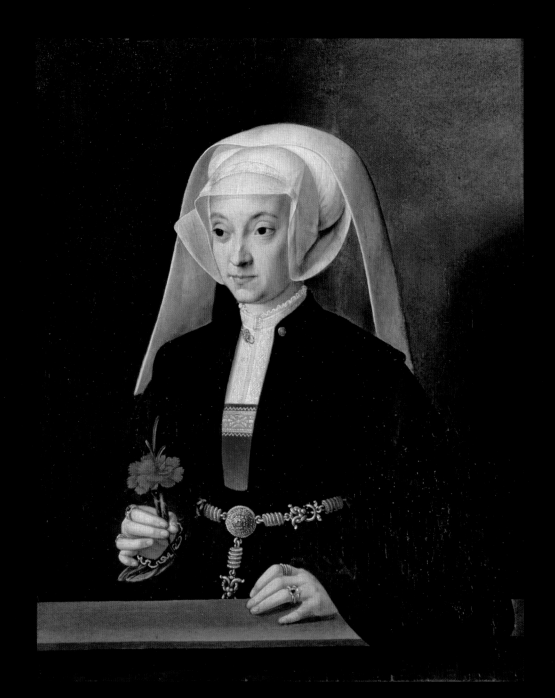

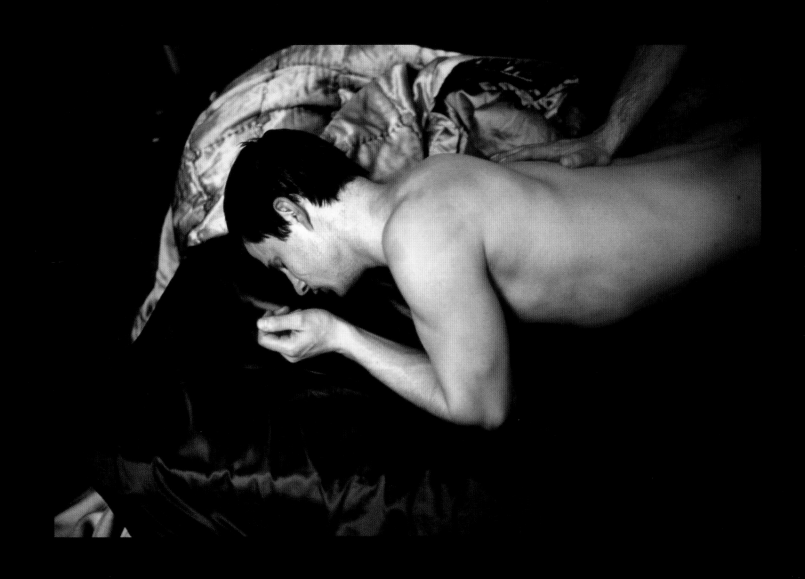

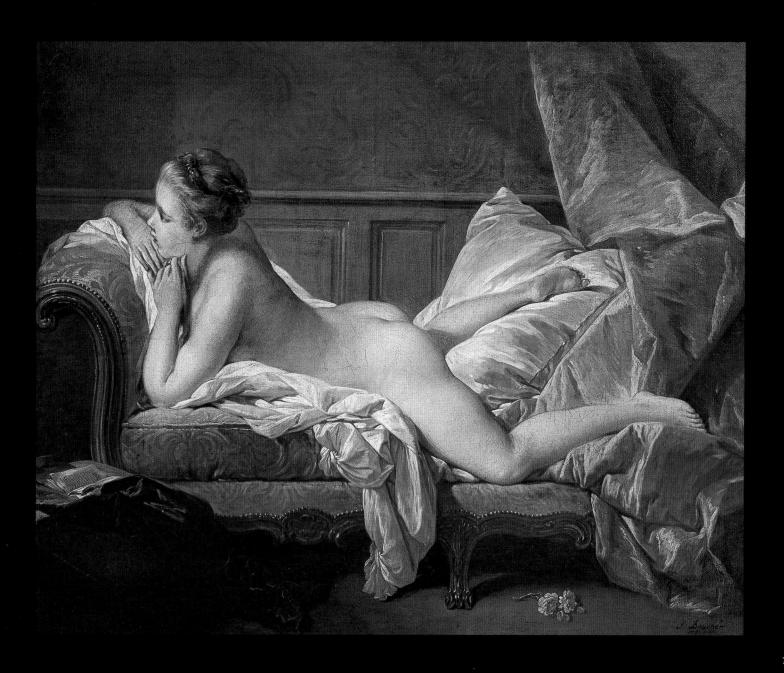

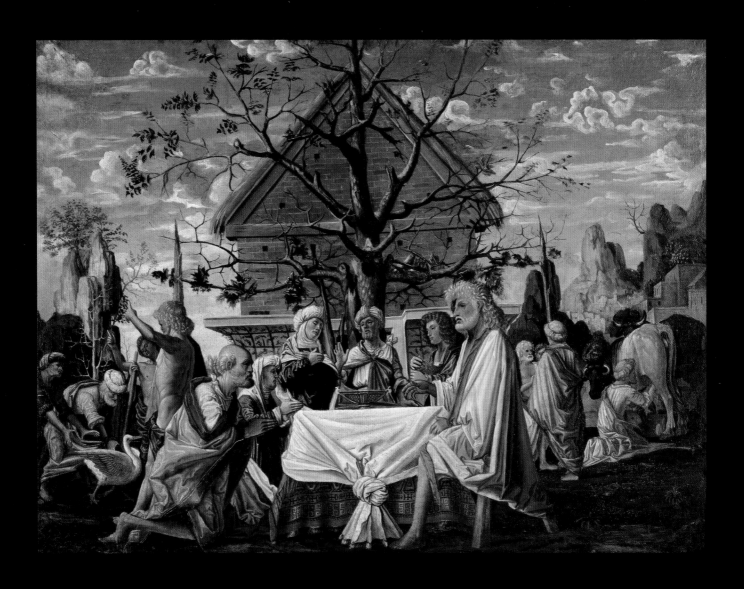

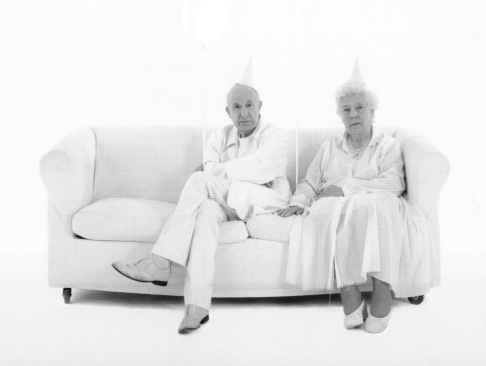

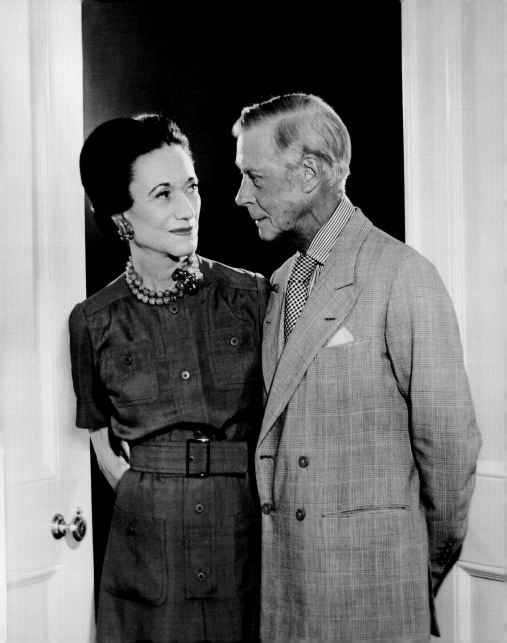

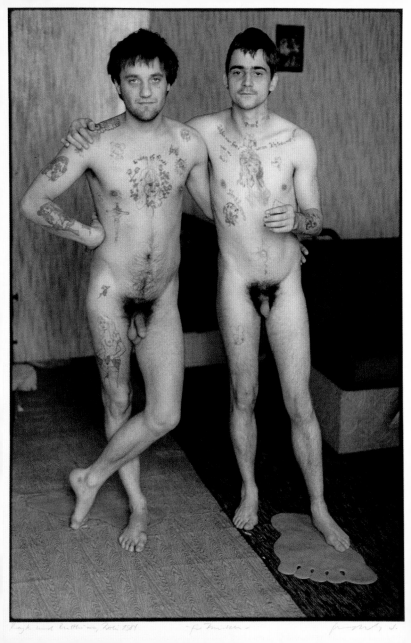

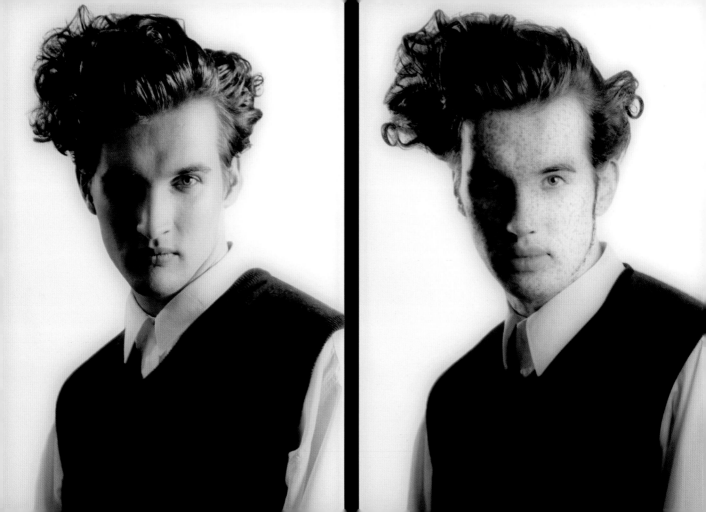

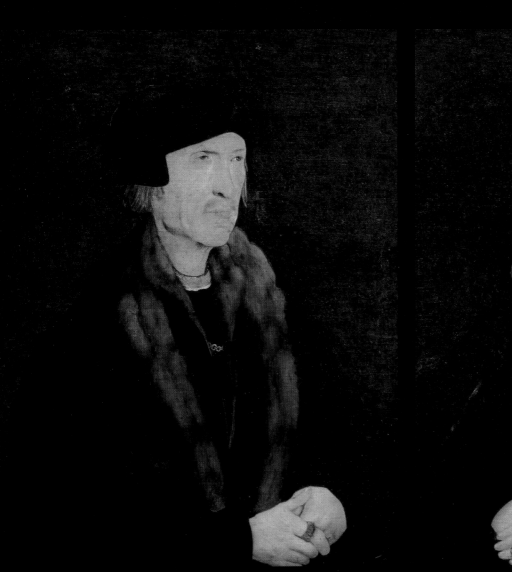
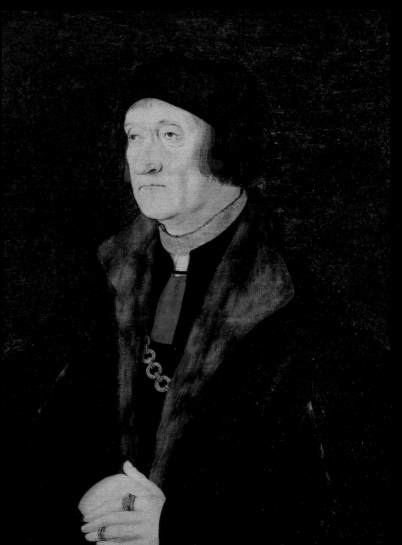

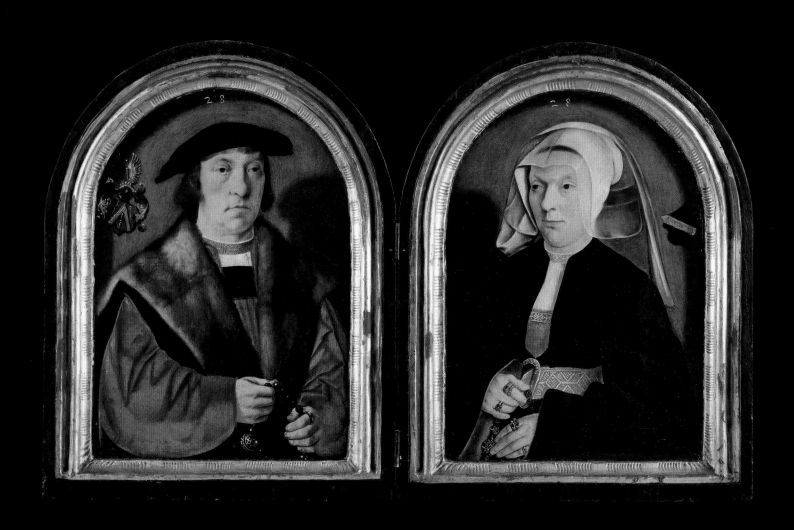

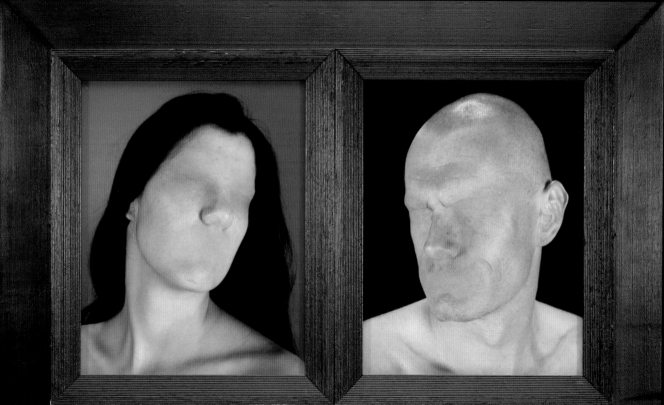

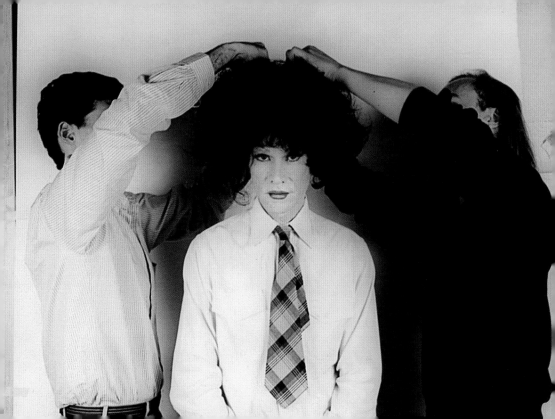

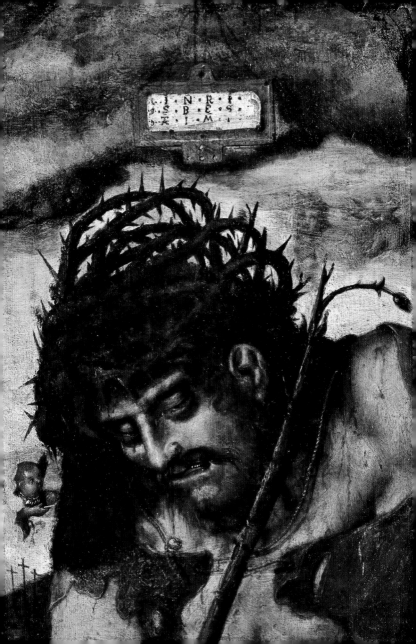

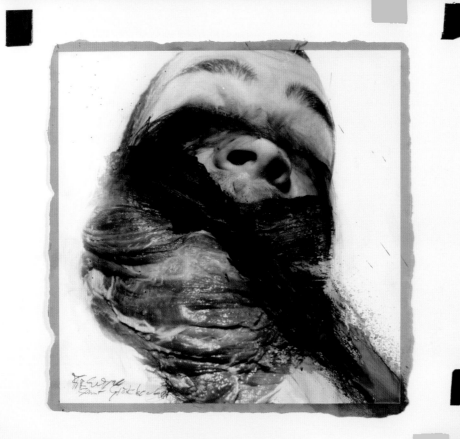

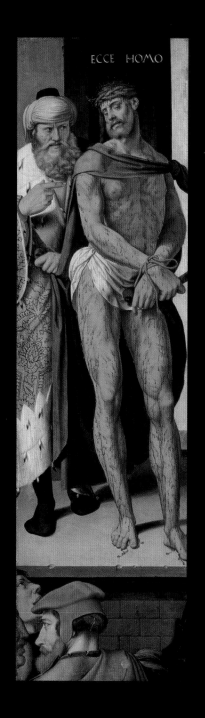

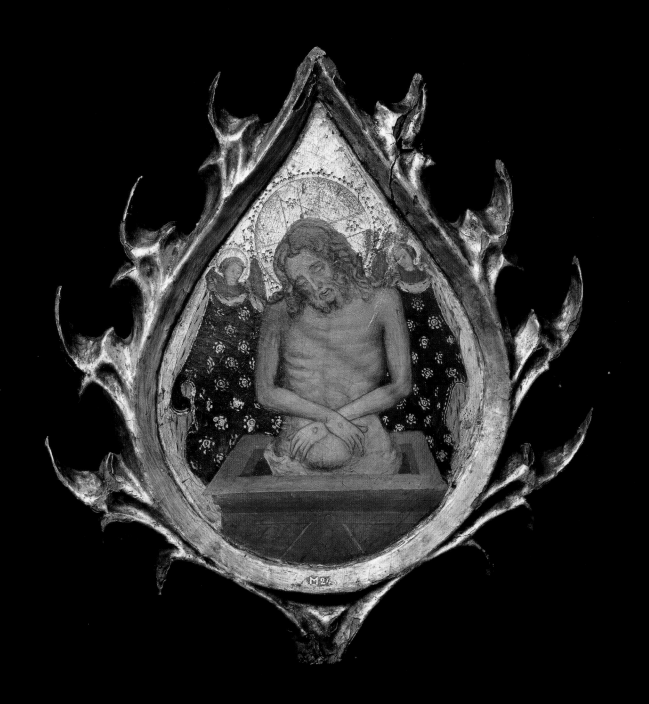

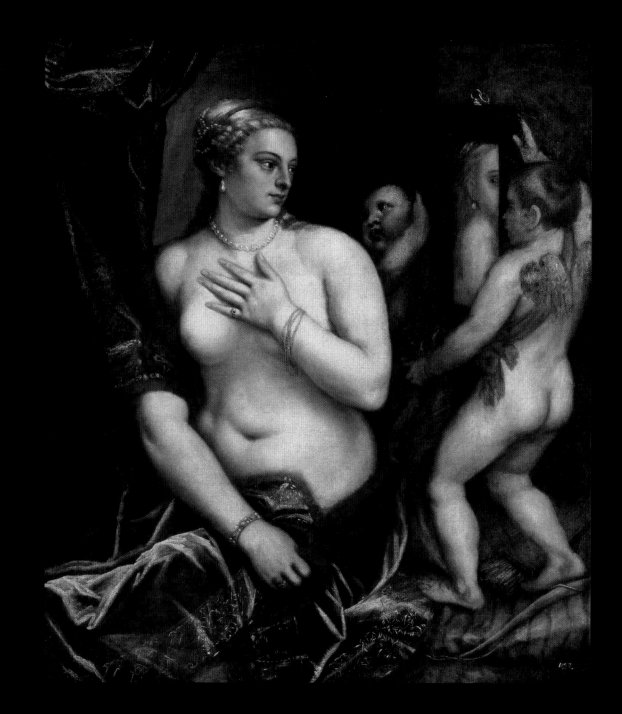

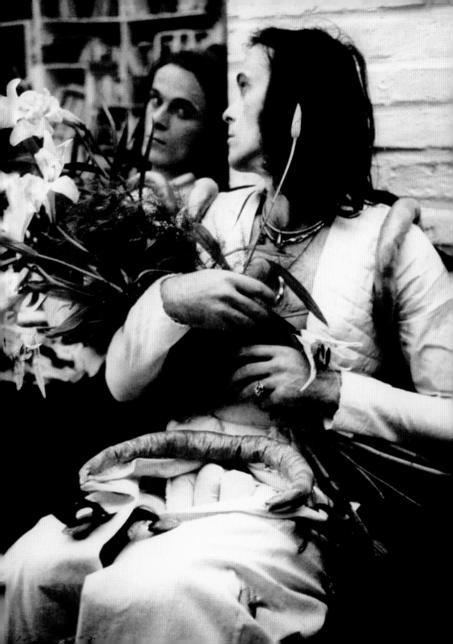

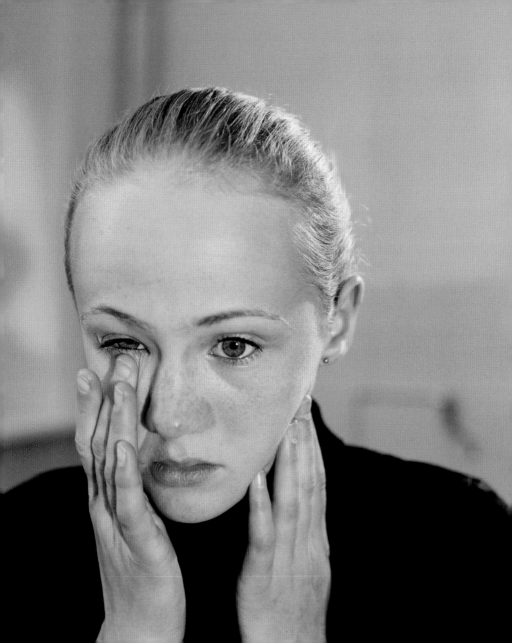

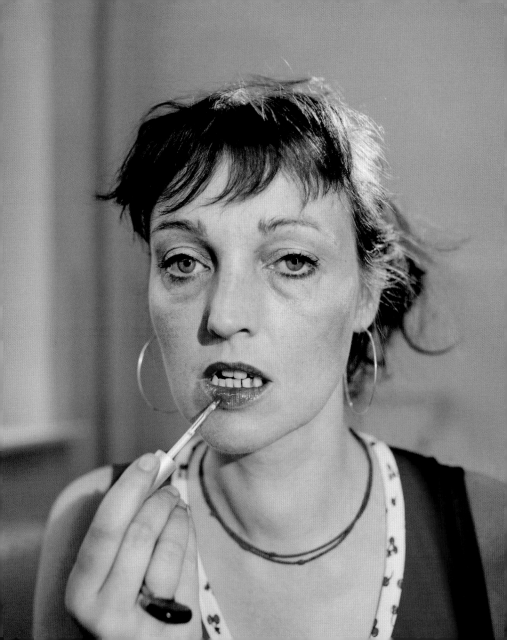

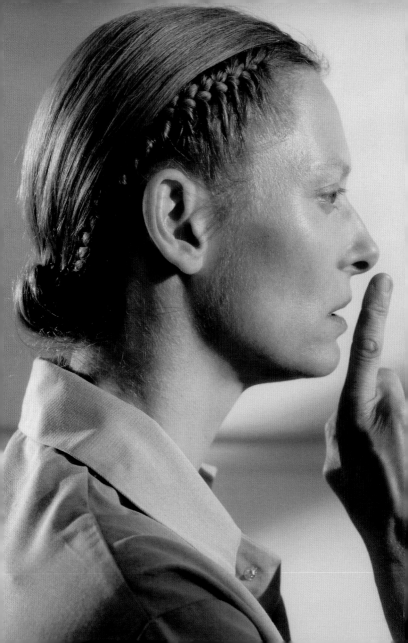

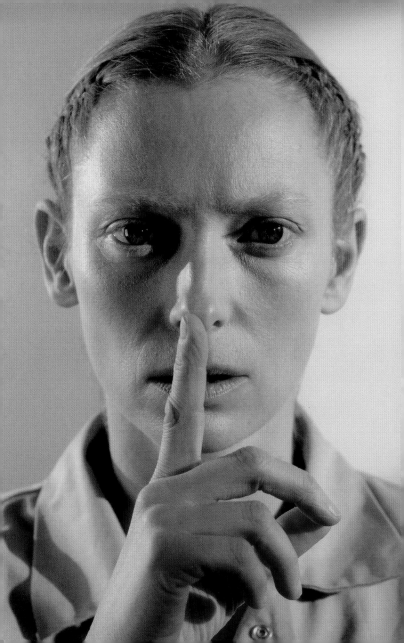

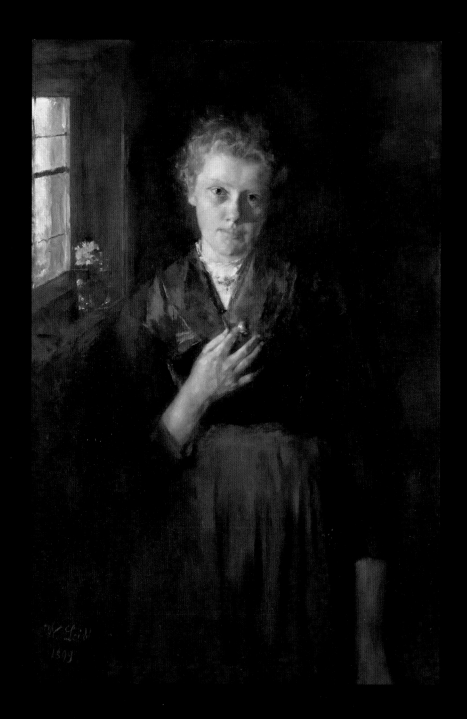

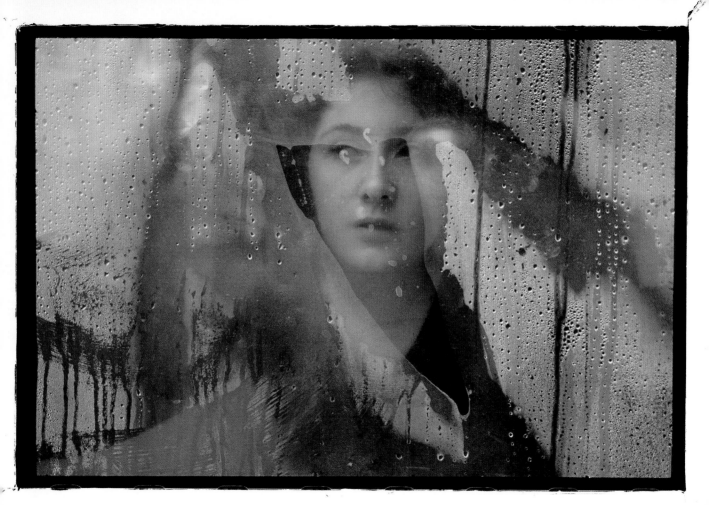

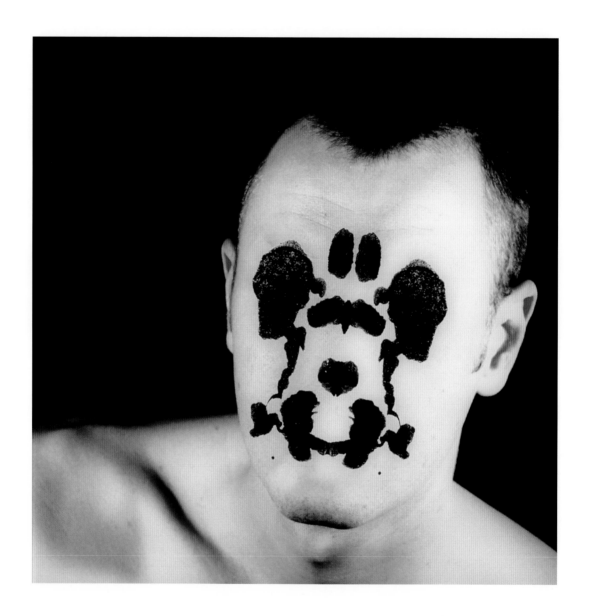

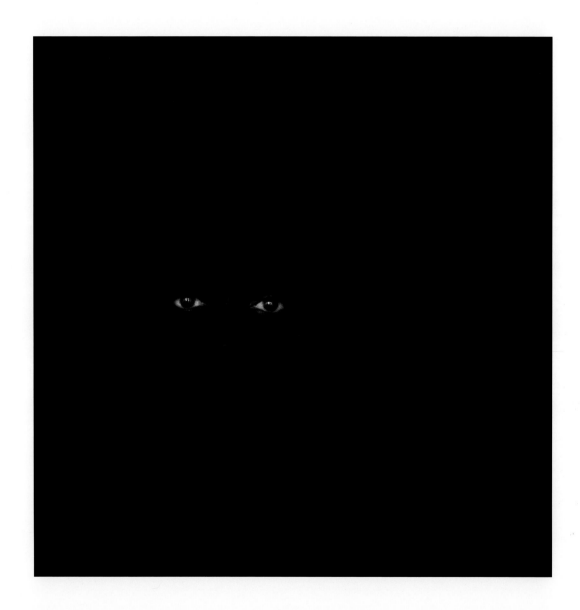

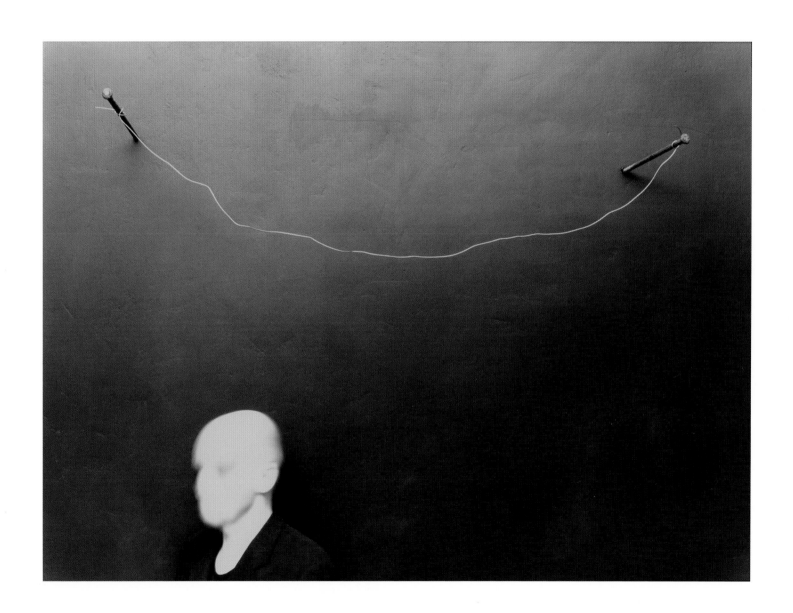

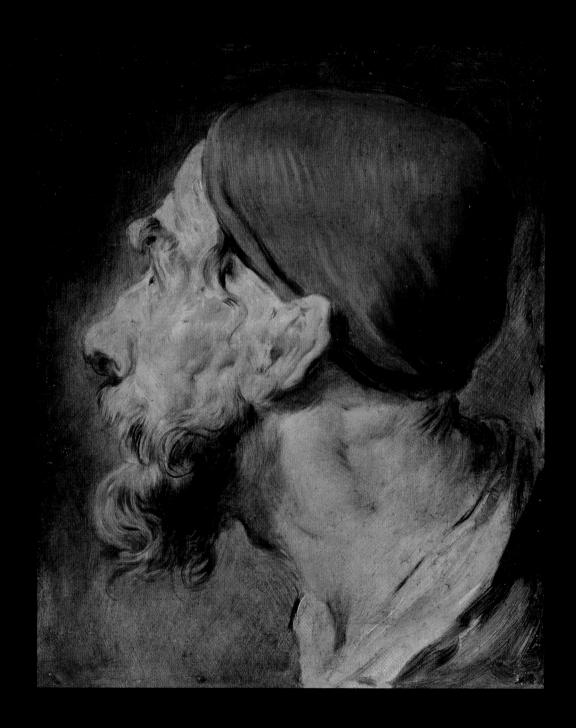

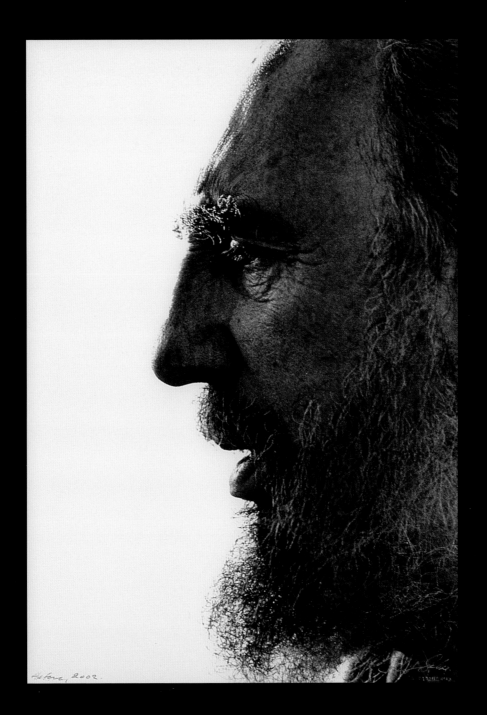

Tuttora, 2002.

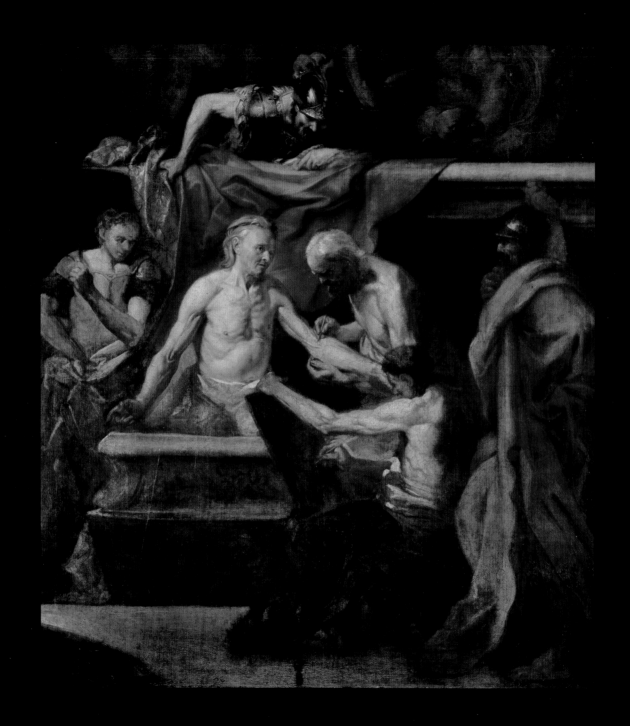

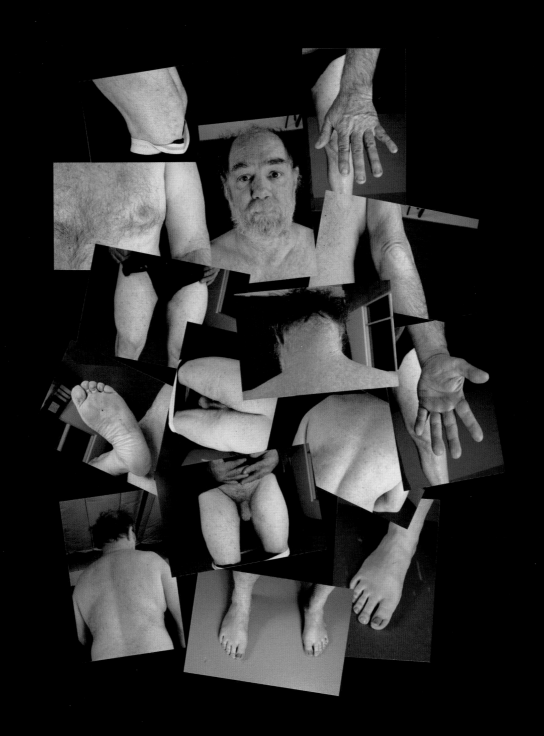

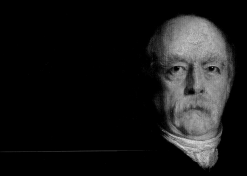

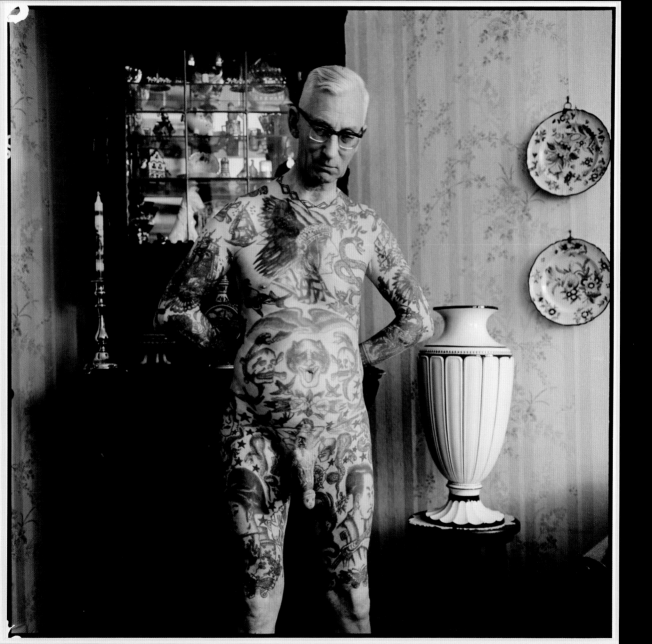

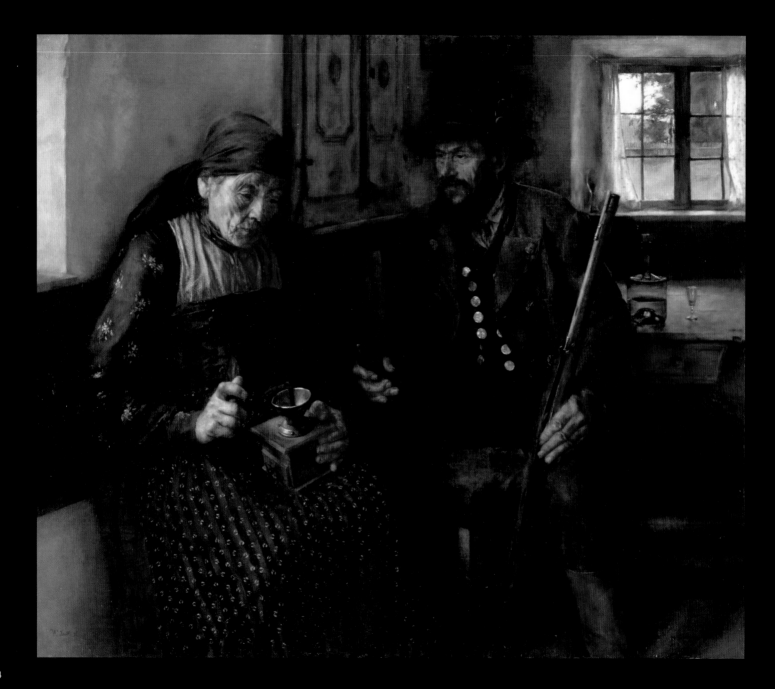

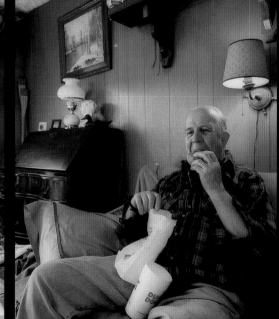

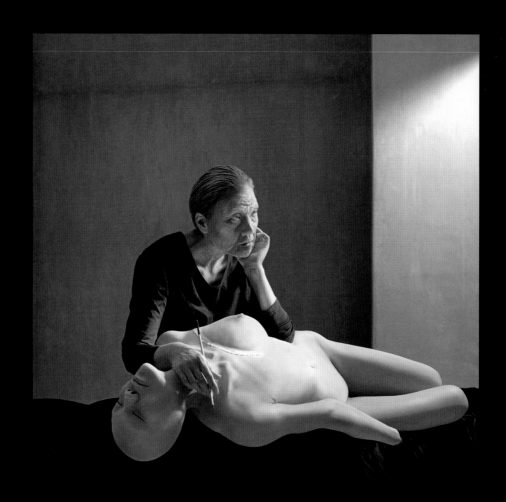

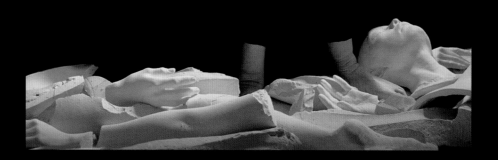

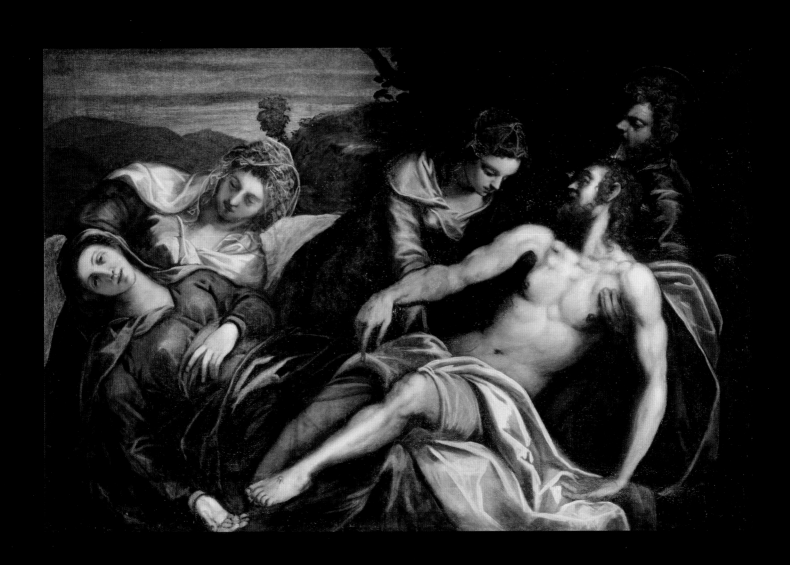

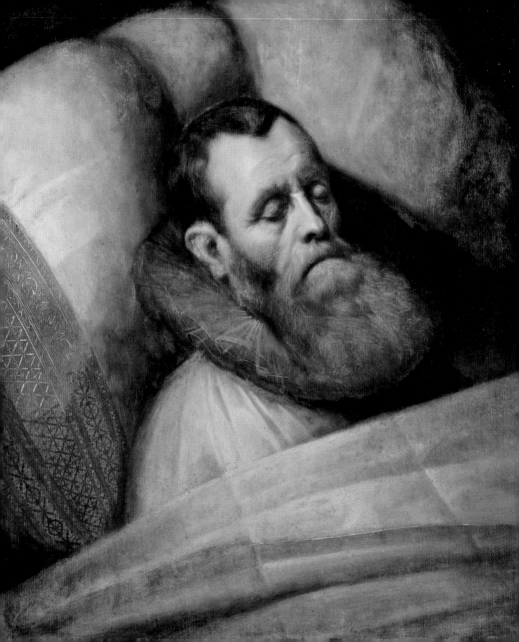

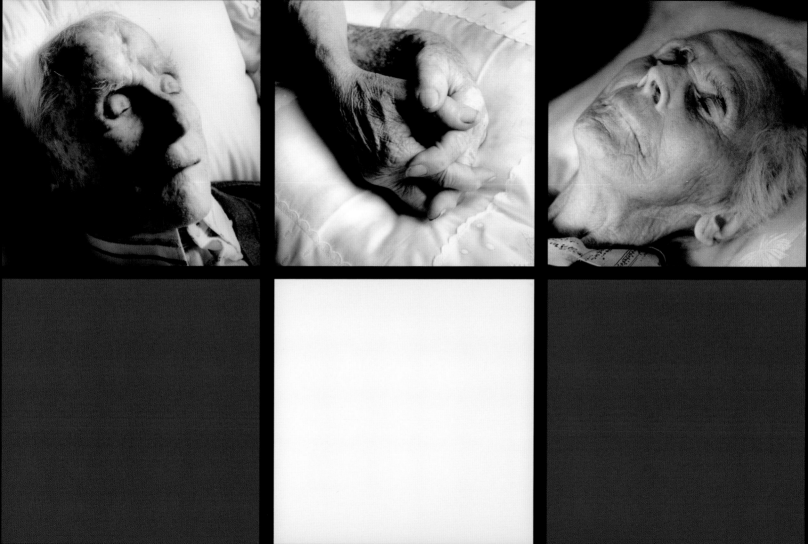

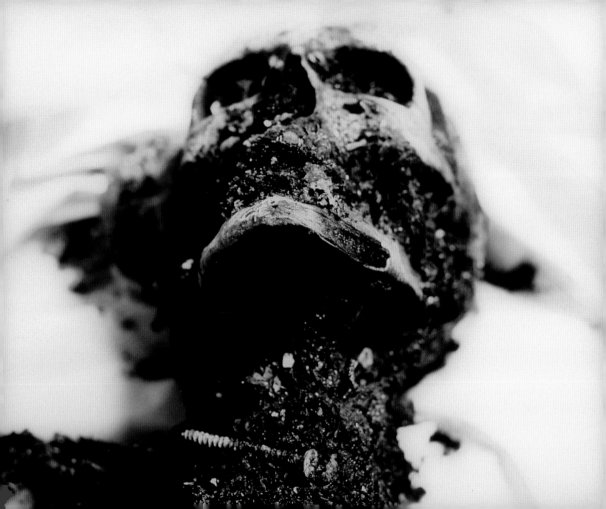

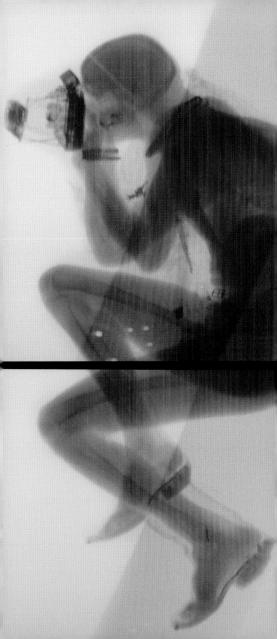

Schwangerschaft – Geburt – Kindheit

Pregnancy – Birth – Childhood

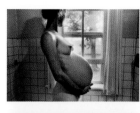

Larry Towell (*1953, lebt in Ontario, Kanada), *Ann Pregnant with Naomi, Lambton County, Ontario, Canada* **(aus der Serie** *Mennonites***), 1984, Silbergelatineprint 1998, 32 x 46,5 cm, rückseitig signiert, betitelt, datiert, Teutloff Photo + Video Collection, Bielefeld**

Seinen Reiz bezieht dieses Bild aus vielfältigen, formalen wie inhaltlichen Gegensätzen (rund–eckig, plastisch–flach, innen–außen, Zivilisation–Natur) und aus starker Symbolik: Der Baum als Zeichen des Lebens scheint aus dem Bauch der Schwangeren zu erwachsen. Die sich im Fensterkreuz fortsetzende Kachelung wirkt wie ein Koordinatensystem, in das sich das künftige Leben einfügen müssen wird – von der Gewöhnung an die Schwerkraft über die Gewinnung des Gleichgewichts bis hin zur Orientierung in Welt und Gesellschaft.

Larry Towell (b. 1953, lives in Ontario, Canada), *Ann Pregnant with Naomi, Lambton County, Ontario, Canada* **(from the series** *Mennonites***), 1984, gelatin silver print 1998, 32 x 46.5 cm, signed, titled and dated verso, Teutloff Photo + Video Collection, Bielefeld**

This picture derives its charm from numerous formal and thematic contrasts (round–angular, plastic–flat, inside–outside, civilization–nature) and from heavy symbolism: the tree as the sign of life seems to grow from the belly of the pregnant woman. The tiles, magnified into the crossbar of the window, have the effect of a coordinate system, into which the future life will have to integrate: from getting used to gravity, via gaining a sense of balance, to orientation in society and the world.

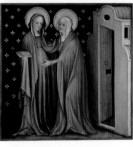

▷ Seite 52/53
Nr. 2, 1 der Ausstellung

Kölnisch, um 1420, *Heimsuchung***, Mischtechnik auf Tannenholz, 82 x 81,4 cm, Wallraf-Richartz-Museum & Fondation Corboud, Köln, Inv.-Nr. WRM 18**

Das Fragment eines Triptychons zeigt den Besuch der mit Jesus schwangeren Maria bei der mit Johannes schwangeren Elisabeth (Lukas 1,39–45). Die künftige Muttergottes erkennt man am Buch in ihrer Rechten: das Alte Testament als »Wort«, das noch nicht »Fleisch geworden ist« (Johannes 1,14). Die reduzierte Komposition betont den Gestus Elisabeths, die an der freudigen Regung ihres eigenen Fötus den noch ungeborenen Heiland erkennt: »Du bist gebenedeit unter den Frauen und gebenedeit ist die Frucht deines Leibes!«

Cologne, ca. 1420, *Visitation***, mixed media on deal, 82 x 81.4 cm, Wallraf-Richartz-Museum & Fondation Corboud, Cologne, inv. no. WRM 18**

The fragment of a triptych shows the visit of Mary (pregnant with Jesus) to Elizabeth (pregnant with John the Baptist) (Luke 1: 39–45). The future Mother of God can be recognized by the book in her right hand: the Old Testament as the "Word" that has *not yet* "been made flesh" (John 1:14). The spare composition emphasizes the gesture of Elizabeth, who recognizes the as yet unborn savior through the joyful quickening of her own unborn child: "Blessed art thou among women, and blessed is the fruit of thy womb."

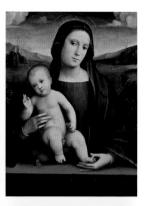

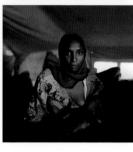

▷ Seite 54/55
Nr. 6, 7 der Ausstellung

Francesco Francia (um 1450–1517, Bologna) und Schüler (Giacomo Francia?), *Maria in Halbfigur mit Kind*, um 1516/17 (?), Öl auf Pappelholz, 56,9 x 42 cm, Wallraf-Richartz-Museum & Fondation Corboud, Köln, Inv.-Nr. WRM 521

Das Gemälde ist ein testamentarisches Vermächtnis des bedeutenden Kölner Kunstsammlers Sulpiz Boisserée, der es überaus schätzte und zwei Kopien davon anfertigen ließ. Die Muttergottes erscheint als Halbfigur hinter einer Brüstung. Während sie mit ihrer rechten Hand behutsam das Christuskind stützt, zeigt sie mit der linken dessen Fuß vor, der ja dereinst mit einem Nagel durchbohrt wird. Die nach links und rechts ausschwingende Landschaft im Hintergrund bildet gleichsam eine Nische für Mutter und Kind.

Adam Nadel (*1967, lebt in Jackson Heights, N.Y.), o.T., aus der Serie *Darfur*, Oktober 2004, C-Print, 49 x 49,5 cm, Teutloff Photo + Video Collection, Bielefeld

Die Reportageaufnahmen von Adam Nadel haben sich rasch aus dem diskursiven Kontext der Pressefotografie gelöst und die Weihen der Hochkunst erhalten. Ein entscheidender Grund dafür ist wohl seine Kenntnis und Verwendung klassischer Bildmotive und -strategien. Wie der Vergleich mit Francias Gemälde (s. oben) zeigt, beruht die Wirkung dieser Fotografie vor allem auf einem Zitat aus der religiösen Kunst: Es ist eine »Schwarze Madonna«, die wir hier sehen! Man vergleiche – quasi als Gegenstück – die *Pietà* von Miwa Yanagi (S. 116).

Francesco Francia (Bologna, ca. 1450–1517) and pupil (Giacomo Francia?), *Virgin and Child*, ca. 1516–17 (?), oil on poplar, 56.9 x 42 cm, Wallraf-Richartz-Museum & Fondation Corboud, Cologne, inv. no. WRM 521

The painting was a bequest from the important Cologne art collector Sulpiz Boisserée, who liked it greatly and had two copies made. The Mother of God appears half-length behind a balustrade. While she carefully supports the Christ Child with her right hand, she presents with her left his foot, which will one day be pierced with a nail. The extensive landscape to left and right in the background provides so to speak a niche for mother and child.

Adam Nadel (b. 1967, lives in Jackson Heights, N.Y.), untitled (from the series *Darfur*), October 2004, C print, 49 x 49.5 cm, Teutloff Photo + Video Collection, Bielefeld

The documentary photographs of Adam Nadel quickly emerged from the discursive context of press photography and were anointed as high art. A decisive reason for this is doubtless his knowledge and use of classical pictorial motifs and strategies. As a comparison with Francia's painting (above) shows, the effect of this photograph is due above all to a quotation from religious art: it is a "Black Madonna" which we see here. Compare, as a kind of opposite number, the *Pietà* of Miwa Yanagi (p. 116).

Loretta Lux (*1969 Dresden, lebt in Monaco), *Ophelia,* 2005, Ilfochrome-Print, 32 x 22,5 cm, Auflage: 5/20, Teutloff Photo + Video Collection, Bielefeld

Die inszenierten, digital bearbeiteten Porträts von Loretta Lux oszillieren zwischen Fotografie und Malerei. Der Titel verweist hier auf eine Figur aus Shakespeares *Hamlet,* zugleich aber auch auf deren zahlreiche Darstellungen von viktorianischen Malern. Obschon auf scheinbar abschüssigem Grund bewegt sich die »neue Ophelia« schlafwandlerisch sicher. Während der Bildausschnitt an Geldorp (s. unten) erinnert, ist die Perspektive eine andere: Erwachsene blicken von oben auf das Kind als fremdes, rätselhaftes Wesen.

Geldorp Gortzius (1553 Löwen – in oder nach 1619 Köln), *Bildnis eines Mädchens,* 1599, Öl auf Eichenholz, 68 x 51,5 cm, signiert, datiert oben rechts: AN°. 1599 . /. GG . F . (GG verschlungen), Wallraf-Richartz-Museum & Fondation Corboud, Köln, Inv.-Nr. WRM 1552

Der in Antwerpen ausgebildete Geldorp ließ sich 1579 in Köln nieder, wo er vor allem als Porträtist tätig war. Dieses Kinderbildnis zeigt eine zeittypische Inszenierung: Zwar begeben sich der Maler und mit ihm der Betrachter des Bildes hinab auf die Augenhöhe des Mädchens, doch erscheint dieses selbst – schon durch die Kleidung – als kleine Erwachsene. Klug eingesetzt ist die fein geklöppelte (wohl flämische) Spitze an den Rändern von Kragen und Haube: Sie verleiht dem sehr lebendigen Kindergesicht eine auratische Ausstrahlung.

Loretta Lux (b. 1969 Dresden, lives in Monaco), *Ophelia,* 2005, Ilfochrome print, 32 x 22.5 cm, edition: 5/20, Teutloff Photo + Video Collection, Bielefeld

The staged, digitally processed portraits by Loretta Lux oscillate between photography and painting. The title here refers to a character in Shakespeare's *Hamlet,* but at the same time also to numerous renderings by Victorian painters. Although she seems to be walking on a slippery slope, the "new Ophelia" is moving with the certainty of a sleepwalker. While the cropping is reminiscent of Geldorp (below), the perspective is different: grown-ups look down on the child as an alien, puzzling being.

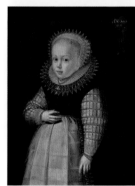

Geldorp Gortzius (1553 Louvain–in or after 1619 Cologne), *Portrait of a Girl,* 1599, oil on oak, 68 x 51.5 cm, signed and dated top right: AN°. 1599 . /. GG . F . (GG as monogram), Wallraf-Richartz-Museum & Fondation Corboud, Cologne, inv. no. WRM 1552

Geldorp was trained in Antwerp and in 1579 settled in Cologne, where he was primarily active as a portraitist. This portrait of a child shows a mise-en-scène typical of the time: While the painter and hence the beholder have a child's eye view, she herself comes across as a small adult, if only by dint of her clothing. A cleverly executed feature is the fine lace (doubtless Flemish) on the edges of her collar and bonnet: it bestows a charismatic aura on the lively face of the child.

▷ Seite 56/57
Nr. 10, 11 der Ausstellung

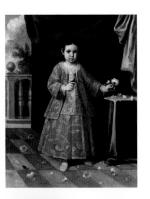

▷ Seite 58/59
Nr. 14, 12/13 der Ausstellung

Alonso Miguel de Tovar (1678 Higuera de la Sierra–1752 Madrid), *Bildnis eines Kindes*, 1732, Öl auf Leinwand, 103 x 81,5 cm, signiert: Tobar ft. 1732, Wallraf-Richartz-Museum & Fondation Corboud, Köln, Inv.-Nr. WRM 2039, erworben 1916 als Vermächtnis der Frau Emmy Schnitzler, Berlin

Dieses wohl in Sevilla gemalte Bild zeigt das Kind einer aristokratischen Familie – vielleicht aus dem Umkreis des Hofes. Man vermutet, dass es zum Zeitpunkt der Bildentstehung bereits gestorben war. Die duftenden, aber kurzlebigen Rosen- und Jasminblüten könnten sowohl auf die Vergänglichkeit des menschlichen Lebens als auch (zusammen mit dem Ausblick im Hintergrund) auf das Paradies verweisen. Mit einem Distelfink in der Hand (als Symbol für die Passion) wird sonst oft das Christuskind dargestellt.

Margi Geerlinks (*1970 Kampen, Niederlande), *Young Lady I*, 2001, Cibachrome mit Plexiglas auf Dibond, 100 x 73 cm, rückseitig signiert, betitelt, nummeriert: Ed. of 9, A.P. 1; *Young Man*, 2002, Ilfoflex mit Plexiglas auf Dibond, 100 x 73 cm, Auflage: 3/6, rückseitig signiert, betitelt, nummeriert, Teutloff Photo + Video Collection, Bielefeld

Die beiden Fotografien reflektieren die Konstruktion von Kindheit und Geschlecht in Sprache, Bild und Mode. Ihre Titel verweisen auf scheinbar spaßige Anreden, mit denen Erwachsene Kinder zu ihresgleichen machen. Während der Junge eine zweite Haut mit Brusthaar trägt, übt sich das Mädchen in Handarbeit, quasi ihre eigene Brust häkelnd. Mehrdeutig ist der fleischfarbene Wollfaden: Nabelschnur oder Ariadnefaden durch das Labyrinth des Lebens (vgl. S. 105)?

Alonso Miguel de Tovar (1678 Higuera de la Sierra–1752 Madrid), *Portrait of a Child*, 1732, oil on canvas, 103 x 81.5 cm, signed: Tobar ft. 1732, Wallraf-Richartz-Museum & Fondation Corboud, Cologne, inv. no. WRM 2039, acquired in 1916 as bequest of Frau Emmy Schnitzler, Berlin

This picture, probably painted in Seville, shows the child of an aristocratic family, maybe one that moved in courtly circles. It is believed that the child was dead by the time the picture was painted. The scented but short-lived roses and jasmines could refer both to the transience of human life and (together with the view in the background) to Paradise. The Christ Child was also often portrayed with a goldfinch as a symbol of the Passion.

Margi Geerlinks (b. 1970 Kampen, The Netherlands), *Young Lady I*, 2001, Cibachrome with Plexiglas on Dibond, 100 x 73 cm, signed, titled, numbered verso: Ed. of 9, A.P. 1; *Young Man*, 2002, Ilfoflex with Plexiglas on Dibond, 100 x 73 cm, edition: 3/6, signed, titled and numbered verso, Teutloff Photo + Video Collection, Bielefeld

The two photographs (which recall a well-known wax sculpture by Robert Gober) reflect on the construction of childhood and gender in language, pictures and fashion. Their title refers to seemingly jocular forms of address by which adults raise children to their own status. While the boy has a second skin with chest hair, the girl is practicing needlework, so to speak crocheting her own breast. The flesh-colored woolen thread is ambiguous: Is it perhaps an umbilical cord or an Ariadne's thread intended to guide the child through the labyrinth of life (cf. p. 105)?

Jugend

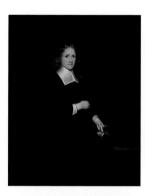

Gerard ter Borch d.J. (1617 Zwolle–1681 Deventer),
Bildnis eines jungen Mannes, Öl auf Leinwand, 46 x 37 cm,
bezeichnet über dem Hut: GTB (verbunden),
Wallraf-Richartz-Museum & Fondation Corboud, Köln,
Inv.-Nr. WRM 1012

Der lebendige, aber träumerische Blick dieses jungen Mannes
scheint knapp am Betrachter vorbei (oder durch ihn hindurch)
zu gehen. Sein feines, unter dem noch zarten Bartflaum nur an-
gedeutetes Lächeln wirkt umso stärker, als das Gemälde selbst
von Ernst und Ruhe getragen ist. Die vom Kopf nach rechts
unten abfallende Kompositionslinie verweist auf abgenommene
Kleidungsstücke: Handschuhe und Hut. Zu dieser ostentativen
Entblößung und Offenheit passt der Beteuerungsgestus der rech-
ten Hand: ein puristisches, ja »puritanisches« Bild.

Thomas Hoepker (*1936 München, lebt in New York),
Muhammad Ali's Fist, 1966, Collectors archival dye print
2007, 83 x 60 cm, Auflage: 4/20, rückseitig signiert, numme-
riert, gestempelt, Teutloff Photo + Video Collection, Bielefeld
Es fällt schwer, eine malerische Tradition für dieses berühmte
Foto namhaft zu machen. Allenfalls mit Bogen oder Armbrust
auf den Betrachter zielende allegorische Figuren der Liebe oder
des Todes wären zu nennen. 1966 zeichnete sich ab, dass
Muhammad Ali den Kriegsdienst in Vietnam verweigern würde.
Dieses Bild antwortet auf das klassische Rekrutierungsplakat
I want you for U.S. Army mit dem auf den Betrachter zeigenden
Uncle Sam. Muhammad Ali hält ihm (und uns) seine nackte –
schwarze – Faust unter die Nase.

Youth

Gerard ter Borch the Younger (1617 Zwolle–1681 Deventer),
Portrait of a Young Man, oil on canvas, 46 x 37 cm, inscribed
above the hat: GTB (as monogram), Wallraf-Richartz-Museum &
Fondation Corboud, Cologne, inv. no. WRM 1012

The lively but dreamy gaze of this young man seems not quite to meet
that of the beholder (or else passes straight through the latter). His
delicate smile, merely hinted at beneath the still soft down of his
beard, comes across all the more strongly in that the painting itself is
characterized by seriousness and calm. The compositional line, falling
away from the head toward the bottom right, leads to clothing acces-
sories that the man has taken off: gloves and hat. The gesture of
assertion made by the right hand fits in with this ostentatious act of
disrobement and frankness: a purist, indeed "puritanical" picture.

Thomas Hoepker (b. 1936 Munich, lives in New York),
Muhammad Ali's Fist, 1966, collectors' archival dye print 2007,
83 x 60 cm, edition: 4/20, signed, numbered and stamped verso,
Teutloff Photo + Video Collection, Bielefeld

It is difficult to name a painterly tradition for this famous photograph.
At most, one could think perhaps of allegorical figures of love or death
aiming at the beholder with a long or cross-bow. In 1966 it was
becoming clear that Muhammad Ali would refuse to do military ser-
vice in Vietnam. This picture is a response to the classic recruitment
poster "I want YOU for U.S. Army" with Uncle Sam pointing to the
beholder. Muhammad Ali holds his naked (black) fist under his (and
our) nose.

▷ Seite 60/61
Nr. 22, 19 der Ausstellung

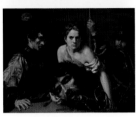

▷ Seite 62/63
Nr. 21, 20 der Ausstellung

Brian Finke (*1976 Philadelphia, lebt in New York), *Untitled (Football #16)*, 2002, C-Print auf Plexiglas mit UV-Beschichtung, 37,5 x 37,5 cm, Auflage: 8/10, rückseitig signiert, datiert, nummeriert, Teutloff Photo + Video Collection, Bielefeld

Mit einem kleinen Bild ruft Brian Finke eine Tradition großformatiger Historiengemälde auf. Bezugspunkte dieser Fotografie sind im Barock (s. unten) und in der französischen Malerei des 19. Jahrhunderts zu finden, bei Jacques-Louis David (*Schwur der Horatier*), Théodore Géricault (*Das Floß der Medusa*) und Eugène Delacroix (*Die Freiheit führt das Volk*). Schon Joe Rosenthals Foto *Hissen der Flagge auf Iwo Jima* (1945) stand in dieser Tradition. Bei Finke allerdings scheinen Held und Historienbild ironisch gebrochen.

Kopie nach Valentin De Boullogne, genannt Le Valentin (1594 [?] Coulommiers/Seine-et-Marne–1632 Rom), *David mit dem Haupt Goliaths*, um 1620/22, Öl auf Leinwand, 105,5 x 133 cm, Wallraf-Richartz-Museum & Fondation Corboud, Köln, Inv.-Nr. WRM 1456

Das von einem römischen Caravaggisten gemalte Bild zeigt David (später König von Israel) als Sieger über Goliath. Der junge Hirte hatte den riesenhaften Philister mit einer Schleuder bezwungen. Hier posiert er mit dessen abgeschlagenem Kopf. Davids Leistung wird durch den Größenvergleich zwischen dem Schwert Goliaths und dem des Kriegers rechts verdeutlicht. Ähnlich wie sehr viel später bei Finke (s. oben) erscheint der jugendliche Held umgeben von Gefährten. Gut vergleichbar ist auch der jeweils entblößte, quergestellte Schultergürtel.

Brian Finke (b. 1976 Philadelphia, lives in New York), untitled *(Football #16)*, 2002, C print on Plexiglas with UV coating, 37.5 x 37.5 cm, edition: 8/10, signed, dated and numbered verso, Teutloff Photo + Video Collection, Bielefeld

With this little picture, Brian Finke recalls the tradition of large-format history painting. The references of this photograph are to be found in the Baroque (below) and in 19th-century French painting, for example Jacques-Louis David (*The Oath of the Horatii*), Théodore Géricault (*The Raft of the Medusa*) and Eugène Delacroix (*Liberty Leading the People*). Joe Rosenthal's 1945 photograph *Raising the Flag on Iwo Jima* was already in this tradition. In Finke's case, however, hero and history picture seem to be treated ironically.

Copy after Valentin De Boullogne, known as Le Valentin (1594 [?] Coulommiers, Seine-et-Marne–1632 Rome), *David with the Head of Goliath*, ca. 1620–22, oil on canvas, 105.5 x 133 cm, Wallraf-Richartz-Museum & Fondation Corboud, Cologne, inv. no. WRM 1456

This picture, painted by a Roman Caravaggisto, shows David (later King of Israel) as victor over Goliath. The young shepherd boy had felled the giant Philistine with a slingshot. Here he is posing with the latter's severed head. David's achievement is emphasized by the relative sizes of Goliath's sword and that of the warrior on the right. Just as very much later in Finke's picture (above), the youthful hero appears surrounded by companions. Also comparable is the shoulder girdle, in both cases naked and oblique to the line of sight.

Louis Ammy Blanc (1810 Berlin–1885 Düsseldorf), *Mädchenkopf*, 1835, Öl auf Leinwand auf Karton, 40,5 x 33,5 cm, mongrammiert, datiert unten links: L. B. / Df. 35., Wallraf-Richartz-Museum & Fondation Corboud, Köln, Inv.-Nr. WRM 1138, erworben 1922 als Geschenk der Domgalerie

Etwa in der Art dieses Bildes möchte man sich das romantische *Oval Portrait* bei Edgar Allan Poe vorstellen (siehe Beitrag Roland Krischel im vorliegenden Band). Die leichte Schrägstellung der Büste, das lockige, wie ziseliert erscheinende Haar, ja selbst das samtene Kleid und die darunter am Décolleté erscheinende feine Wäsche sind durchaus vergleichbar mit Damenporträts der italienischen Renaissance (Leonardo, Tizian). Neu ist die Wendung des Kopfes: Als reagiere sie auf eine Ansprache, wendet sich die Porträtierte dem Licht zu.

Daniele Buetti (*1955 Fribourg, Professur für Fotografie in Münster), *Benetton*, 1998/2004, Inkjet-Print auf gestrichenem Papier, 43 x 32,2 cm, Auflage: 15/40, rückseitig bezeichnet, datiert, signiert, Teutloff Photo + Video Collection, Bielefeld

Als Bildnis steht die Aufnahme in der Nachfolge von Blanc (s. oben). Ein Verfremdungseffekt entsteht durch den in die Wange getriebenen Markennamen. Man denkt an Oliviero Toscanis Werbefotos für Benetton und an Juergen Tellers Versace-Aufnahmen. Menschliche Haut und Epidermis des fotografischen Bildes werden bei Buetti zur Deckung gebracht und zugleich die widerstreitenden Auffassungen von diesem Medium (»Abdruck« versus »Codierung«) ironisch zusammengeführt. Letztlich mutiert die junge Frau zu einer Allegorie der Fotografie.

Louis Ammy Blanc (1810 Berlin–1885 Düsseldorf), *Head of Girl*, 1835, oil on canvas mounted on cardboard, 40.5 x 33.5 cm, monogrammed, dated bottom left: L. B. / Df. 35., Wallraf-Richartz-Museum & Fondation Corboud, Cologne, inv. no. WRM 1138, acquired in 1922 as a gift from the Domgalerie

It is something like this picture that one would like to imagine the Romantic *Oval Portrait* in the story of that name by Edgar Allan Poe (see the essay by Roland Krischel in this volume). The slight obliquity of the bust, the curly hair, looking like goldsmith's work, and indeed even the velvet dress and the delicate lingerie visible at the décolleté are entirely comparable with Italian Renaissance portraits of ladies (Leonardo, Titian). What is new is the turn of the head: as though she were reacting to words being addressed to her, the sitter is turning to the light.

Daniele Buetti (b. 1955 Fribourg, professor of photography in Münster), *Benetton*, 1998/2004, inkjet print on coated paper, 43 x 32.2 cm, edition: 15/40, inscribed, dated and signed verso, Teutloff Photo + Video Collection, Bielefeld

As a portrait, this photograph is in the tradition of Blanc (above). A defamiliarization effect is achieved by the brand-name scarification of the cheek. One is reminded of Oliviero Toscani's advertising photos for Benetton and Juergen Teller's Versace pictures. Human skin and the epidermis of the photographic image are matched in Buetti's work, and at the same time the rival views of this medium ("indexicality" versus "coding") are ironically brought together. Ultimately the young woman mutates into an allegory of photography.

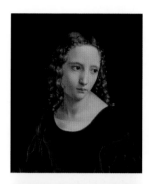

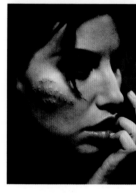

▷ Seite 64/65
Nr. 24, 25 der Ausstellung

128

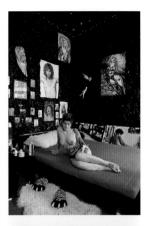

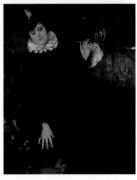

▷ Seite 66/67
Nr. 27, 26 der Ausstellung

Herlinde Koelbl (*1939 Lindau, lebt in München), *Berlin, Andrea Kummer, Studentin* (aus der Serie *Bedrooms*), 2004, C-Print auf Spezialpapier, Blattmaß: 41,6 x 61,8 cm, Teutloff Photo + Video Collection, Bielefeld

Wie Leibl (s. unten) zeigt Koelbl einen neuen Typus der jungen Frau und verweist dabei zugleich auf ältere künstlerische Traditionen: Spiegelbilder nackter junger Damen finden sich in den Venusdarstellungen von Tizian (S. 92) und Diego Velázquez. Bei Koelbl fungieren die Bilder im Bild als zusätzliche Spiegelungen der Dargestellten. Im Gegenzug setzt sich die Bildwelt der Wände auf der Haut der Porträtierten fort: »Der linke Arm ist der böse mit Teufelsfrauen, der rechte wird der gute, auf dem werden Jesus und Maria tätowiert.« (Andrea Kummer)

Wilhelm Leibl (1844 Köln–1900 Würzburg), *Die junge Pariserin*, 1869, Öl auf Mahagoniholz, 64,5 x 52,5 cm, signiert, datiert oben rechts: W. Leibl/1869, Wallraf-Richartz-Museum & Fondation Corboud, Köln, Inv.-Nr. WRM 1170

Die Gattung Porträt dient hier als Vorwand für eine äußerst delikate, man möchte sagen: kulinarische Komposition aus Farben und Formen. Sowohl die dunkle, atmosphärische Tonigkeit des Gemäldes wie auch die Motivwahl (teppichartiger Stoff, Krug aus glasiertem Steinzeug, langstielige Tonpfeife) und der Farbauftrag verweisen auf die holländische Malerei des 17. Jahrhunderts (Jan Steen, Frans Hals). Zu Leibls Ärger deutete man die rauchende Frau mit Pierrotkragen als Dame der Halbwelt, als »Kokotte«.

Herlinde Koelbl (b. 1939 Lindau, lives in Munich), *Berlin, Andrea Kummer, Student* (from the series *Bedrooms*), 2004, C print on special paper, sheet: 41.6 x 61.8 cm, Teutloff Photo + Video Collection, Bielefeld

Like Leibl (below) Koelbl shows a new type of young woman and refers at the same time to earlier artistic traditions: Pictures of naked young ladies in mirrors can be found in depictions of Venus by Titian (p. 92) and Diego Velázquez. In Koelbl's work, the pictures within the picture function as additional reflections of the sitter. Conversely, the pictorial world of the walls is continued on her skin: "The left arm is the evil one with devil's women, the right arm is the good one, with tattoos of Jesus and Mary" (Andrea Kummer).

Wilhelm Leibl (1844 Cologne–1900 Würzburg), *The Young Parisienne*, 1869, oil on mahogany, 64.5 x 52.5 cm, signed and dated top right: W. Leibl/1869, Wallraf-Richartz-Museum & Fondation Corboud, Cologne, inv. no. WRM 1170

The portrait genre serves here as a pretext for an extremely delicate, one is tempted to say culinary, composition of colors and forms. Both the dark, atmospheric tonality of the painting and also the choice of motif (carpet-like material, glazed stoneware jug, long-shanked clay pipe) and the paint application refer back to Dutch painting of the 17th century (Jan Steen, Frans Hals). Leibl was annoyed to find that the smoking woman with the Pierrot collar was interpreted as a lady of the *demi-monde*.

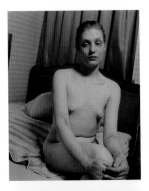

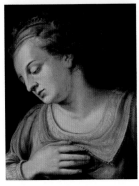

Schönheit

Peter Hendricks (*1955, lebt in Hamburg), *sehsüchtig – sehsüchtig*, 1994–1998, C-Print, 28,5 x 23 cm, Auflage: 10, Teutloff Photo + Video Collection, Bielefeld

Dieses erschütternde Bild verwüsteter jugendlicher, ja beinahe noch kindlicher Schönheit steht formal in expressionistischer Tradition. Man denkt an die Darstellung adoleszenter Mädchen bei Edvard Munch oder an Holzschnitte Erich Heckels, bei denen die Brust der neunjährigen Fränzi als Pest- oder Seitenwunde erscheint. Stärker noch als bei Loretta Lux (S. 56) signalisieren schiefer Winkel und Abschüssigkeit existenzielle Gefährdung. Das Bett ist ein Joch auf den zarten Schultern, der gelbe Vorhang die Aureole einer Märtyrerin.

Frans Floris (1516/20 Antwerpen–1570 Antwerpen), *Kopfstudie*, Öl auf Eichenholz, 49,5 x 38,5 cm, Wallraf-Richartz-Museum & Fondation Corboud, Köln, Inv.-Nr. WRM 1787

Ähnlich wie bei Hendricks (s. oben) schaut die gezeigte Person nach unten: vielleicht eine Darstellung jenes bescheidenen, »disziplinierten« Blicks, der den Frauen lange abverlangt wurde. Allerdings bleibt das Geschlecht unklar: Frau oder Mann? Magdalena oder Johannes? Wahrscheinlich wurde das Bild als »Auskopplung« aus einer Beweinung oder Grablegung entwickelt (vgl. S. 71). Da es sich um kein eigentliches Porträt handelt, darf man dieses Kopfstück als sehr frühes Beispiel für die niederländische Bildgattung der *tronie* werten.

Beauty

Peter Hendricks (b. 1955, lives in Hamburg), *sehsüchtig – sehsüchtig*, 1994–98, C print, 28.5 x 23 cm, edition: 10, Teutloff Photo + Video Collection, Bielefeld

Formally, this disturbing picture of ravaged, youthful, indeed almost childlike beauty is in the Expressionist tradition. We are reminded of the rendering of adolescent girls in Edvard Munch's work, or of woodcuts by Erich Heckel, in which the breast of nine-year-old Fränzi appears as a plague mark, or a wound in the side. Even more strongly than in the work of Loretta Lux (p. 56), the oblique angle and the sloping bed signal existential danger. The headboard is a yoke on the young shoulders, the yellow curtain the aureole of a martyr.

Frans Floris (1516/20 Antwerp–1570 Antwerp), *Study for a Head*, oil on oak, 49.5 x 38.5 cm, Wallraf-Richartz-Museum & Fondation Corboud, Cologne, inv. no. WRM 1787

As with Hendricks (above), the person shown is looking down: Maybe it is a rendering of that modest, "disciplined" look that was long required of women. However, the sex of the sitter is uncertain: woman or man? Mary Magdalene or John? The picture probably originated as part of a Lamentation (cf. p. 71) or Entombment. As it is not a portrait as such, this head may be seen as a very early example of the Netherlandish genre known as *tronie*.

▷ Seite 68/69
Nr. 28, 31 der Ausstellung

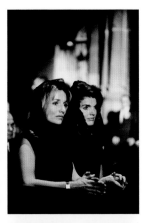

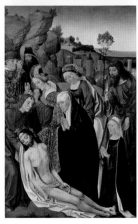

▷ Seite 70/71
Nr. 33, 32 der Ausstellung

Robert Lebeck (*1929, lebt in Berlin), *Jackie Kennedy und Lee Radziwill am Sarg von Robert Kennedy*, New York, 1968, Bildgröße: 56 x 37,5 cm, Blattgröße: 60 x 50 cm, späterer Abzug, signiert unten rechts: Robert Lebeck, links unten handschriftlich betitelt, Teutloff Photo + Video Collection, Bielefeld

Im Juni 1968, viereinhalb Jahre nach der Ermordung seines älteren Bruders, wurde auch Robert Kennedy Opfer eines Attentats. Die Parallelität der Ereignisse und die tragische Aura einer glamourösen Familie spiegeln sich hier in einer Dopplung der trauernden Schönheit. Hinter einer Säule der St. Patrick's Cathedral versteckt fotografierte Lebeck um zwei Uhr nachts Jackie Kennedy und ihre jüngere Schwester Lee Radziwill bei der Totenwache: Alles um sie herum versinkt im Unscharfen, tränenverschwommen (vgl. S. 99).

Meister der hl. Sippe d. J. (um 1480–um 1520, tätig in Köln) und Werkstatt, *Beweinung Christi*, um 1483–1485, Mischtechnik auf Eichenholz, 120 x 78,5 cm, Wallraf-Richartz-Museum & Fondation Corboud, Köln, Inv.-Nr. WRM 159

Diese Innenseite eines rechten Retabelflügels zeigt die Beweinung des toten Christus nach seiner Kreuzabnahme und vor der Grablegung. Zu den biblischen Figuren hat sich rechts unten die Stifterin des Altarbildes hinzugesellt – in bescheiden verkleinertem Maßstab. Ihr Mann erschien entsprechend auf dem linken (verlorenen) Flügel. Auch wenn die Stifterin aus dem Bild heraus auf den (heute fehlenden) Gekreuzigten in der Altarmitte blickt, »reimt« sich ihre Körperhaltung mit der Mariens: Sie trauert so intensiv wie die Muttergottes selbst.

Robert Lebeck (b. 1929, lives in Berlin), *Jackie Kennedy and Lee Radziwill at the Coffin of Robert Kennedy, New York*, 1968, image: 56 x 37.5 cm, sheet: 60 x 50 cm, later proof, signed bottom right: Robert Lebeck, handwritten title bottom left, Teutloff Photo + Video Collection, Bielefeld

In June 1968, four and a half years after the murder of his elder brother, Robert Kennedy was also the victim of an assassination. The parallelism of the events and the tragic aura of a glamorous family are reflected here in a double portrait of grieving beauty. Hidden behind a column in St. Patrick's Cathedral at two o'clock in the morning, Lebeck photographed Jackie Kennedy and her younger sister Lee Radziwill during the vigil: everything around them is submerged in a tear-soaked blur (cf. p. 99).

Master of the Holy Kinship the Younger (ca. 1480–ca. 1520, active in Cologne) and studio, *Lamentation of Christ*, ca. 1483–85, mixed media on oak, 120 x 78.5 cm, Wallraf-Richartz-Museum & Fondation Corboud, Cologne, inv. no. WRM 159

This inside panel of the right-hand wing of a retable shows the Lamentation of the dead Christ following His Deposition from the Cross and before the Entombment. The biblical figures have been joined at the bottom right by the donor of the altarpiece, on a suitably modest smaller scale. Her husband appeared correspondingly on the left-hand wing (now lost). Although the donor is looking up out of the picture at the (now lost) figure of the crucified Christ in the middle of the altar, her physical attitude "rhymes" with that of the Virgin Mary: Her grief is no less intense than that of the Mother of God herself.

Bartholomäus Bruyn d. Ä. (1493 Wesel [?]–1555 Köln), *Bildnis einer jüngeren Frau mit Nelke*, um 1538, Öl auf Eichenholz, 37 x 30 cm, Wallraf-Richartz-Museum & Fondation Corboud, Köln, Inv.-Nr. WRM 266

Bartholomäus Bruyn d. Ä. war der wichtigste Kölner Porträtist der Renaissance. Die wohl dem Patriziat der Stadt angehörende fromme Dame weist eine Nelke als Symbol für die Passion Christi vor: Die Knospen der ähnlich duftenden Gewürznelke (»Nägelchen«) erinnern in ihrer Form an die Nägel vom Kreuz Christi. Das ursprünglich oben halbrund geschlossene Bildnis hatte wohl ein Gegenstück mit dem Porträt des Ehemannes (vgl. S. 82), der, heraldischer Hierarchie zufolge, auf der höherrangigen linken Seite erschien.

Hendrik Kerstens (*1956 Den Haag), *Bag*, November 2007, Farbnegativ/C-Print auf Dibond, 100 x 80 cm, Auflage: 5/6, Teutloff Photo + Video Collection, Bielefeld

In Komposition, Farbigkeit und Beleuchtung zitiert diese Fotografie ganz bewusst altniederländische oder -deutsche Porträts (s. oben). Insofern ist sie vergleichbar mit bestimmten Werken von Hiroshi Sugimoto oder Desiree Dolron. Die Pointe besteht im Austausch der Haube gegen eine ordinäre weiße Plastiktüte. Hier eröffnet sich ein weites Assoziationsfeld zwischen *high* und *low*, Popkultur und Hochkunst: von der Mode als sozialer und ästhetischer Praxis über den Konsum und seine Kritik bis hin zur Braut als Ware.

Bartholomäus Bruyn the Elder (1493 Wesel [?]–1555 Cologne), *Portrait of a Young Lady with Carnation*, ca. 1538, oil on oak, 37 x 30 cm, Wallraf-Richartz-Museum & Fondation Corboud, Cologne, inv. no. WRM 266

Bartholomäus Bruyn the Elder was the most important Renaissance portraitist in Cologne. The pious lady, doubtless from one of the city's patrician families, is holding a carnation as a symbol of the Passion of Christ: The carnation has the scent of cloves, which, because of their shape, take their name from the Latin *clavus* ("nail") and hence allude to the nails of the Cross. The portrait was originally semicircular at the top, and probably was one of a pair with the sitter's husband (cf. p. 82), who, in heraldic terms, would have taken the superior position on the left.

Hendrik Kerstens (b. 1956 The Hague), *Bag*, November 2007, color negative / C print on Dibond, 100 x 80 cm, edition: 5/6, Teutloff Photo + Video Collection, Bielefeld

In composition, coloration and illumination, this photograph quite consciously quotes Old Netherlandish or Old German portraits (above). To this extent it is comparable with certain works by Hiroshi Sugimoto or Desiree Dolron. The point of the photo is the substitution of a banal white plastic bag for the bonnet. This opens up a broad field of association between high and low, pop culture and high art: from fashion as social and aesthetic practice via consumerism and its critiques to the bride as commodity.

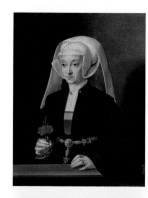

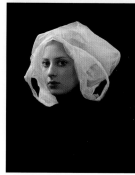

▷ Seite 72/73
Nr. 35, 36 der Ausstellung

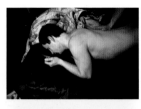

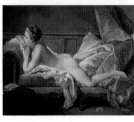

▷ Seite 74/75
Nr. 37, 38 der Ausstellung

Nan Goldin (*1953 Washington D.C., lebt in New York), *Jens' Hand on Clemens' Back*, Paris 2001, Cibachrome-Print, 40 x 60 cm, Spezialedition für Phaidon Press: 84/100, rückseitig signiert, nummeriert, betitelt, Teutloff Photo + Video Collection, Bielefeld

Das Werk steht im Zusammenhang mit Aufnahmen eines homosexuellen Paares. Zeigen andere Fotografien dieser Serie die beiden Männer explizit beim Liebesakt, so finden sich hier (neben dem Streicheln) eher nur Spuren der Leidenschaft wie gerötete Ohren und Knutschflecken. Verwandtschaften zu Boucher (s. unten) ergeben sich in mehrfacher Hinsicht: Neben der spurenhaften Erotik und der ästhetischen Kombination nackter Haut mit seidigen Stoffen ist auch der lückenhafte, ja fragmentarische Charakter zu nennen.

François Boucher (1703 Paris–1770 Paris), *Ruhendes Mädchen (Louise O'Murphy)*, 1751, Öl auf Leinwand, 59,5 x 73,5 cm, signiert, datiert unten rechts: F. Boucher 1751, Wallraf-Richartz-Museum & Fondation Corboud, Köln, Inv.-Nr. WRM 2639

Das Mädchen wurde als Marie-Louise O'Murphy identifiziert, eine Näherin, die für Boucher als Modell arbeitete und bald zur Mätresse Ludwigs XV. wurde. Sie ist hier nicht älter als vierzehn und so wirkt das erotische Programm des Bildes aus heutiger Sicht schockierend. Unterwäsche hängt von der improvisierten Bettstatt; zerwühlte Textilien, Rosen (als Liebesgabe) und die aufgeschlagene, wohl pornografische Literatur evozieren eine sexuelle Handlung, in die sich der männliche Betrachter selbst hineinprojizieren soll.

Nan Goldin (b. 1953 Washington, D.C., lives in New York), *Jens' Hand on Clemens' Back*, Paris 2001, Cibachrome print, 40 x 60 cm, special edition for Phaidon Press: 84/100, signed, numbered and titled verso, Teutloff Photo + Video Collection, Bielefeld

This work is associated with a homosexual couple. While other photographs in this series show men explicitly performing sexual acts, here (apart from the caress) we see at most traces of arousal, such as reddened ears and lovebites. Relationships with Boucher (below) are numerous: Alongside the vestigial eroticism and the aesthetic combination of bare skin and silky materials, one might also mention the incomplete, indeed fragmentary character of the work.

François Boucher (1703 Paris–1770 Paris), *Recumbent Girl (Louise O'Murphy)*, 1751, oil on canvas, 59.5 x 73.5 cm, signed and dated bottom right: F. Boucher 1751, Wallraf-Richartz-Museum & Fondation Corboud, Cologne, inv. no. WRM 2639

The girl has been identified as Marie-Louise O'Murphy, a seamstress who worked for Boucher as a model and soon became the mistress of Louis XV. Here she is no older than fourteen, and to this extent the erotic program of the picture is shocking to our modern sensibilities. Underwear draping from the improvised bed, tousled textiles, roses (a gift from an admirer) and the open, doubtless pornographic book evoke a sexual act into which the male beholder is invited to project himself.

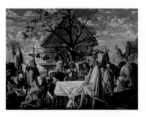

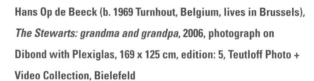

▷ Seite 76/77
Nr. 44, 45 der Ausstellung

Paare

Couples

Bramantino (Bartolomeo Suardi, nach 1465 Bergamo[?] – 1530 Mailand), *Jupiter und Merkur bei Philemon und Baucis,* **um 1500, Pergament auf (neuerem) Pappelholz, Bildfläche: 57,5 x 78 cm, Wallraf-Richartz-Museum & Fondation Corboud, Köln, Inv.-Nr. WRM 527**

Gegenstand ist eine mythologische Fabel, die der römische Dichter Ovid in seinen *Metamorphosen* literarisch gestaltete: Überaus gastfreundlich nimmt das alte Ehepaar Philemon und Baucis die inkognito, in Gestalt von Sterblichen erscheinenden Götter Jupiter und Merkur auf. Zur Belohnung werden beide am Ende ihres menschlichen Lebens gleichzeitig in zwei (miteinander verschlungene) Bäume verwandelt. Trägermaterial, Thema und Komposition des Bildes deuten auf den Entwurf (»modello«) für eine Tapisserie hin.

Hans Op de Beeck (*1969 Turnhout/Belgien, lebt in Brüssel), *The Stewarts: grandma and grandpa,* **2006, Fotografie auf Dibond mit Plexiglas, 169 x 125 cm, Auflage: 5, Teutloff Photo + Video Collection, Bielefeld**

Die weiße Kleidung des alten Paares verweist zwar zurück auf hochzeitliche Assoziationen, doch greift die Gestik nicht ineinander. Auf dem weißen Sofa wie auf einer Wolke sitzend erscheinen beide dem irdischen Dasein bereits entrückt. Ihre weißen Ballons und Hütchen deuten in die gleiche Richtung. Soll man vor diesem Bild lachen oder weinen? Es kritisiert wohl nicht zuletzt eine bestimmte »Affektpolitik«. So erinnert das Weiß hier letztlich an die aseptische Ästhetik des Sarginnenraums, den »Sarg als White Cube« (Heidi Helmhold).

Bramantino (Bartolomeo Suardi; after 1465 Bergamo [?] – 1530 Milan), *Jupiter and Mercury with Philemon and Baucis,* **ca. 1500, parchment on (more recent) poplar, picture: 57.5 x 78 cm, Wallraf-Richartz-Museum & Fondation Corboud, Cologne, inv. no. WRM 527**

The subject is a mythological fable to which the Roman poet Ovid gave literary form in his *Metamorphoses*. Showing great hospitality, the old married couple Philemon and Baucis receive the gods Jupiter and Mercury, who appear incognito in mortal guise. As a reward, the couple are transformed at the end of their human lives into two intertwining trees. The material of the picture support, the subject and the composition all point to this being a *modello* for a tapestry.

Hans Op de Beeck (b. 1969 Turnhout, Belgium, lives in Brussels), *The Stewarts: grandma and grandpa,* **2006, photograph on Dibond with Plexiglas, 169 x 125 cm, edition: 5, Teutloff Photo + Video Collection, Bielefeld**

The white clothing of the old couple has wedding connotations, but their gestures suggest a certain distance. Sitting on the white sofa as if on a cloud, the two already seem detached from earthly life. The white balloons and hats point in the same direction. Are we supposed to laugh or cry? The picture criticizes not least a particular "emotions policy." Thus the white here ultimately recalls the aseptic aesthetic of the lining of a coffin, the "coffin as White Cube" (Heidi Helmhold).

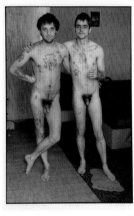

▷ Seite 78/79
Nr. 52, 53 der Ausstellung

Yousuf Karsh (1908 Mardin/Türkei – 2002 Boston/Mass.),
Duke and Duchess of Windsor, 1971, Silbergelatineprint,
Blattmaß: 29 x 23,6 cm, Originalabzug, Teutloff
Photo + Video Collection, Bielefeld

Im Dezember 1936, weniger als ein Jahr nach seiner Thronbesteigung, dankte König Edward VIII. von England ab, um die geschiedene Amerikanerin Wallis Simpson heiraten zu können: eine berühmte Skandal- und Liebesgeschichte. Karsh stellt die unverminderte Zuneigung des alten Paares heraus. Programmatisch ist die geöffnete Flügeltür, die an das Ehe-Diptychon von Bruyn (S. 82) erinnert: Gemeinsam haben die Windsors eine Schwelle überschritten, gemeinsam sind sie ins Alter eingetreten, umgeben von einer Aureole aus Gegenlicht.

Gundula Schulze Eldowy (*1954 Erfurt), *Rajk und Matthias*, Berlin 1984, Silbergelatineprint, 59,5 x 39,5 cm, unten betitelt, datiert, signiert: Gundula S., Teutloff Photo + Video Collection, Bielefeld

Vor dem Hintergrund von Schulze Eldowys Biografie möchte man ihre persönliche Stil- und Motivwahl als »sozialen (statt: sozialistischen) Realismus« bezeichnen. Ob sie bewusst das berühmte Karsh-Foto (s. oben) beantwortet? Auf geradezu unheimlich subtile – auch komische – Weise spiegelt sich in der Bodendarstellung ihrer Fotografie das geteilte Berlin. Zwischen den beiden Männern grenzen zwei Terrains aneinander, ironisch überbrückt durch den riesenhaften Schritt der »Fuß«-Matten. Das Foto als »Spur« und »Code« zugleich.

Yousuf Karsh (1908 Mardin, Turkey–Boston, Mass. 2002),
Duke and Duchess of Windsor, 1971, original proof, gelatin
silver print, sheet: 29 x 23.6 cm, Teutloff Photo + Video
Collection, Bielefeld

In December 1936, less than twelve months after his accession to the throne, King Edward VIII of Great Britain and Northern Ireland abdicated in order to be able to marry the American divorcée Wallis Simpson: It was a famous scandal and love story. Karsh brings out the undiminished mutual fondness of the couple in old age. The open double door is programmatic, recalling the marriage diptych by Bruyn (p. 82): Together the Windsors have crossed a threshold, together they have entered old age, surrounded by an aureole of back-lighting.

Gundula Schulze Eldowy (b. 1954 Erfurt), *Rajk and Matthias*,
Berlin 1984, gelatin silver print, titled, dated, signed at bottom:
Gundula S., 59.5 x 39.5 cm, Teutloff Photo + Video Collection,
Bielefeld

Against the background of Schulze Eldowy's life story one is tempted to call her personal choice of style and motifs "Social" (not "Socialist") Realism. Is she deliberately responding to the famous Karsh photograph (above)? In a downright eerily subtle (and comic) fashion, the rendering of the floor in her photograph reflects divided Berlin. Between the two men, two territories meet, ironically bridged by the huge step taken by the "foot" mats: the photograph as "trace" and "code" at the same time.

Martin C. de Waal (auch: Martin Duvall), *Untitled (Diptychon)*, 2001, digitaler S/W-Druck auf Reynobond mit Plexiglas, 40,3 x 28,2 cm, Auflage: 2/4, rückseitig signiert: MC de Waal, Teutloff Photo + Video Collection, Bielefeld

Formal erinnert dieses Doppelporträt an Andy Warhols »doppelte« Elvisdarstellungen, nicht aber inhaltlich. 2000 wurde die provisorische Durchsequenzierung des menschlichen Genoms veröffentlicht, 2001 eine Genkarte des Humangenoms. De Waal zeigt den Menschen »im Zeitalter seiner genetischen Reproduzierbarkeit«. Das romantische, seit je beunruhigende Thema des Doppelgängers kehrt hier zurück. In den Manipulationsmöglichkeiten der digitalen Fotografie reflektieren sich die Manipulationsmöglichkeiten der Genetik.

Hans Abel (II) d.J. (vor 1506 [?] Frankfurt– um 1567 Mainz [?]), *Bildnis des Grafen Thomas von Rieneck / Bildnis des Grafen Johann von Rieneck*, um 1530, Öl auf Lindenholz, je 53,5 x 41 cm, Wallraf-Richartz-Museum & Fondation Corboud, Köln, Inv.-Nr. WRM 370/371

Rückseitig angebrachte Inschriften erlauben die Identifikation der beiden Dargestellten: Die Brüder Thomas und Johann von Rieneck gehörten dem ältesten deutschen Adel an. Zugunsten ihres älteren Bruders Reinhard verzichteten sie auf ihre am Main (zwischen Aschaffenburg und Würzburg) gelegene Grafschaft. Sie erhielten dafür eine Rente und wurden – standesgemäß – Geistliche, unter anderem als Domherren in Köln. Die ernsten Porträts haben unter älteren Verputzungen gelitten, so dass ihre hohe Qualität nicht mehr ganz in Erscheinung tritt.

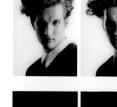

Martin C. de Waal (also: Martin Duvall), untitled (diptych), 2001, digital b/w print on Reynobond with Plexiglas, 40.3 x 28.2 cm, edition: 2/4, signed verso: MC de Waal, Teutloff Photo + Video Collection, Bielefeld

Formally, but not thematically, this double portrait recalls Andy Warhol's "double" renderings of Elvis. In 2000 the provisional sequencing of the human genome was published, in 2001 a human gene map. De Waal shows the human being "in the age of his genetic reproducibility." This represents the return of the romantic theme of the doppelganger, a source of unease since time immemorial. The possibilities of genetic manipulation are reflected in the possibilities of photographic manipulation in the digital age.

▷ Seite 80/81
Nr. 55, 54 der Ausstellung

Hans Abel (II) the Younger (before 1506 [?] Frankfurt am Main– ca. 1567 Mainz [?]), *Portrait of Count Thomas von Rieneck / Portrait of Count Johann von Rieneck*, ca. 1530, oil on limewood, each 53.5 x 41 cm, Wallraf-Richartz-Museum & Fondation Corboud, Cologne, inv. no. WRM 370/371

Inscriptions verso enable the two sitters to be identified. They are the brothers Thomas and Johann von Rieneck, members of the oldest German aristocracy. In return for pensions, they renounced their county on the River Main (between Aschaffenburg and Würzburg) in favor of their elder brother Reinhard, and, as their station demanded, entered the Church, where among other things they became canons of Cologne Cathedral. The serious portraits have suffered from earlier attempts at cleaning, so that their high quality can no longer be fully appreciated.

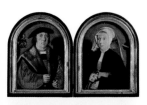

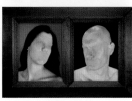

▷ Seite 82/83
Nr. 56, 57 der Ausstellung

Bartholomäus Bruyn d. Ä. (1493 Wesel [?]–1555 Köln), *Bildnisdiptychon des Gerhard Pilgrum und seiner Frau*, 1528, Öl auf Eichenholz, jeweils 38 x 30,5 cm mit dem Originalrahmen, Wallraf-Richartz-Museum & Fondation Corboud, Köln, Inv.-Nr. Dep. 14/15, Leihgabe des Kölner Gymnasial- und Stiftungsfonds

Dieses inhaltsreiche Doppelporträt wurde angewinkelt aufgestellt oder flach an der Wand aufgehängt. Die mit den Rosenkränzen verbundenen Bisamäpfel (Duftkugeln) sind Ausweis von Kultiviertheit und Verweis auf die Erbsünde: Wie Adam und Eva sind auch Gerhard und Anna »nach Seinem Bilde« geschaffen; ihre Ausstrahlung wird von den Einkerbungen im vergoldeten Rahmen betont. Die konträre Beleuchtung enthebt sie dem rationalen Raum-Zeit-Gefüge, verklammert sie und lässt ihre Schatten auf durchaus poetische Weise verschmelzen.

Aziz + Cucher (Anthony Aziz, *1961 Lunenburg/Mass.; Sammy Cucher, *1958 Caracas), *Couple*, 1995, zwei C-Prints im Künstlerrahmen, Blattmaß: je 25 x 20 cm, Rahmenmaß: 38,5 x 57,5 cm, Auflage: 4/5, Teutloff Photo + Video Collection, Bielefeld

In Format, Komposition und Rahmung rekurriert dieses Porträtdiptychon auf die von Bruyn (s. oben) verkörperte Tradition. Früher als bei de Waal (S. 80) wird hier digitale Bildmanipulation zum Ausdrucksmittel der »gentechnischen Kränkung« (Kristin Marek), des Gedankens an die genetische Manipulier- und Reproduzierbarkeit des Menschen. Eine negative Utopie: Durch Tilgung der Sinne entstehen fensterlose »Monaden« (vgl. S. 101); der Körper wird zum Gefängnis und jede Kommunikation – zumal zwischen den Geschlechtern – unmöglich.

Bartholomäus Bruyn the Elder (1493 Wesel [?]–1555 Cologne), *Portrait Diptych of Gerhard Pilgrum and his Wife*, 1528, oil on oak, each 38 x 30.5 cm with the original frame, Wallraf-Richartz-Museum & Fondation Corboud, Cologne, inv. no. Dep. 14/15, on loan from the Kölner Gymnasial- und Stiftungsfonds

This detailed double portrait was either stood on a support with the two wings at an angle, or hung flat on the wall. The rosaries are linked by pomanders (balls of perfume). This points to the couple's level of cultivation, but also to original sin (another name for pomanders was musk *apples*). Like Adam and Eve, Gerhard and Anna Pilgrum are created "in His image." Their charisma is emphasized by the grooves in the gilt frame. The lighting, from opposite directions, lifts them out of the rational structure of time and space, allowing their shadows to merge in a positively poetic fashion.

Aziz + Cucher (Anthony Aziz, b. 1961 Lunenburg, Mass.; Sammy Cucher, b. 1958 Caracas), *Couple*, 1995, two C prints in artists' frame, sheets: each 25 x 20 cm, frame: 38.5 x 57.5 cm, edition: 4/5, Teutloff Photo + Video Collection, Bielefeld

In format, composition and framing this portrait diptych goes back to the tradition embodied by Bruyn (above). Earlier than in de Waal's work (p. 80), digital image manipulation here becomes the means of expression of "genetically engineered hurt" (Kristin Marek), the idea that people can be genetically manipulated and reproduced. A negative utopia: The elimination of the senses gives rise to windowless "monads" (cf. p. 101); the body becomes a prison and all communication, especially between the sexes, becomes impossible.

Leid und Schmerz

Flämisch, *Dornenkrönung mit Blumenkranz*, Mitte 17. Jahrhundert, Öl auf Leinwand, 134,5 x 110 cm, Wallraf-Richartz-Museum & Fondation Corboud, Köln, Inv.-Nr. WRM 2345, erworben 1894 als Geschenk des Schaaffhausenschen Bankvereins, Köln

Bilder wie diese entstanden oft in Zusammenarbeit von zwei Spezialisten, einem Blumen- und einem Figurenmaler. Im Grunde handelt es sich um ein *trompe-l'œil* (illusionistische Augentäuschung), denn das »eigentliche« Gemälde erscheint erst als Bild im Bild. Die acht Ecken seines Rahmens verweisen im Sinne religiöser Zahlensymbolik auf Tod und Wiederauferstehung. So wie sich das Leiden Christi in einen Triumph über den Tod verwandelt, so verwandelt sich die gemalte Dornenkrone in einen »echten« Blumenkranz.

Christopher Makos (*1948 Lowell/Mass.), *Altered Image*, 1981, Barytpapier, 20,5 x 25,3 cm, Auflage: 3/13, Teutloff Photo + Video Collection, Bielefeld

Vorbild für die Serie *Altered Image* war Man Rays fotografisches Porträt der *Rrose Sélavy* (1921), das heißt des als Frau verkleideten Künstlers Marcel Duchamp. In zwei Tagen entstanden 349 Aufnahmen von einem professionell geschminkten und mit diversen Perücken versehenen Warhol. Kennzeichnend für die abgründige Serie ist eine doppelte Travestie: Warhol erscheint als Frau, die sich wiederum (siehe Krawatte) als Mann kleidet. Dieses Foto wirkt wie die Darstellung einer Dornenkrönung des Künstlers (s. oben).

Suffering and Pain

Flemish, *Crowning with Thorns, with Garland of Flowers*, mid-17th century, oil on canvas, 134.5 x 110 cm, Wallraf-Richartz-Museum & Fondation Corboud, Cologne, inv. no. WRM 2345, acquired in 1894 as a gift of the Schaaffhausenscher Bankverein, Cologne

Pictures like these often were the work of two specialists, one in figure painting, the other in painting flowers. Basically it is a *trompe l'œil*, for the "actual" painting appears as a picture within a picture. The eight corners of the frame point, in the spirit of religious numerology, to death and resurrection. As the Passion of Christ is transformed into a victory over death, the painted Crown of Thorns is transformed into a "real" garland of flowers.

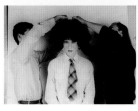

▷ Seite 84/85
Nr. 59, 60 der Ausstellung

Christopher Makos (b. 1948 Lowell, Mass.), *Altered Image*, 1981, baryta paper, 20.5 x 25.3 cm, edition: 3/13, Teutloff Photo + Video Collection, Bielefeld

The exemplar for the series *Altered Image* was Man Ray's photographic portrait of *Rrose Sélavy* (1921), that is, the artist Marcel Duchamp disguised as a woman. In two days, 349 photographs were taken of a professionally made up and variously bewigged Warhol. Characteristic of the inscrutable series is a double transvestism: Warhol appears as a woman who in turn (see the necktie) dresses as a man. This photograph has the effect of a picture of the artist receiving a crown of thorns (above).

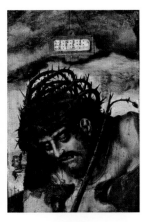

▷ Seite 86/87
Nr. 61, 62 der Ausstellung

Oberdeutsch (Donauschule?), *Christus im Elend*, Mitte 16. Jahrhundert, Öl auf Eichenholz, 32 x 22,2 cm, Wallraf-Richartz-Museum & Fondation Corboud, Köln, Inv.-Nr. WRM 706

Das kleinformatige Andachtsbild zeigt Christus nach Geißelung und Dornenkrönung und vor der Kreuzigung. Die – noch leeren – Kreuze auf Golgatha sind links hinten bereits sichtbar. Die Kreuzesinschrift, die nach römischer Gepflogenheit den Grund für eine Hinrichtung angab, hängt am Bilderrahmen. Ihre dreisprachige (lateinisch-griechisch-hebräische) Abkürzung verweist auf »Jesus von Nazareth, König der Juden«. Sie hebt damit die »Insignien« der Passion hervor, namentlich Dornenkrone und Rohr (als Zepter).

Micha Brendel (*1959 Weida/Thüringen, lebt in Berlin), aus der Serie *Brendel samt Störtebecker*, 1989, Unikat, Silbergelatineprint auf Barytpapier, mit unterschiedlichen Materialien, darunter Blut, Öl, Asphalt, übermalt, außen mit braunem Papierrand, gerissen, Blattmaß: ca. 51 x 51 cm, signiert unten links: BRENDEL, darunter betitelt: samt Störtebecker, Teutloff Photo + Video Collection, Bielefeld

Wie bei Buetti (S. 65) haben wir es mit einer physisch veränderten Fotografie zu tun. Gerissener Papierrand, ausführliche Beschriftung und intensive Überarbeitung betonen den Objektcharakter des Werkes, das als Reliquie in Erscheinung tritt – als Überbleibsel eines künstlerischen Akts, aber auch als Zeugnis des Leidens, ja der »Zernichtung«. Neben der älteren christlichen Ikonografie (s. oben) wird eine jüngere Tradition existenzieller Kunst aufgerufen: Man denkt an Werke von Francis Bacon, Paul Thek und Arnulf Rainer.

South German (Danube School?), *Christ as Man of Sorrows*, mid-16th century, oil on oak, 32 x 22.2 cm, Wallraf-Richartz-Museum & Fondation Corboud, Cologne, inv. no. WRM 706

This small-format devotional picture shows Christ following His scourging and with the Crown of Thorns, but before the Crucifixion. The still empty crosses on Golgotha are visible in the left background. The inscription on the Cross, which by Roman custom indicated the reason for the execution, hangs from the frame of the picture. Its trilingual (Latin, Greek, Hebrew) abbreviated text reads: "Jesus of Nazareth, King of the Jews." It thus emphasizes the "regalia" of the Passion, the Crown (of Thorns) and the cane (as scepter).

Micha Brendel (b. 1959 Weida, Thuringia, lives in Berlin), from the series *Brendel samt Störtebecker*, 1989, gelatin silver print on baryta paper, overpainted with various materials (including blood, oil, asphalt), brown paper edge, torn, sheet: ca. 51 x 51 cm, signed bottom left: BRENDEL, with title below: samt Störtebecker, Teutloff Photo + Video Collection, Bielefeld

As with Buetti (p. 65), here we have a physically altered photograph. The torn edge of the paper, the detailed inscription and intensive reworking emphasize the physical presence of the work, which appears as a relic, as the remnant of an artistic act, but also as a witness to suffering, indeed, of annihilation. Alongside the older Christian iconography (above), a more recent tradition of existential art is invoked. We are thus reminded of works by Francis Bacon, Paul Thek and Arnulf Rainer.

Bartholomäus Bruyn d. Ä. (1493 Wesel [?]–1555 Köln), *Ecce Homo*, um 1545–1548, Öl auf Eichenholz, 149,5 x 41,5 cm, Wallraf-Richartz-Museum & Fondation Corboud, Köln, Inv.-Nr. WRM 242

Auf einer Plattform des Prätoriums führt Pilatus, römischer Statthalter, Jesus dem Volk vor, das unten in Gestalt weniger, stark angeschnittener Personen präsent ist: auf einer Höhe mit dem einst vor dem Altarbild stehenden Kirchenbesucher. Als Hinweis auf das Erlösungswerk rinnt ein Blutstropfen hinab zum Volk – und zum Bildbetrachter. Bruyn verbindet hier mittelalterliche »Heilig-Blut-Mystik« mit dem antikischen Körperideal der Renaissance. Vorbild für die athletische Hauptfigur war Michelangelos marmorner *Christus* von 1519/20.

Jack Pierson (*1960, Plymouth/Mass.), *Self Portrait #25*, 2005, Pigmentdruck auf Hahnemühle Rag-Fotopapier, 135,9 x 109,2 cm, Auflage: 1/7, Teutloff Photo + Video Collection, Bielefeld

In der Serie *Self Portraits* zeigt Pierson nicht sich selbst, sondern namenlose, gutaussehende Männer verschiedener Altersstufen (vgl. Miwa Yanagis Projekt My *Grandmothers*, S. 116). Dass »jeder Maler« – unwillkürlich – »sich selbst malt«, besagte um 1478 ein toskanisches Sprichwort. Pierson geht es gerade nicht um »Automimesis«, sondern um die kulturelle Konstruktion des individuellen Selbst, etwa aus Vor- und Wunschbildern. Hier kombiniert er Sebastians- und Christusbilder (s. oben) mit Porträtformeln der Renaissance.

Bartholomäus Bruyn the Elder (1493 Wesel [?]–1555 Cologne), *Ecce Homo*, ca. 1545–48, oil on oak, 149.5 x 41.5 cm, Wallraf-Richartz-Museum & Fondation Corboud, Cologne, inv. no. WRM 242

On a platform of the Praetorium, the Roman governor Pontius Pilate presents Jesus to the people, who are present at the bottom in the guise of a few heavily cropped individuals, on a level with the churchgoers who would once have seen this picture on an altar. As a reference to the process of salvation, a drop of blood runs down to the people, and to the beholder of the picture. Bruyn here combines medieval holy-blood mysticism with the classical body ideal of the Renaissance. The model for the athletic Jesus was Michelangelo's marble *Christ* of 1519–20.

Jack Pierson (b. 1960, Plymouth, Mass.), *Self Portrait # 25*, 2005, pigment print on Hahnemühle rag photo paper, 135.9 x 109.2 cm, edition: 1/7, Teutloff Photo + Video Collection, Bielefeld

In the series *Self Portraits* Pierson does not in fact portray himself, but unnamed, good-looking men of various ages (cf. Miwa Yanagi's project *My Grandmothers*, p. 116). That willy-nilly "every painter paints himself" was a Tuscan saying in the late 15th century. Pierson is precisely not concerned with "automimesis," but rather with the cultural construct of the individual self, for example from role models and ideal images. Here he combines images of Christ (above) and St. Sebastian with Renaissance portrait formulae.

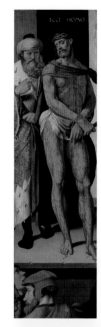

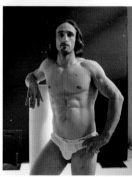

▷ Seite 88/89
Nr. 66, 67 der Ausstellung

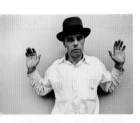

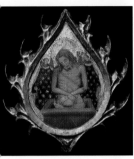

▷ Seite 90/91
Nr. 72, 71 der Ausstellung

Stefan Moses (*1928 Liegnitz/Schlesien, lebt in München), *Joseph Beuys*, München, 1968, Silbergelatineprint, 26 x 35 cm, Teutloff Photo + Video Collection, Bielefeld

Wie ein Priester bei der Wandlung imitiert Beuys hier göttliche Gestik, etwa die des »konzipierenden« Gottvaters in Lochners *Muttergottes in der Rosenlaube*, die des gekreuzigten Christus oder des seine Wundmale vorweisenden Schmerzensmannes. In ähnlicher Haltung war ein Jahr zuvor Jim Morrison von Joel Brodsky porträtiert worden (siehe S. 66). Bei Beuys werden der Hut zur Dornenkrone (oder Aureole), der Farbfleck auf der Brusttasche zur Seitenwunde – und die Zigarette zum Ausweis von *coolness*.

Cristoforo de' Moretti (tätig 1452–1485, Maler aus Cremona), *Christus als Schmerzensmann*, um 1460, Mischtechnik auf Pappelholz, Bildfläche: 29 x 21 cm, Wallraf-Richartz-Museum & Fondation Corboud, Köln, Inv.-Nr. WRM 748

Der Bildtypus des toten und dennoch aufrecht im Sarkophag stehenden Christus (*imago pietatis*) wird mit einer Vision Papst Gregors des Großen (ca. 540–604) in Verbindung gebracht: Diesem erschien während der Messe in Santa Croce in Gerusalemme (Rom) der vom Kreuz gestiegene Christus, um sein Blut in den Messkelch zu gießen. Kopftypus und Oberkörper mit den gekreuzten Händen entsprechen in etwa dem Turiner Grabtuch, das von André Bazin als »Synthese von Reliquie und Fotografie« bezeichnet wurde.

Stefan Moses (b. 1928 Liegnitz, Silesia, lives in Munich), *Joseph Beuys, Munich*, 1968, gelatin silver print, 26 x 35 cm, Teutloff Photo + Video Collection, Bielefeld

Like a priest consecrating the bread and wine, Beuys here imitates divine gestures, for example that of the "conceiving" God the Father in Lochner's *Madonna in the Rose Bower*, that of the crucified Christ or that of the Man of Sorrows showing his wounds. A year earlier Jim Morrison had been portrayed in a similar pose by Joel Brodsky (see p. 66). In Beuys's case, the hat becomes the Crown of Thorns (or halo), the mark on the breast pocket becomes the wound in the side – and the cigarette the expression of coolness.

Cristoforo de' Moretti (active 1452–85, painter from Cremona), *Christ as Man of Sorrows*, ca. 1460, mixed media on poplar, picture: 29 x 21 cm, Wallraf-Richartz-Museum & Fondation Corboud, Cologne, inv. no. WRM 748

The type of the dead Christ standing upright in the sarcophagus (*imago pietatis*) is linked to a vision experienced by Pope Gregory the Great (ca. 540–604): There appeared to him during mass in the church of Santa Croce in Gerusalemme in Rome the figure of Christ, who had descended from the Cross to pour his blood into the chalice. The type of head and the upper body with crossed arms are approximately as we see them on the Turin Shroud, which was described by André Bazin as a "synthesis of relic and photograph."

Reflexion

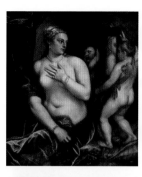

Tizian (Tiziano Vecellio, um 1482 Pieve di Cadore–1576 Venedig), Werkstatt, *Venus mit dem Spiegel*, um 1555, Öl auf Leinwand, 117,5 x 101 cm, Wallraf-Richartz-Museum & Fondation Corboud, Köln, Inv.-Nr. Dep. 332, Leihgabe der Bundesrepublik Deutschland seit 1968

Aus Tizians Werkstatt gingen mehrere Varianten der *Venus mit dem Spiegel* hervor, darunter die *Mellon Venus* der National Gallery in Washington. Der Spiegel dient bei Tizian nicht nur als Toilettenartikel, Symbol für Eitelkeit oder Instrument der Selbsterkenntnis, sondern auch als Waffe im Paragone, dem Wettstreit zwischen Malerei und Skulptur: Mit Hilfe eines Spiegels kann auch der Maler den Menschen (hier: sein Gesicht) wie der Bildhauer *rundum* zeigen.

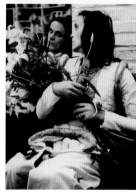

Jürgen Klauke (*1943 Kliding bei Cochem/Mosel, lebt in Köln), *Self Performance*, 1972/73, aus einer 13-teiligen Fotoarbeit, S/W-Druck auf Barytpapier, 57 x 42 cm, Auflage: 40/50, unten links signiert, datiert: J. Klauke 73, Teutloff Photo + Video Collection, Bielefeld

Klaukes frühe Fotosequenz *Self Performance* ist ein Vorläufer von Christopher Makos' *Altered Image*-Sequenz (S. 85) und Jack Piersons *Self Portraits* (S. 89). Vor dem Hintergrund popkultureller Phänomene wie Glamrock lotet Klauke systematisch ein geschlechtlich binär codiertes Körperbild aus. Dabei spielt die prothetische Durchdringung und Erweiterung der Kleidung mit hypertrophen Geschlechtsorganen aus Stoff eine wichtige Rolle. Vorbild für dieses Foto war wohl die *Venus* des Wallraf-Richartz-Museums (s. oben).

Reflection

Titian (Tiziano Vecellio; ca. 1482 Pieve di Cadore–1576 Venice), studio, *Venus with a Mirror*, ca. 1555, oil on canvas, 117.5 x 101 cm, Wallraf-Richartz-Museum & Fondation Corboud, Cologne, inv. no. Dep. 332, on loan from the Federal Republic of Germany since 1968

Titian's studio produced a number of variations of the *Venus with a Mirror*, including the *Mellon Venus* in the National Gallery in Washington, D.C. The mirror served Titian not only as an article of toiletry, a symbol of vanity or instrument of self-knowledge, but also as a weapon in the *paragone*, the contest between painting and sculpture. By using a mirror, the painter too, like the sculptor, can portray someone (or here, the face) from both sides.

Jürgen Klauke (b. 1943 Kliding near Cochem, Mosel, lives in Cologne), *Self Performance*, 1972–73, from a 13-part photographic work, b/w print on baryta paper, 57 x 42 cm, edition: 40/50, signed and dated bottom left: J. Klauke 73, Teutloff Photo + Video Collection, Bielefeld

Klauke's early photographic cycle *Self Performance* is a precursor of Makos's *Altered Image* series (p. 85) and Pierson's *Self Portraits* (p. 89). Against the background of pop-culture phenomena such as glam rock, Klauke systematically plumbs the possibilities of a sexually binary-coded body image. In the process, the penetration and stretching of clothing with over-sized genitalia plays an important role. The model for this photograph was most probably the *Venus* in the Wallraf-Richartz-Museum (above).

▷ Seite 92/93
Nr. 74, 75 der Ausstellung

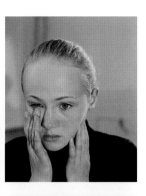

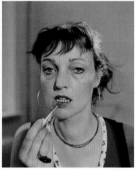

▷ Seite 94/95
Nr. 78, 79 der Ausstellung

Malin Schulz (*1979 Itzehoe, lebt in Hamburg), o. T. (aus der Serie *Schönheit*), 2004, zwei C-Prints auf Diasec, 98,5 x 80 cm, Teutloff Photo + Video Collection, Bielefeld

Schönheit war ein Gemeinschaftsprojekt zweier damaliger Studentinnen der Hochschule für Angewandte Wissenschaften in Hamburg: Malin Schulz und Sina Preikschat. Durch einen Spiegel hindurch wurden Frauen bei der »ritualisierten Auseinandersetzung mit sich selbst« fotografiert. Die entstandenen Arbeiten erinnern in ihrer Ästhetik an fotorealistische Gemälde von Franz Gertsch. Sie eröffnen einige grundsätzliche Fragen: Sehen wir nun das leibhaftige »Original«, dessen Spiegelbild oder nicht doch nur ein fotografisches Abbild?

Malin Schulz (b. 1979 Itzehoe, Schleswig-Holstein, lives in Hamburg), untitled (from the series *Schönheit*), 2004, two C prints on Diasec, 98.5 x 80 cm, Teutloff Photo + Video Collection, Bielefeld

Schönheit ("Beauty") was a joint project by two women, Malin Schulz and Sina Preikschat, who at the time were students at the Hochschule für Angewandte Wissenschaften (University of Applied Sciences) in Hamburg. Through a mirror, women were photographed in the "ritual confrontation with themselves." The resulting works recall the aesthetics of Photorealist paintings by Franz Gertsch. They raise a number of fundamental questions: Are we seeing the personification of the "original," its reflection or simply a photographic image?

143

Hussein Chalayan (*1970 Nikosia/Zypern, lebt in London), *The Absent Presence*, 2005, zwei C-Prints, Blattmaß: 76,2 x 50,8 cm, Auflage: 2/6, rückseitig signiert, betitelt, Teutloff Photo + Video Collection, Bielefeld

Als Vertreter der Türkei machte der Konzept- und Modekünstler Hussein Chalayan auf der Biennale in Venedig 2005 mit seiner Videoinstallation *The Absent Presence* Furore. Der rätselhafte Film mit Tilda Swinton rankt sich um Themen wie Biologie und Ethnologie, Identität und Genetik, Geografie und Migration. Die beiden Einzelaufnahmen erinnern an mehransichtige Porträts weltlicher und geistlicher Fürsten, welche Barockmaler als Vorlagen für den Bildhauer Bernini schufen. In dieser Tradition stehen auch erkennungsdienstliche Fotos.

Hussein Chalayan (b. 1970 Nicosia, Cyprus, lives in London), *The Absent Presence*, 2005, two C prints, sheet: 76.2 x 50.8 cm, edition: 2/6, signed and titled verso, Teutloff Photo + Video Collection, Bielefeld

As the Turkish representative, the concept and fashion artist Hussein Chalayan caused a stir at the 2005 Venice Biennale with his video installation *The Absent Presence*. The mysterious film with Tilda Swinton is concerned with themes such as biology and ethnology, identity and genetics, geography and migration. The two individual photographs recall the multi-view portraits of kings and cardinals which Baroque painters made as models for the sculptor Bernini. Police mugshots are in the same tradition.

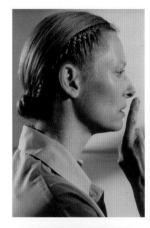

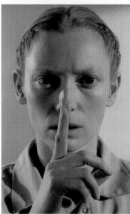

▷ Seite 96/97
Nr. 80 der Ausstellung

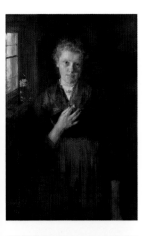

▷ Seite 98/99
Nr. 81, 82 der Ausstellung

Wilhelm Leibl (1844 Köln–1900 Würzburg), *Mädchen am Fenster*, 1899, Öl auf Leinwand, 109 x 72,5 cm, bezeichnet unten links: W.Leibl/1899, Wallraf-Richartz-Museum & Fondation Corboud, Köln, Inv.-Nr. WRM 1161

Das Porträt der »Wab'n« (Babette Maurer, geb. Jordan) gehört zu Leibls letzten Gemälden. Hinter großer Schlichtheit verbergen sich diverse inhaltliche und formale Parallelen. Der rötliche Farbton der Haare wird vielfach aufgegriffen, variiert und gesteigert. Das kleine Fenster gibt programmatische Hinweise auf die Zartheit, Transparenz und Klarheit der jungen Frau und ihres Blickes. Das auf der Fensterbank stehende Glas mit einer Nelkenblüte verweist auf eine lange, bis zu Jan van Eyck (gest. 1441) zurückreichende malerische Tradition.

Stanley Greene (*1949 New York, lebt in Paris und New York), *Zelina, Centreville Grozny, April 2001*, 2001/2005, C-Print, Blattmaß: 60 x 90 cm, rückseitig signiert, datiert, nummeriert: 2/15, Teutloff Photo + Video Collection, Bielefeld

Diese äußerst kunstvoll wirkende Fotografie stammt aus dokumentarischem Zusammenhang. Zelina schaut mit verlorenem Blick aus dem Fenster ihres Apartments im Stadtzentrum von Grosny. Ihre Hände sind von innen an die verregnete Scheibe gepresst: Sucht sie Kontakt zu einer Erinnerung oder wehrt sie eine solche ab? Bei der Belagerung Grosnys durch russische Truppen im November 1999 starb Zelinas Kind. Das Foto – ein tragisches Gegenstück zu Towell (S. 52) – legt einen Tränenschleier vor die Augen des Betrachters.

Wilhelm Leibl (1844 Cologne–1900 Würzburg), *Girl at the Window*, 1899, oil on canvas, 109 x 72.5 cm, inscribed bottom left: W.Leibl/1899, Wallraf-Richartz-Museum & Fondation Corboud, Cologne, inv. no. WRM 1161

The portrait of "Wab'n" (Babette Maurer, née Jordan) was one of Leibl's last paintings. The great simplicity hides diverse thematic and formal parallels. The reddish tone of the hair is taken up a number of times, varied, and intensified. The little window gives programmatic clues to the tenderness, transparency and clarity of the young woman and her gaze. The glass with a carnation on the window sill harks back to a long painterly tradition beginning with Jan van Eyck (d. 1441).

Stanley Greene (b. 1949 New York, lives in Paris and New York), *Zelina, Centreville Grozny, April 2001*, 2001/2005, C print, sheet: 60 x 90 cm, signed, dated and numbered verso: 2/15, Teutloff Photo + Video Collection, Bielefeld

This photograph derives from a documentary context, but comes across as highly artistic. Zelina is looking with a sense of loss out of the window of her apartment in the center of Grosny. Her hands are pressed against the inner surface of the pane, which is soaked with rain on the outside. Is she seeking contact with a memory or is she trying to keep one away? Zelina's child died during the siege of the Chechen capital by Russian troops in November 1999. The photograph, a tragic counterpart to Towell (p. 52), lays a veil of tears across the eyes of the beholder.

House of Leaves

Bill Jacobson (*1955 Norwich/Conn.), *New Year's Day #4550*, 2002, C-Print, 91,44 x 76,2 cm, Auflage: 1/7, rückseitig signiert, datiert, betitel, nummeriert, Teutloff Photo + Video Collection, Bielefeld

Der Mensch am Fenster ist ein altes, seit der Romantik geradezu zitathaft eingesetztes künstlerisches Motiv (vgl. S. 52, 98, 99), dem oft eine elegische Note eignet. Jacobson betont diesen Aspekt durch die mit einer Streulinse erzielte Unschärfe. Diese gibt seiner Darstellung etwas Immaterielles, Gespenstisches – als handle es sich um Gedankenfotografie. Im Zusammenspiel mit dem Serientitel *New Year's Day* evoziert sie eine Schwellensituation zwischen verschwimmenden Erinnerungen und unklaren Aussichten.

Aziz + Cucher (Anthony Aziz, *1961 Lunenburg/Mass.; Sammy Cucher, *1958 Caracas), *Interior #2*, 1999, C-Print auf Diasec, 98 x 69 cm, Auflage: 1/6, unten links signiert, datiert, nummeriert, Teutloff Photo + Video Collection, Bielefeld

Nicht ohne schwarzen Humor wird hier ein Bild des Unheimlichen schlechthin entworfen. Menschliche Haut (an Poren, Leberflecken, Unreinheiten klar erkennbar) verbindet sich auf verstörende Weise mit architektonischen Formen. Das Äußere stülpt sich ein, und es eröffnet sich der ebenso unerwartete wie erschreckende Zugang zu einem inneren Abgrund. Die Metapher vom Körper als Wohnung der Seele ist hier wörtlich genommen und mit dem Kamerablick des Horrorfilms inszeniert. Man denkt an Werke David Cronenbergs.

"House of Leaves"

Bill Jacobson (b. 1955 Norwich, Conn.), *New Year's Day #4550*, 2002, C print, 91.44 x 76.2 cm, edition: 1/7, signed, dated, titled and numbered verso, Teutloff Photo + Video Collection, Bielefeld

A person at a window is an old motif, often with an elegiac note, and one which since the Romantic period has been exploited as a quotation time and again (cf. pp. 52, 98, 99). Jacobson emphasizes this aspect by using a diffuser lens to create an ultra-soft focus. This lends his depiction something immaterial, something ghostly, as though this were thought-photography. In the interplay with the series title *New Year's Day*, it evokes a threshold situation between blurred memories and unclear prospects.

Aziz + Cucher (Anthony Aziz, b. 1961 Lunenburg, Mass.; Sammy Cucher, b. 1958 Caracas), *Interior # 2*, 1999, C print on Diasec, 98 x 69 cm, edition: 1/6, signed, dated and numbered bottom left, Teutloff Photo + Video Collection, Bielefeld

Not without black humor, what has been designed here is a picture of the uncanny, period. Human skin (clearly recognizable by the pores, moles and other impurities) combines in a disturbing way with architectural forms. The exterior is turned "outside in", and there opens up an access into an inner abyss which is as unexpected as it is frightening. The metaphor of the body as the dwelling of the soul is taken literally here, and staged with the camera eye of the horror movie, bringing to mind the works of David Cronenberg.

▷ Seite 100/101
Nr. 84, 91 der Ausstellung

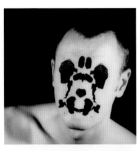

▷ Seite 102/103
Nr. 85 der Ausstellung

John Isaacs (*1968 Großbritannien), *The Matrix of Amnesia*, 1999, zwei C-Prints auf Diasec, 60 x 60 und 60 x 80 cm, Auflage: 2/6, rückseitig signiert, datiert, betitelt, nummeriert, Teutloff Photo + Video Collection, Bielefeld

Die beiden Fotoarbeiten gehörten zu Isaacs Schau *The Matrix of Amnesia* im Londoner Imperial College of Science, Technology and Medicine, die sich auf Biomedizin und ihre Ethik bezog. Wie bei einer Figur aus *Watchmen* (1986/87), einer *graphic novel*, sind Isaacs Gesichtszüge durch einen Rorschachtest ersetzt: Individuum und Maske, Zufall und Bestimmung, Deutung von Mimik und Kunst werden thematisiert. Der phallische, parasitäre Fisch wirkt wie ein monströser Verwandter oder gar Ahnherr des Porträtierten.

John Isaacs (b. 1968 Great Britain), *The Matrix of Amnesia*, 1999, two C prints on Diasec, 60 x 60 and 60 x 80 cm, edition: 2/6, signed, dated, titled and numbered verso, Teutloff Photo + Video Collection, Bielefeld

The two photographic works were shown in Isaacs's exhibition "The Matrix of Amnesia" at Imperial College of Science, Technology and Medicine, London, which was concerned with biomedicine and the ethics thereof. As with a figure from *Watchmen* (1986–87), a comic-book limited series, Isaacs's facial features are replaced by a Rorschach test: The themes are individual and mask, chance and predetermination, interpretation of facial expression and art. The phallic, parasitic fish comes across as a monstrous relative or even the ancestor of the sitter.

Adam Nadel (*1967, lebt in Jackson Heights, N.Y.), o. T. (aus der Serie *Rwanda September 2003*), 2003, C-Print, 48,5 x 49 cm, Teutloff Photo + Video Collection, Bielefeld

Nach Krieg (1990–1994) und Völkermord (1994) erhielt Ruanda 2003 eine neue Verfassung. Von August bis Oktober fanden Präsidentschafts- und Parlamentswahlen statt. Bei Nadel gestaltet sich dieser Aufbruch in eine neue, bessere Zeit als ein Heraustreten aus dem Dunkel, gewissermaßen ein Verlassen des Tunnels. Durch das Verschmelzen des Gesichts mit dem dunklen Hintergrund erlangen die Bildgrenzen besondere Bedeutung. Die Fotografie selbst erhält hier ein Gesicht; es entsteht ein Bild, das den Betracherblick erwidert.

Gerd Bonfert (*1953 Blaj [Blasendorf]/Rumänien, lebt in Köln), *G 51-1 (Selbst)*, 2002, Silbergelatineprint, Blattmaß: 97 x 130 cm, Auflage: 5, Teutloff Photo + Video Collection, Bielefeld

Der Mensch, das Licht und die Zeit gelten als Haupmaterialien in Bonferts Kunst. Hinzu kommt die Bewegung, die hier für eine gespenstische Auflösung der Gesichtszüge des Künstlers sorgt (vgl. S. 83, 100). Die überdimensionierten Nägel mit dem hängenden Draht wirken wie eine primitive Versuchsanordnung oder ein rudimentäres Kommunikationsmodell: Sie charakterisieren den Künstler als »Medium« im doppelten Sinne. Ästhetik und Machart der Arbeit verweisen denn auch zurück auf die Geisterfotografie des 19. Jahrhunderts.

Adam Nadel (b. 1967, lives in Jackson Heights, N.Y.), untitled (from the series *Rwanda September 2003*), 2003, C print, 48.5 x 49 cm, Teutloff Photo + Video Collection, Bielefeld

After war (1990–94) and genocide (1994), Rwanda received a new constitution in 2003. Presidential and parliamentary elections took place between August and October. Nadel presents this emergence into a new and better age as a stepping out from the dark, of emerging from a tunnel. The fusion of the face with the dark background lends particular importance to the borders of the picture. The photograph itself is given a face; a picture is created that answers the gaze of the beholder.

Gerd Bonfert (b. 1953 Blaj, Romania, lives in Cologne), *G 51-1 (Selbst)*, 2002, gelatin silver print, sheet: 97 x 130 cm, edition: 5, Teutloff Photo + Video Collection, Bielefeld

The human being, light and time are the main materials of Bonfert's art. In addition there is movement, which here causes the artist's facial features to dissolve in a ghostly way (cf. pp. 83, 100). The oversize nails with the hanging wire come across as a primitive experimental set-up or a rudimentary communication model: They characterize the artist as "medium" in two senses. The aesthetic and execution of the work hark back to the spirit photography of the 19th century.

▷ Seite 104/105
Nr. 88, 89 der Ausstellung

Christian Boltanski (*1944 Paris, lebt in Malakoff bei Paris), *Les fantômes de Varsovie*, 2002, zwei S/W-Fotografien, je 119 x 64 cm, Auflage: 2/3, rückseitig Zertifikat mit Signatur, Teutloff Photo + Video Collection, Bielefeld

Mit dem Motiv der Sängerin beschäftigte sich Boltanski mehrfach. In den 1990er Jahren entstanden zu diesem Thema Fotografien auf Transparentpapier und das Mappenwerk *La Chanteuse* mit Heliogravüren. Der Titel dieses Diptychons mag an die berühmte jüdische Sängerin im Warschauer Ghetto, Marysia Ajzensztat, erinnern, die 1942 von der SS ermordet wurde. Gerade in diesem Zusammenhang erscheint die Unschärfe »wie ein Vorzeichen des Verschwindens«, als »Stilmittel einer Ikonografie der Katastrophe« (Wolfgang Ullrich).

Christian Boltanski (b. 1944 Paris, lives in Malakoff near Paris), *Les fantômes de Varsovie*, 2002, two b/w photographs, each 119 x 64 cm, edition: 2/3, certificate with signature verso, Teutloff Photo + Video Collection, Bielefeld

Boltanski has used this motif of the singer several times. In the 1990s he produced photographs on this theme on transparent paper, as well as the portfolio of photogravures *La Chanteuse*. The title of this diptych may recall the famous Jewish singer in the Warsaw Ghetto, Marysia Ajzensztat, who was murdered by the SS in 1942. It is precisely in this context that the lack of focus comes across "like a preliminary to disappearance," as a "stylistic means of an iconography of catastrophe" (Wolfgang Ullrich).

▷ Seite 106/107
Nr. 90 der Ausstellung

Alter

Old Age

Hans Canon (Johann von Strašiřipka, 1829 Wien–1885 Wien), *Studienkopf eines bärtigen Mannes*, um 1873 (?), Öl auf Leinwand, 40 x 33 cm, Wallraf-Richartz-Museum & Fondation Corboud, Köln, Inv.-Nr. WRM 2383, erworben 1929 als Geschenk der Galerie Caspari, München

Noch vor Aufkommen der eigentlichen Ölskizze entstand im 16. Jahrhundert die farbige Kopfstudie als vorbereitende Stufe des Porträts. Im Barock – und besonders im Umfeld von Peter Paul Rubens – bekam die skizzenhafte Darstellung von Köpfen alter Männer einen Eigenwert, der nicht zuletzt auf dem malerischen Reiz alter Haut und rauschender Bärte beruhte. Im 19. Jahrhundert gehörte der Altmännerkopf zu den Standardmotiven der akademischen malerischen Ausbildung. In dieser Tradition steht auch die Skizze von Hans Canon.

Roberto Salas (*1940, lebt auf Kuba), *Habana*, 2002, Silbergelatineprint, 61,5 x 51,5 cm, handschriftlich betitelt, datiert unten links: Habana, 2002, Teutloff Photo + Video Collection, Bielefeld

Diese Profilaufnahme aus kurzer Distanz entkleidet Fidel Castro zwar seiner Insignien und reduziert ihn auf seine Physiognomie. Sie steht aber in einer langen, bis in die Antike zurückreichenden Tradition der Herrscherporträts auf Münzen und Medaillen. Neu ist die enorme physische Präsenz des Porträtierten, von den Poren, Falten und Flecken der Haut bis hin zur Struktur von Haupt- und Barthaar, Brauen und Wimpern. Der geöffnete Mund verweist auf die rhetorische Kraft des »máximo líder« – berühmt für seine Endlosreden.

Old Age

Hans Canon (Johann von Strašiřipka; 1829 Vienna–1885 Vienna), *Study of Head of a Bearded Man*, ca. 1873 (?), oil on canvas, 40 x 33 cm, Wallraf-Richartz-Museum & Fondation Corboud, Cologne, inv. no. WRM 2383, acquired in 1929 as gift of the Galerie Caspari, Munich

In the 16th century, even before the actual oil sketch came into being, a colored head study was made as a preparatory stage in the process of painting a portrait. In the Baroque period, and particularly in the circle of Peter Paul Rubens, the sketch-like rendering of the heads of old men took on a life of their own, not least due to the stimulus for the painter provided by old skin and flowing beards. In the 19th century the old man's head was part of the standard academic training of painters. The sketch by Canon is in this tradition.

Roberto Salas (b. 1940, lives in Cuba), *Habana*, 2002, gelatin silver print, 61.5 x 51.5 cm, handwritten title and date bottom left: Habana, 2002, Teutloff Photo + Video Collection, Bielefeld

While this close-up profile strips Fidel Castro of his insignia and reduces him to his facial features, it continues a long tradition, going back to classical antiquity, of ruler-portraits on coins and medals. What is new here is the huge physical presence of the sitter, from the pores, wrinkles and marks on the skin to the structure of the hair and the beard, the eyebrows and the eyelashes. The open mouth points to the rhetorical strength of the "máximo líder," famous for his endless speeches.

▷ Seite 108/109
Nr. 94, 93 der Ausstellung

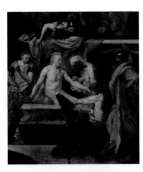

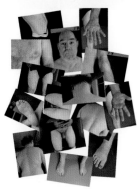

▷ Seite 110/111
Nr. 104, 95 der Ausstellung

Johann Anton De Peters (1725 Köln–1795 Köln), *Der Tod des Seneca*, Öl auf Leinwand, 97,5 x 86,5 cm, Wallraf-Richartz-Museum & Fondation Corboud, Köln, Inv.-Nr. WRM 1294

Der römische Historiker Tacitus beschreibt, wie der Dichter und Philosoph Seneca durch Kaiser Nero 65 n. Chr. zum Selbstmord gezwungen wurde, da er an einer Verschwörung teilgenommen habe. Dieses unvollendete Gemälde aus den 1780er Jahren zeigt, wie die Venen des linken Armes von einem Helfer geöffnet werden. Vor dem blutroten Tuch wie in einem Sarkophag stehend erinnert die Senecafigur an Christusdarstellungen (S. 91). Einflüsse der Stoa auf das Christentum erfolgten zum Beispiel über Paulus.

Paul McCarthy (*1945 Salt Lake City/Utah, lebt in Los Angeles und Altadena, Kalifornien), *Peter Paul Skin Sample*, 2005, digitaler Laserdruck, je 16,8 x 25,4 cm, 15 Aufnahmen in einer Box, Edition für Parkett 73, Auflage: 36/XII, Teutloff Photo + Video Collection, Bielefeld

Derlei fotografische »Hautproben« kennt man sonst aus Lehr- oder Handbüchern der Dermatologie (jetzt natürlich auch aus dem Internet). Der mit einer doppelten Alliteration operierende Titel verweist auf die wichtigsten römischen Märtyrer, die »Apostelfürsten« Petrus und Paulus, wie auch auf gängige Sprichwörter (»rob Peter to pay Paul«). Die Fotografie wird hier nicht nur gleichsam zum Objektträger, sondern auch zur Reliquie – ein Gedanke, den Theoretiker der Fotografie wie André Bazin und Susan Sontag formulierten.

Johann Anton De Peters (1725 Cologne–1795 Cologne), *The Death of Seneca*, oil on canvas, 97.5 x 86.5 cm, Wallraf-Richartz-Museum & Fondation Corboud, Cologne, inv. no. WRM 1294

The Roman historian Tacitus describes how the poet and philosopher Seneca was forced to commit suicide by the Emperor Nero in AD 65, following his alleged involvement in a conspiracy. This unfinished painting dating from the 1780s shows the veins of the left arm being opened by an assistant. Standing in front of a blood-red cloth as if in a sarcophagus, the figure of Seneca is reminiscent of depictions of Christ (p. 91). Christianity was influenced by the Stoics, of which Seneca was a famous representative, for example through St. Paul.

Paul McCarthy (b. 1945 Salt Lake City, Utah, lives in Los Angeles and Altadena, Calif.), *Peter Paul Skin Sample*, 2005, digital laser prints, each 16.8 x 25.4 cm, 15 photographs in a box, edition for Parkett 73, edition: 36/XII, Teutloff Photo + Video Collection, Bielefeld

This kind of photographic "skin sample" is otherwise known only from textbooks on dermatology (and nowadays of course from the Internet too). The title with its double alliteration refers to the most important of the martyrs in Rome, the Holy Apostles Peter and Paul, as well as to commonly used turns of phrase ("rob Peter to pay Paul"). The photograph thus becomes not only a kind of microscope slide, but also a relic, an idea formulated by such theoreticians of photography as André Bazin and Susan Sontag.

Franz Seraph von Lenbach (1836 Schrobenhausen/ Oberbayern–1904 München), *Otto Fürst Bismarck*, 1887/88 Öl auf Weidenholz, 125 x 100 cm, bezeichnet unten rechts: F. Lenbach 1888, Wallraf-Richartz-Museum & Fondation Corboud, Köln, Inv.-Nr. WRM 1144

Briefen Lenbachs zufolge wurde dieses Porträt in der Weihnachtswoche 1887 in Friedrichsruh begonnen und im Auftrag der Stadt Köln im Dezember 1888 fertiggestellt. Es zeigt also den 72- bis 73-jährigen Bismarck. Das formal stark reduzierte, ganz auf den festen Blick konzentrierte Bildnis ist insofern »historistisch«, als es Porträtformeln der venezianischen Renaissance verwendet. Besonders Tizian, aber auch Tintoretto – als Bildnismaler der venezianischen Gerontokratie – sind hier zu nennen.

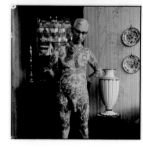

▷ Seite 112/113 Nr. 96, 103 der Ausstellung

Herbert Hoffmann (*1919 Stettin – 2010 Appenzell/ Schweiz), *Dr. Hubert Clotten, fotografiert 1965 in Hamburg*, Silbergelatineprint, 28,9 x 28,6 cm, Auflage: 7/12, rückseitig signiert, datiert, betitelt, nummeriert, Teutloff Photo + Video Collection, Bielefeld

Der berühmte, einst in Hamburg tätige Tätowierer Herbert Hoffmann hat hier einen seiner Kunden dokumentiert. Staunenswert ist nicht nur dessen aufwändiger, selbst noch die Eichel erfassender Körperschmuck, sondern auch die durchaus vergleichbare Dichte des Porträts. Ähnlich wie bei Koelbl (S. 66) spiegeln sich die Dekoration des Körpers und des Ambientes (hier: Hoffmanns Wohnung) ineinander. Es scheint, als sollten Kerze und Vase an die Vergänglichkeit des menschlichen Körpers erinnern.

Franz Seraph von Lenbach (1836 Schrobenhausen, Bavaria– 1904 Munich), *Otto, Prince Bismarck*, 1887/88, oil on willow, 125 x 100 cm, inscribed bottom right: F. Lenbach 1888, Wallraf-Richartz-Museum & Fondation Corboud, Cologne, inv. no. WRM 1144

According to letters written by Lenbach, this portrait was begun during Christmas week 1887 at Bismarck's country seat in Friedrichsruh, and completed on the commission of Cologne City Council the following December. It thus shows Bismarck aged 72 to 73. The formally spare portrait, which concentrates entirely on the statesman's fixed gaze, is "historicist" to the extent that it uses portrait formulae of the Venetian Renaissance. Titian in particular, but also Tintoretto (as portrait painter to the Venetian gerontocracy), could be mentioned in this connection.

Herbert Hoffmann (b. 1919 Stettin – 2010 Appenzell, Switzerland), *Dr. Hubert Clotten, photographed in Hamburg in 1965*, gelatin silver print, 28.9 x 28.6 cm, edition: 7/12, signed, dated, titled and numbered verso, Teutloff Photo + Video Collection, Bielefeld

The famous tattooist Herbert Hoffmann, who used to work in Hamburg, has here documented one of his customers. What is amazing is not only the elaborate whole-body decoration, which does not even exclude the *glans penis*, but also the comparable density of the picture itself. As with Koelbl (p. 66), the decoration of the body and the ambience (in this case, Hoffmann's apartment) are mutually reflective. It seems as though candle and vase are there to remind us of the transience of the human body.

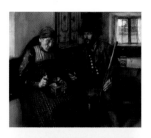

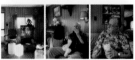

▷ Seite 114/115
Nr. 100, 102 der Ausstellung

Wilhelm Leibl (1844 Köln–1900 Würzburg), *Bauernjägers Einkehr*, Öl auf Leinwand, 73,4 x 86 cm, bezeichnet unten links: W. Leibl 93, Wallraf-Richartz-Museum & Fondation Corboud, Köln, Inv.-Nr. WRM 1168

Das Gemälde lebt vom offensichtlichen Gegensatz zwischen der gezeigten Situation und dem unsichtbaren Fortschritt. Bildgegenstand ist ein *happy moment* der dargestellten Personen, der aus einfachen Genüssen besteht: Schnaps, Tabak, Kaffee. Der Betrachter seinerseits darf eine altmeisterliche Malkultur genießen, die noch lange nach Erfindung der Fotografie auf der Erkundung von Natur und Wirklichkeit insistiert sowie mit delikaten Farbakkorden und stofflicher Differenzierung eine Atmosphäre von beinahe riechbarer Dichte erzeugt.

David Hilliard (*1964 Lowell/Mass., lebt in Boston/Mass.), *Hot Coffee, Soft Porn*, 1999, C-Print auf Aluminium, je 57,6 x 46,2 cm, Teutloff Photo + Video Collection, Bielefeld

In drei Bildern entwickelt der Künstler ein kurioses Panorama. Wie bei Leibl (s. oben) – aber auch bereits in manchen niederländischen Barockgemälden – verschwimmt die Grenze zwischen Porträt und Genre. Der dargestellte Raum wird in einer quasi-filmischen Montage »rekonstruiert«. Zugleich verweist die Dreiteilung des Werkes auf die ältere und jüngere Tradition des Triptychons. Vor dem Hintergrund dieser »Würdeformel« (Klaus Lankheit) hebt sich der inszenierte *trash* umso kraftvoller ab.

Wilhelm Leibl (1844 Cologne–1900 Würzburg), *Return of the Peasant Hunter*, oil on canvas, 73.4 x 86 cm, signed bottom left: W. Leibl 93, Wallraf-Richartz-Museum & Fondation Corboud, Cologne, inv. no. WRM 1168

The painting lives from the obvious contrast between the situation here depicted and unseen progress. The motif is a happy moment in the daily life of the persons depicted: schnapps, tobacco, coffee. The beholder for his part can enjoy old-masterly painting culture, which, long after the invention of photography, still insists on exploring nature and reality, and, with delicate color matches and textural nuances, creates an atmosphere of almost olfactory denseness.

David Hilliard (b. 1964 Lowell, Mass., lives in Boston, Mass.), *Hot Coffee, Soft Porn*, 1999, C print on aluminum, each 57.6 x 46.2 cm, Teutloff Photo + Video Collection, Bielefeld

In three pictures, the artist develops a curious panorama. As with Leibl (above), but also already in some Dutch Baroque paintings, the boundary between portrait and genre painting is blurred. The room depicted is "reconstructed" in a quasi filmic montage. At the same time, the trisection of the work recalls the older and more recent tradition of the triptych. Against the background of this "dignity formula" (Klaus Lankheit), the staged trash is all the more strongly emphasized.

Tod

Miwa Yanagi (*1967 Kōbe/Japan, lebt in Kyōto), *Shizuka* (aus der Serie *My Grandmothers*), 2004, C-Print auf Diasec, 140 x 100 cm, Auflage: 2/7, rückseitig signiert, nummeriert, Teutloff Photo + Video Collection, Bielefeld

»Die Serie My *Grandmothers* visualisiert Vorstellungen, die mehrere junge Frauen als Antwort auf die Frage entwickelten, welchen Frauentyp sie selbst in fünfzig Jahren verkörpern würden. Diese Werke sind nicht bloß Bilder meiner eigenen fiktiven Großmütter, sondern in Kooperation entstandene Idealporträts der älteren Frau.« (Miwa Yanagi) Hier ist es die ältere Frau, welche – als Schöpferin – die jüngere konstruiert und sich damit selbst zur Wiedergeburt verhilft. Formal wird die westliche Bildtradition der *Pietà* (s. unten) zitiert.

Jacopo Tintoretto (1519 Venedig–1594 Venedig) und Werkstatt, *Beweinung Christi*, um 1575, Öl auf Leinwand, 137 x 206 cm, Wallraf-Richartz-Museum & Fondation Corboud, Köln, Inv.-Nr. Dep. 277, Leihgabe der Bundesrepublik Deutschland seit 1966

Tintorettos zentrifugale Komposition ist typisch für das raum- und medienübergreifende Denken dieses Künstlers. In der leeren Bildmitte sieht man die geisterhaft deutende Hand des toten Gottessohnes. Stellt man sich das Gemälde über einem Sakramentsaltar vor, so wird die Geste verständlich: Christus verweist auf die Hostie als eucharistische Form seines am Kreuz geopferten Leibes.

Death

Miwa Yanagi (b. 1967 Kōbe, Japan, lives in Kyōto), *Shizuka* (from the series *My Grandmothers*), 2004, C print on Diasec, 140 x 100 cm, edition: 2/7, signed and numbered verso, Teutloff Photo + Video Collection, Bielefeld

Miwa Yanagi has said of her work: "The *My Grandmothers* series […] visualizes the self-perceived notions of several young women when asked to imagine what type of woman they themselves might become fifty years later. […] these works are not only images of my own fictitious grandmothers, for they also stand as collaborative portraits of the ideal elderly woman." Here it is the older woman who, as creatrix, constructs the younger and thus helps her own rebirth. Formally, Yanagi quotes the Western pictorial tradition of the *Pietà* (below).

Jacopo Tintoretto (1519 Venice–1594 Venice) and studio, *Lamentation of Christ*, ca. 1575, oil on canvas, 137 x 206 cm, Wallraf-Richartz-Museum & Fondation Corboud, Cologne, inv. no. Dep. 277, on loan from the Federal Republic of Germany since 1966

Tintoretto's centrifugal composition is typical of the way this artist's thinking transcended space and media. In the empty center of the picture can be seen the ghostly hand of the dead Son of God. If one imagines the painting above a sacramental altar, the gesture becomes comprehensible: Christ is pointing to the host as the eucharistic form of his body, sacrificed on the Cross.

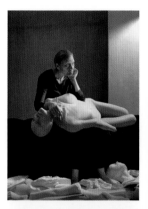

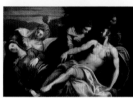

▷ Seite 116/117
Nr. 106, 105 der Ausstellung

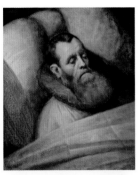

▷ Seite 118/119
Nr. 112, 111 der Ausstellung

Art des Geldorp (Geldorp Gortzius, 1553 Löwen–in oder nach 1619 Köln), *Bildnis eines Toten*, Öl auf Eichenholz, 71,5 x 60 cm, Wallraf-Richartz-Museum & Fondation Corboud, Köln, Inv.-Nr. WRM 1551

Totenmasken und Totenporträts bildeten einst eine wichtige künstlerische Aufgabe. So ist »aus frühen Kölner Versteigerungskatalogen zu belegen, dass Totenbildnisse Geldorps oder seiner Nachfolge in Köln geläufig waren« (Horst Vey/Annamaria Kesting). Das hier gezeigte, rasch und dünn gemalte Porträt weist trotz älterer Verputzungen erstaunliche Qualitäten auf. Der schöne Kragen hebt den Kopf wie auf einer »Johannesschüssel« hervor. Unter fein geklöppelter Spitze kontrastiert das leuchtend rote Kissen mit der wolkigen Bettwäsche.

Herlinde Koelbl (*1939 Lindau, lebt in München), *Sterbezyklus Tod und Abschied*, 1988/1989/2003, sechs Teile, S/W-Druck auf Aluminium, je 49,5 x 49,5 cm, Auflage: 1/7, rückseitig signiert, nummeriert, datiert: 08/2005, Teutloff Photo + Video Collection, Bielefeld

Schon 1839 wurde die Daguerreotypie sogleich auf eine tote Person angewandt. Der Franzose Nadar fotografierte berühmte Tote wie Victor Hugo oder Gustave Doré. Frühe amerikanische Fotofirmen warben mit ihren »lebendigen«, »wie schlafend« wirkenden Totenporträts. Dieses Werk erinnert, mit der Suggestion des gleichzeitig verstorbenen hochbetagten Paares, an den Mythos von Philemon und Baucis (S. 76). Die im positiven Sinne pathetische Wirkung des doppelten Triptychons beruht auch auf den Leerfeldern, die an Andy Warhols *blanks* erinnern.

In the manner of Geldorp Gortzius (1553 Louvain–in or after 1619 Cologne), *Portrait of a Dead Man*, oil on oak, 71.5 x 60 cm, Wallraf-Richartz-Museum & Fondation Corboud, Cologne, inv. no. WRM 1551

Death masks and postmortem portraits once served an important artistic function. Thus "there is evidence from early Cologne auction catalogues that postmortem portraits by Geldorp or his successors were common in the city" (Horst Vey and Annamaria Kesting). The portrait shown here, executed rapidly with thin paint, evinces extraordinary qualities in spite of past attempts to clean it. The fine ruff emphasizes the head, as if it were that of John the Baptist on a charger (Mark 6: 23–28). Beneath the finely worked lace, the bright red pillow contrasts with the cloudy bedlinen.

Herlinde Koelbl (b. 1939 Lindau, lives in Munich), *Sterbezyklus Tod und Abschied*, 1988/1989/2003, 6 parts, b/w print on aluminum, each 49.5 x 49.5 cm, edition: 1/7, signed, numbered and dated verso: 08/2005, Teutloff Photo + Video Collection, Bielefeld

As long ago as 1839 the new daguerreotype process was immediately applied to capture the image of a deceased person. The French photographer Nadar took pictures of famous corpses, including those of Victor Hugo and Gustave Doré. Early American photographic companies advertised with postmortem portraits that showed their subjects "as in life" or "as sleeping." This work reminds us, with the suggestion that a very old couple died at the same time, of the myth of Philemon and Baucis (p. 76). The pathetic (in the positive sense) effect of the double triptych is also due to the empty fields, which are reminiscent of Andy Warhol's "blanks."

Andres Serrano (*1950, lebt in New York), *The Morgue (Burnt to Death)*, 1992, Cibachrome-Print im Künstlerrahmen, 82,5 x 101,6 cm, Auflage: 2/7, rückseitig signiert, betitelt, nummeriert, Teutloff Photo + Video Collection, Bielefeld

Serranos Serie von überlebensgroßen Detailfotografien aus dem Leichenschauhaus ist – wie viele seiner Werke – umstritten. Der Künstler verwies auf Inspirationsquellen in der italienischen Renaissancemalerei (Bellini, Michelangelo). Man denkt aber auch an die Studien von Leichenteilen, die Géricault 1818/19 in Vorbereitung auf das *Floß der Medusa* malte. Roland Barthes zufolge blockiert das Trauma die Sprache, weshalb »das Schockfoto strukturbedingt insignifikant« sei. Serrano steigert diese Unsagbarkeit ins Monumentale.

Jürgen Klauke (*1943 Kliding bei Cochem/Mosel, lebt in Köln), *Toter Photograph*, 1988/1993, zweiteilige Fotoarbeit auf Barytpapier, oberer Teil: 149,7 x 119 cm, unterer Teil: 112,8 x 119 cm, Auflage: 1/2, Teutloff Photo + Video Collection, Bielefeld

Bis zur Entdeckung der Röntgenstrahlung (deren Nutzen für die Zollkontrolle man in Frankreich übrigens schon 1897 diskutierte) bildete die menschliche Haut eine entscheidende Grenze für die Gewinnung von Erkenntnissen über den lebenden menschlichen Körper. Lange vor der Diskussion um Nacktscanner legte sich Klauke im Flughafen Köln/Bonn auf das Förderband durch den »Kofferschacht«. Sein fingierter Blick in ein Hockergrab erinnert mit schwarzem Humor an die Vor- und Frühgeschichte der Fotografie als »Schattenkunst«.

Andres Serrano (b. 1950, lives in New York), *The Morgue (Burnt to Death)*, 1992, Cibachrome print in artist's frame, 82.5 x 101.6 cm, edition: 2/7, signed, titled and numbered verso, Teutloff Photo + Video Collection, Bielefeld

Serrano's series of over-lifesize detailed photographs from the mortuary is no less controversial than many of his other works. The artist has pointed to sources of inspiration in the painting of the Italian Renaissance (Bellini, Michelangelo). But one is also reminded of the studies of body parts painted by Géricault in 1818–19 when preparing the *Raft of the Medusa*. According to Roland Barthes, trauma blocks speech, which is why "the shock photo is, because of its structure, insignificant." Serrano pushes this ineffability to monumental grandeur.

Jürgen Klauke (b. 1943 Kliding near Cochem, Mosel, lives in Cologne), *Toter Photograph*, 1988/1993, 2-part photographic work on baryta paper, top part: 149.7 x 119 cm, bottom part: 112.8 x 119 cm, edition: 1/2, Teutloff Photo + Video Collection, Bielefeld

Until the invention of the X-ray (whose potential for customs checks was incidentally discussed in France as early as 1897) the skin formed a crucial barrier to obtaining knowledge of the living human body. Long before the debate about body or "strip" scanners, Klauke lay on the X-ray luggage conveyor belt at Cologne/Bonn airport. His fictitious look into a flexed-position burial site recalls with black humor the pre- and early history of photography as "shadow art."

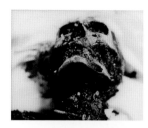
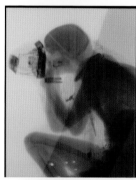

▷ Seite 120/121
Nr. 108, 113 der Ausstellung

156

Literatur / Literature

Andree, Rolf: Katalog der Gemälde des 19. Jahrhunderts im Wallraf-Richartz-Museum (Kataloge des Wallraf-Richartz-Museums, I), Köln 1964

Andy Warhol by Christopher Makos, Mailand 2002

Angell, Callie: Andy Warhol Screen Tests (The Films of Andy Warhol, Catalogue Raisonné, vol. 1), New York 2006

Anker, Suzanne/Nelkin, Dorothy: The Molecular Gaze. Art in the Genetic Age, Cold Spring Harbor/N.Y. 2004

Balzac, Honoré de: Le chef-d'œuvre inconnu, Paris 1966

Berns, Jörg Jochen: Geflacker in dunklen Räumen. Von der Camera obscura zu Kino und Bildschirm, in: Bruhn, Matthias/Hemken, Kai-Uwe (Hrsg./ Eds.): Modernisierung des Sehens. Sehweisen zwischen Künsten und Medien, Bielefeld 2008, 24–36

Billeter, Erika: Malerei und Photographie im Dialog von 1840 bis heute, Zürich/ Bern 1979

Blühm, Andreas/Krischel, Roland: Hotel California. Desiree Dolron – Thomas Wrede, Ausstellungskatalog/exhibition catalogue, Wallraf-Richartz-Museum & Fondation Corboud, Köln, 7.9.– 18.11.2007, München 2007

Bolloch, Joëlle: Photographies après décès: pratique, usages et fonctions, in: Le Dernier Portrait, Ausstellungskatalog/ exhibition catalogue, Musée d'Orsay, Paris, 5.3.–26.5.2002, Paris 2002, 112–145

Cachey, Theodore: Cartographic Dante, in: Italica, 2010 (im Druck/forthcoming)

Campbell, Thomas P.: Tapestry in the Renaissance. Art and Magnificence, Ausstellungskatalog/exhibition catalogue, The Metropolitan Museum of Art, New York, 12.3.–19.6.2002, New York 2002

Czymmek, Götz/Lenz, Christian (Hrsg./ Eds.): Wilhelm Leibl zum 150. Geburtstag, Ausstellungskatalog/exhibition catalogue, Neue Pinakothek, München, 12.5.–24.7.1994; Wallraf-Richartz-Museum, Köln, 4.8.–23.10.1994, Heidelberg 1994

Danielewski, Mark Z.: House of Leaves, London/New York ²2001

Davitt Asmus, Ute: Corpus quasi vas. Beiträge zur Ikonographie der italienischen Renaissance, Berlin 1977

Drewes, Franz Josef: Hans Canon (1829–1885). Werkverzeichnis und Monographie, Bd./vol. 1, Hildesheim/Zürich/ New York 1994

Dünkel, Vera: Das Auge der Radiographie. Zur Wahrnehmung einer neuen Art von Bildern, in: Bruhn, Matthias/ Hemken, Kai-Uwe (Hrsg./Eds.): Modernisierung des Sehens. Sehweisen zwischen Künsten und Medien, Bielefeld 2008, 206–220

Erichsen-Firle, Ursula/Vey, Horst: Katalog der deutschen Gemälde von 1550 bis 1800 im Wallraf-Richartz-Museum und im öffentlichen Besitz der Stadt Köln (Kataloge des Wallraf-Richartz-Museums, X), Köln 1973

Galassi, Peter: Before Photography. Painting and the Invention of Photography, Ausstellungskatalog/exhibition catalogue, The Museum of Modern Art, New York, 9.5.–5.7.1981, New York 1981

Geimer, Peter: Theorien der Fotografie zur Einführung, Hamburg 2009

Gide, André: Les faux-monnayeurs, Paris 1978

Gottwald, Franziska: Das Tronie. Muster – Studie – Meisterwerk. Die Genese einer Gattung der Malerei vom 15. Jahrhundert bis zu Rembrandt, München/Berlin 2009

Helmhold, Heidi: Totenfutterale. Zur Affektpolitik des Letzten Raumes, in: Ellwanger, Karen/Helmhold, Heidi u.a./ et al. (Hrsg./Eds.), Das »letzte Hemd«. Zur Konstruktion von Tod und Geschlecht in der materiellen und visuellen Kultur, Bielefeld 2010, 323–348

Héran, Emmanuelle: Le dernier portrait ou la belle mort, in: Le Dernier Portrait, Ausstellungskatalog/exhibition catalogue, Musée d'Orsay, Paris, 5.3.–26.5.2002, Paris 2002, 25–101

Herweg, Henriette (Hrsg./Ed.): Alterskonzepte in Literatur, bildender Kunst, Film und Medizin (Rombach Wissenschaften – Reihe/series Litterae, Bd./vol. 152), Freiburg i.Br./Berlin/ Wien 2009

Hiller, Irmgard/Vey, Horst (mit Vorarbeiten von/with preliminary work by Tilman Falk): Katalog der deutschen und niederländischen Gemälde bis 1550 (mit Ausnahme der Kölner Malerei)

im Wallraf-Richartz-Museum und im Kunstgewerbemuseum der Stadt Köln (Kataloge des Wallraf-Richartz-Museums, V), Köln 1969

Hirschfelder, Dagmar: Tronie und Porträt in der niederländischen Malerei des 17. Jahrhunderts, Berlin 2008

Hope, Charles: Titian, London 1980

Jael Lehmann, Annette: Matthew Bradys Illustrious Americans. Inszenierte Porträts in den USA des 19. Jahrhunderts, in: Deppner, Martin Roman (Hrsg./Ed.): Fotografie im Diskurs performativer Kulturen. 27. Bielefelder Symposium über Fotografie und Medien in Zusammenarbeit mit dem Bielefelder Kunstverein, 27./28.10.2006, Heidelberg 2009, 104–123

Johann Anton de Peters – Ein Kölner Maler des 18. Jahrhunderts, Ausstellungskatalog/exhibition catalogue, Wallraf-Richartz-Museum, Köln, 12.6.–9.8.1981, Köln 1981

Klesse, Brigitte: Katalog der italienischen, französischen und spanischen Gemälde bis 1800 im Wallraf-Richartz-Museum (Kataloge des Wallraf-Richartz-Museums, VI), Köln 1973

Koschatzky, Walter: Die Kunst der Photographie. Technik, Geschichte, Meisterwerke, Salzburg/Wien 1984

Krischel, Roland: Vom Bilder-Buch zum Buch-Bild – Ein Diptychon des Barthel Bruyn als gemalte Theologie, in: Lambert, Katja/Eberhardt, Silke u.a./et al. (Hrsg./Eds.), Festschrift für Gesina Kronenburg, Köln 2009, 13–19

Krischel, Roland: »I don't think I missed a stroke«. Andy Warhols *Jackie Triptych* für Henry Geldzahler, in: Kölner Museums-Bulletin, 1/2006, 4–15

Krischel, Roland/Morello, Giovanni/Nagel, Tobias (Hrsg./Eds.): Ansichten Christi. Christusbilder von der Antike bis zum 20. Jahrhundert, Ausstellungskatalog/exhibition catalogue, Wallraf-Richartz-Museum – Fondation Corboud, Köln, 1.7.–2.10.2005, Köln 2005

Kruse, Christiane: Tote und künstliche Haut. Die Maske des Stars zwischen Kunst und Massenmedien, in: Bohde, Daniela/Fend, Mechthild (Hrsg./Eds.): Weder Haut noch Fleisch. Das Inkarnat in der Kunstgeschichte, Berlin 2007, 181–198

Lankheit, Klaus: Das Triptychon als Pathosformel, Heidelberg 1959

Lehnert, Gertrud: Zweite Haut? Körper und Kleid, in: Arburg, Hans-Georg von/Brunner, Philipp u.a./et al. (Hrsg./Eds.): Mehr als Schein. Ästhetik der Oberfläche in Film, Kunst, Literatur und Theater, Zürich/Berlin 2008, 89–99

Löcher, Kurt: Rezension zu: Brinkmann, Bodo/Kemperdick, Stephan: Deutsche Gemälde im Städel 1500–1550, in: Kunstchronik, Jg. 60, Heft 2, Feb. 2007

Marek, Kristin: Bildliche Codierungen. Körperparadigmen im Posthumanismus, in: kritische berichte, Jg. 37, Heft 4, 2009, 83–91

Marek, Kristin: Mediale Strukturen. Die Fotografie als Form des Historischen, in: Bruhn, Matthias/Hemken, Kai-Uwe (Hrsg./Eds.): Modernisierung des Sehens. Sehweisen zwischen Künsten und Medien, Bielefeld 2008, 270–285

Mojana, Marina: Valentin de Boulogne, Mailand 1989

Negro, Emilio/Roio, Nicosetta: Francesco Francia e la sua scuola, Modena o. J./n.d. (1998)

Nemeczek, Rolf/Paltzer, Allan: Ohne Fotos keine Gemälde, in: art, 1/1984, 20–41

Petherbridge, Deanna/Jordanova, Ludmilla: The Quick and the Dead. Artists and Anatomy, Ausstellungskatalog/exhibition catalogue, Royal College of Art, London, 28.10.–24.11.1997; Mead Gallery, Warwick Arts Centre, Coventry, 10.1.–14.3.1998; Leeds City Art Gallery, 28.3.–24.5.1998, Manchester 1997

Poe, Edgar Allan: The Oval Portrait, in: Selected Writings of Edgar Allan Poe. Poems, Tales, Essays and Reviews. Edited with an introduction by David Galloway, Harmondsworth [10]1978, 250–253

Prettejohn, Elizabeth: Beauty and Art 1750–2000, Oxford/New York 2005

Quiles, Fernando: Alonso Miguel de Tovar (1678–1752), Arte Hispalense, 77, Sevilla 2005

Raynaud, Clémence: Du cortège funèbre au portrait posthume: Fonctions et enjeux du masque mortuaire à la fin du Moyen Âge, in: Le Dernier Portrait, Ausstellungskatalog/exhibition catalogue, Musée d'Orsay, Paris, 5.3.–26.5.2002, Paris 2002, 16–24

Scruton, Roger: Beauty, Oxford/New York 2009

Stremmel, Kerstin: Geflügelte Bilder. Neuere fotografische Repräsentationen von Klassikern der bildenden Kunst, Holzminden 2000

Sykora, Katharina: Letzte Fetzen, in: Ellwanger, Karen/Helmhold, Heidi u.a./et al. (Hrsg./Eds.), Das »letzte Hemd«. Zur Konstruktion von Tod und Geschlecht in der materiellen und visuellen Kultur, Bielefeld 2010, 263–275

Theye, Thomas: Einführung, in: Theye, Thomas (Hrsg./Ed.): Der geraubte Schatten. Die Photographie als ethnographisches Dokument, Ausstellungskatalog/exhibition catalogue, Münchner Stadtmuseum, 24.11.1989–11.2. 1990; Haus der Kulturen der Welt, Berlin, 9.3.–6.5.1990; Rautenstrauch-Joest-Museum für Völkerkunde Köln, 7.6.–29.10.1990, München/Luzern 1989, 8–59

Tournier, Michel: La jeune fille et la mort et autres nouvelles présentées et annotées par Willi Jung, Frankfurt am Main 1988

Ullrich, Wolfgang: Die Geschichte der Unschärfe (Kleine kulturwissenschaftliche Bibliothek, Bd./vol. 69), Berlin 2002

Vey, Horst/Kesting, Annamaria: Katalog der niederländischen Gemälde von 1550 bis 1800 im Wallraf-Richartz-Museum und im öffentlichen Besitz der Stadt Köln (Kataloge des Wallraf-Richartz-Museums, III), Köln 1967

Wallraf-Richartz-Museum Köln. Von Stefan Lochner bis Paul Cézanne – 120 Meisterwerke der Gemäldesammlung, Köln/Mailand 1986

Wilde, Oscar: The Picture of Dorian Gray, Harmondsworth 1979

Willcock, John: The Autobiography and Sex Life of Andy Warhol, New York 1971

Zehnder, Frank Günter: Katalog der Altkölner Malerei (Kataloge des Wallraf-Richartz-Museums, XI), Köln 1990

Zika, Anna: Bild wird Mode. Mode wird Bild – Fotografie und Lifestyle …, in: Deppner, Martin Roman (Hrsg./Ed.): Fotografie im Diskurs performativer Kulturen. 27. Bielefelder Symposium über Fotografie und Medien in Zusammenarbeit mit dem Bielefelder Kunstverein, 27./28.10.2006, Heidelberg 2009, 132–145

Internet

Blume, Anna: Andres Serrano, aus/from: Bomb, 43/Spring 1993:
http://bombsite.com/issues/43/articles/1631 (31.5.2010)

Borchhart-Birbaumer, Brigitte: Antifaustus Jürgen Klauke oder Stirbt das Genie
in schwarzer Anarchie?, aus/from: Museum Moderner Kunst Passau (Hrsg./issued by):
Jürgen Klauke, Hoffnungsträger. Aspekte des desaströsen Ich, 2006:
www.juergenklauke.de/texte/2006_01-borchart.html (31.5.2010)

Brown, Neal: John Isaacs. Imperial College, aus/from: Frieze, 38, Januar/Februar 1998:
www.frieze.com/issue/print_back/john_isaacs1 (27.5.2010)

Gefter, Philip: Self-Portrait as Obscure Object of Desire; Jack Pierson's Autobiography,
of Sorts, in Photographs of Unidentified Men, aus/from: The New York Times,
18.12.2003: www.nytimes.com/2003/12/18/books/self-portrait-obscure-object-desire-jack-
pierson-s-autobiography-sorts.html (26.5.2010)

Kühn, Sabrina: Jürgen Klaukes Self Performances:
www.ruhr-uni-bochum.de/genderstudies/kulturundgeschlecht/pdf/Kuehn.pdf

Kuhrt, Nicola: Tattoo-Kunst: Meister des Körperstichs, in: Spiegel Online, 30.8.2003:
www.spiegel.de/kultur/gesellschaft/0,1518,druck-263482,00.html (17.7.2009)

Lifson, Ben: Andres Serrano, aus/from: Artforum, April 1993:
http://findarticles.com/p/articles/mi_m0268/is_n8_v31/ai_13905184 (31.5.2010)

Poe, Edgar Allan: Life in Death (= Erstfassung von/first version of The Oval Portrait,
aus/from: Graham's Magazine, April 1842): www.eapoe.org/works/tales/ovlprta.htm
(4.5.2010)

Poe, Edgar Allan: The Daguerreotype, aus/from: Alexander's Weekly Messenger,
Jan. 1840: http://xroads.virginia.edu/~hyper/POE/daguer.html (6.5.2010)

Schlink, Wilhelm: Die Kunstsammlung, aus/from: Trierer Beiträge, 14, 1984, 4–10:
http://freidok.uni-freiburg.de/volltexte/454/pdf/sammlung.pdf

Zöllner, Frank: »Ogni pittore dipinge sè«. Leonardo da Vinci and »aoutomimesis«,
aus/from: Matthias Winner (Hrsg./Ed.): Der Künstler über sich in seinem Werk.
Internationales Symposium der Bibliotheca Hertziana, Rom 1989, Weinheim 1992,
137–160: http://archiv.ub.uni-heidelberg.de/artdok/volltexte/2006/161

www.art-in.de/incmeldung.php?id=1369 (17.7.2009)

http://brianfinke.com/cv.html (16.7.2009)

www.fabula.org/actualites/article12533.php

www.hansopdebeeck.com (16.7.2009)

www.herbert-hoffmann-taetowierungen.de/home.html (17.7.2009)

http://isaacs.aeroplastics.net

www.kunstaspekte.de/index.php?tid=16625&action=termin (26.5.2010)

www.kunstaspekte.de/index.php?tid=40009&action=termin (27.5.2010)

www.mcdewaal.com

www.mocp.org/exhibitions/2005/05/painting_on_pho.php (27.10.2009)

http://pagesperso-orange.fr/noir-ivoire/association/stan_greene.htm (17.7.2009)

http://prophoto-online.de/visualgallery/kodak-nachwuchs-foerderpreis-10000613
(27.5.2010)

http://stern.de/fotografie/robert-lebeck-hinter-dem-leben-her-521737.html (12.5.2010)

www.perlentaucher.de/autoren/7453/Peter_Hendricks.html (16.7.2009)

http://print.perlentaucher.de/autoren/1231/Osvaldo_Salas.html (17.7.2009)

www.saulgallery.com/jacobson/statement.html (21.7.2009)

www.visitcenter.org/programs.cfm?p=Project06Nadel (21.7.2009)

www.yanagimiwa.net/My/e (16.10.2009)

Wikipedia:
Marysia Ajzensztat (27.5.2010); Muhammad Ali (2.2.1010); Christian Boltanski
(17.7.2009); Daniele Buetti (16.7.2009); Hussein Chalayan (17.7.2009); Nan Goldin
(20.7.2009); Graham's Magazine (28.4.2010); David Hilliard (17.7.2009); Thomas
Höpker (16.7.2009); House of Leaves (18.5.2010); Yousuf Karsh (17.7.2009); Jürgen
Klauke (17.7.2009); Herlinde Koelbl (16.7.2009); Robert Lebeck (17.7.2009); Lord
Kitchener Wants You (2.2.2010); Loretta Lux (16.7.2009); Christopher Makos
(17.7.2009); Paul McCarthy (17.7.2009); Stefan Moses (17.7.2009); Das ovale Porträt
(28.4.2010); The Oval Portrait (28.4.2010); Jack Pierson (17.7.2009); Poe, singer
(18.5.2010); Andres Serrano (17.7.2009); Thomas Sully (8.6.2010); Tronie
(27.10.2009); Larry Towell (16.7.2009); Watchmen (22.7.2009); Miwa Yanagi
(17.7.2009)